My
Photoshop®
Elements 13

Cheryl Brumbaugh-Duncan

800 East 96th Street,
Indianapolis, Indiana 46240 USA

My Photoshop® Elements 13

Copyright © 2015 by Pearson Education, Inc.

ISBN-13: 978-0-7897-5380-9
ISBN-10: 0-7897-5380-4

Library of Congress Control Number: 2014954706

Printed in the United States of America

First Printing: December 2014

Trademarks

Warning and Disclaimer

Special Sales

For information about buying this title in bulk quantities, or for special sales opportunities (which may include electronic versions; custom cover designs; and content particular to your business, training goals, marketing focus, or branding interests), please contact our corporate sales department at corpsales@pearsoned.com or (800) 382-3419.

For government sales inquiries, please contact governmentsales@pearsoned.com.

For questions about sales outside the U.S., please contact international@pearsoned.com.

Editor-in-Chief
Greg Wiegand

Senior Acquisitions Editor
Laura Norman

Development Editor
Brandon Cackowski-Schnell

Managing Editor
Sandra Schroeder

Senior Project Editor
Tonya Simpson

Copy Editor
Barbara Hacha

Indexer
Lisa Stumpf

Proofreader
The Wordsmithery LLC

Technical Editor
J. Boyd Nolan

Editorial Assistant
Kristen Watterson

Interior Designer
Anne Jones

Cover Designer
Mark Shirar

Compositor
Bronkella Publishing

Contents at a Glance

Bonus Tasks Available Online

Table of Contents

Bonus Tasks Available Online

Additional tasks for Chapters 1, 2, 3, 4, 6, 7, 10, 13, and 14 are available online. This content can be found at www.quepublishing.com/title/9780789753809.

Chapter 1: Overview of Photoshop Elements 13 Preferences

Chapter 2: Customizing Default Settings for Files

Chapter 3: Elements Organizer: Setting Viewer Preferences

Chapter 4: More Ways to Work with Tags

Chapter 6: More Ways to Use the Photo Editor

Chapter 7: More on Layers: Clipping Masks and Blending

Chapter 10: More Ways to Enhance Photos

Chapter 13: More Ways to Print

Chapter 14: Sharing with Adobe ID

About the Author

Cheryl Brumbaugh-Duncan is committed to education and technology. For more than 15 years, Cheryl has run her own company, Virtually Global Communications (VGC), a web design and development company with a focus in online education. Armed with a master's degree in education, as well as being an expert in web design and development, she has been developing cutting-edge websites and mobile Internet applications, as well as teaching individuals and companies about computers, technology, and web design.

Combining web technologies and education strategies, Cheryl has developed and authored books, instructor-led training curriculum, and online education courses for clientele that includes QWEST, Que Publishing, Alpha Publishing, New Riders Publishing, ADIC, Dell, and Sun Microsystems. She also has authored an Internet-delivered training course on Excel 2007 through the Virtual Training Company, or VTC.

Cheryl also teaches classes in web development and design, as well as a custom class for starting and running a successful business. Cheryl's commitment to the combination of education, technology, and various delivery methods for communicating information keeps her very busy in this ever-changing world. Please visit her website at www.virtuallyglobal.com to learn more about Cheryl and her company, Virtually Global Communications.

Dedication

I would like to dedicate this book to my family—in particular, to my Nana and grandfather. They had the foresight to purchase our wonderful cottage that has offered so many years of fun, play, and love to my parents, siblings, and now our children.

Acknowledgments

Many thanks go to my agent, Carole Jelen of Waterside Productions, for her many years of service. I look forward to more projects and opportunities with you and Waterside Productions, Inc.

I would also like to thank Laura Norman and all the other editors and designers at Que Publishing for all their dedicated work, keen eyes, and helpful comments and suggestions. This book is better because of everyone's efforts!

Thank you to Adobe, Inc. for Adobe Photoshop Elements 13 and all their other products and software. They truly are innovators and leaders in today's fast-paced, technology-driven world.

As always, I need to thank my husband, David, for supporting me through this endeavor. And finally, I cannot forget my beautiful daughter, Tasmin, who is becoming an independent, respectful, and thoughtful young lady!

We Want to Hear from You!

As the reader of this book, *you* are our most important critic and commentator. We value your opinion and want to know what we're doing right, what we could do better, what areas you'd like to see us publish in, and any other words of wisdom you're willing to pass our way.

We welcome your comments. You can email or write to let us know what you did or didn't like about this book—as well as what we can do to make our books better.

Please note that we cannot help you with technical problems related to the topic of this book.

When you write, please be sure to include this book's title and author as well as your name and email address. We will carefully review your comments and share them with the author and editors who worked on the book.

Email: feedback@quepublishing.com

Mail: Que Publishing
ATTN: Reader Feedback
800 East 96th Street
Indianapolis, IN 46240 USA

Reader Services

Visit our website and register this book at quepublishing.com/register for convenient access to any updates, downloads, or errata that might be available for this book.

Elements Organizer 13

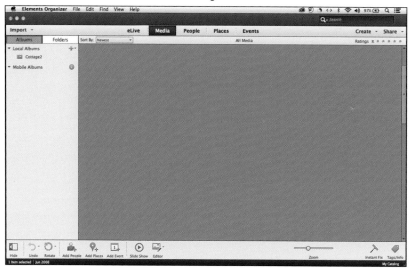

Elements Editor 13

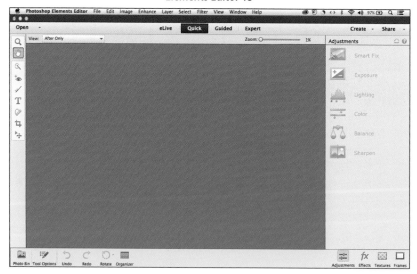

In this prologue, you become familiar with the Adobe Elements family of products, in particular with Photoshop Elements. Common components, terminology, and workspace elements are explored. Topics include the following:

→ Becoming familiar with the Adobe Elements 13 family of products
→ Becoming familiar with Adobe Photoshop Elements 13
→ Understanding Workspace Elements of Adobe Photoshop Elements 13
→ Becoming familiar with common terminology of Adobe Photoshop Elements 13

Getting to Know Adobe Photoshop Elements 13

Adobe Photoshop Elements 13 is the latest version of Photoshop Elements. This powerful software release comes with many new features that extend the functionality of Photoshop Elements, as well as a slightly different interface for the workspace when compared to earlier versions. Before you get started using Photoshop Elements 13, you need to become familiar with the workspace, components, and terminology of this photo catalog and photo-editing product.

Overview of Adobe Elements 13 Family of Products

Adobe Elements 13 is the latest version of Adobe's family of products for managing, editing, modifying, and enhancing digital media such as photos, videos, and audio. The Adobe Elements 13

family of products is made up of Photoshop Elements 13 and Premiere Elements 13.

Photoshop Elements 13 lets you manage and modify your photos, and Premiere Elements lets you manage and modify your videos. This book covers Adobe Photoshop Elements.

Adobe Elements Family of Products

Adobe offers the Adobe Elements 13 family of products as a packaged deal or as individual products. They are not part of the Adobe CC cloud distribution model, like Photoshop CC or InDesign CC, but are sold as individual products. You can purchase them on DVD or for direct download from Adobe or from other third-party retail sites, such as Amazon.com.

Photoshop Elements 13 Versus Photoshop CC

Let's take a look at how Adobe Photoshop Elements 13 compares to Adobe Photoshop CC. Both are image-editing software and use many of the same tools, features, and functionality. Photoshop Elements is developed for working with photos, whereas Photoshop CC is developed for graphic design and image-editing and is more robust in its functionality.

Photoshop Elements 13 is made up of two components, the Organizer and the Photo Editor. Each component has its own distinct use in working with and managing your digital media. The Elements Organizer is photo cataloging software that lets you organize and manage your digital media, both photos and videos, as well as perform automated quick fixes to your media.

Organizer

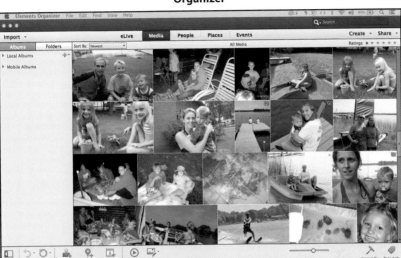

The Photo Editor lets you manipulate, enhance, edit, or modify your photos. Photoshop Elements 13 is developed for home users and semiprofessionals for organizing, managing, enhancing, and modifying photos.

Photo Editor

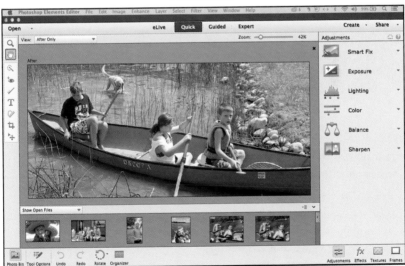

In comparison, Photoshop CC is used by professional graphic designers and can perform all the functions of Photoshop Elements 13, with many of the same features and tools, but it adds more image-manipulation features and image-editing tools needed by the professional graphic designer in today's

digital world. It has a different workspace and includes even more tools than Photoshop Elements 13.

Photoshop CC

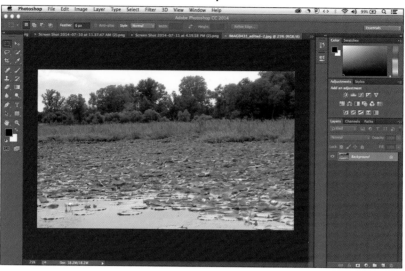

Designed for Home Use and Printer Output

Photoshop Elements 13 is designed for your personal use for managing, editing, enhancing, and printing your digital media. You can print individual photos or print from an online vendor such as Shutterfly.com. You can also create photo projects like photo books, slideshows, DVD and CD covers. Photoshop Elements 13 incorporates many of the powerful features of Adobe Photoshop CC but in a user-friendly workspace designed just for photo management and editing. You can fix blemishes, water spots, or lens flares in your photos to give them a more polished look. You can quickly correct the red eye effect that occurs in photos, too. Drop out a background and insert a new one to really spruce up your photos.

Photoshop Elements 13 also comes with many new filters, filter variations, and special effects that can change the look and feel of a photo. Add a custom frame or texture to your photos. Photoshop Elements has themed layouts that guide you through the creation of scrapbooks, photo books, slideshows, and CD-ROM and DVD covers. Connect to other online services and offerings to create hardbound photo books and professional photo printing.

Digital Darkroom

Today, with the popularity of digital media and digital cameras, Photoshop Elements 13 brings the power of a digital darkroom to your computer. Import your photos and videos from a digital camera, flash disk, or external hard drive. Unlike a traditional darkroom, you do not need special paper and chemicals to process the film to photos. After photos are imported, you can begin to work with them. View them in Elements Organizer and add tags, captions, and ratings to your photos for easy management of your digital media. Change the photo orientation by rotating it in 90-degree increments. Fix blemishes and imperfections caught by the camera. Enhance and modify your photos and add special effects and filters. Unlike a traditional darkroom, Photoshop Elements brings the darkroom to you via your computer and lets you take the development of your photos and photo projects wherever you want, limited only by your creativity and imagination.

Digital Darkroom—What Is This?

Darkrooms have been around since the inception of photography in the 19th century. They are an integral part of processing photographic film. A darkroom is dark except for the use of red safelights for seeing in the dark, and uses light-sensitive materials for processing the film. Minor corrections and modifications like cropping and resizing, as well as dodging and burning, can be performed on photos. A digital darkroom takes the edits and modifications of the traditional darkroom much further by offering many more photo-editing corrections, enhancements, and modification features and tools.

>>>Go Further
THE FOUR MODES OF THE ELEMENTS EDITOR

The Elements Editor, also referred to as the Photo Editor, has four modes: eLive, Quick, Guided, and Expert.

Elements Live, or eLive, is the default view mode that you see when you open the Photo Editor and the Organizer. This is a new feature of Photoshop Elements 13 and is a great starting point for people new to the software. It provides information, tutorials, tips, and techniques for using the Photo Editor and the Organizer. See Chapter 1, "Getting Comfortable with the Photoshop Elements 13 Workspace, Preferences, and Settings," for instruction on Elements Live.

The other three modes, Quick, Guided, and Expert, let you enhance and modify your photos, taking the concept of a darkroom much further than the good old days of film by allowing all kinds of photo enhancements, modifications, and corrections. This book provides instruction on each of these modes and the many features and functionality in each mode of the Photo Editor.

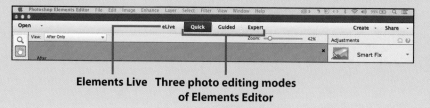

Elements Live Three photo editing modes of Elements Editor

Photoshop Elements Use of Color

Photoshop Elements 13 uses two color models for representing color: RGB and HSB. RGB stands for Red, Green, Blue and is based on how computer monitors display color. When you set an RGB value for your color, you are determining the amount of red, green, or blue to be used for that color.

The other model is HSB, which stands for Hue, Saturation, and Brightness. The HSB color model is based on how the human eye sees color. Our eyes interpret color based on hue, saturation, and brightness. Photoshop Elements uses a color wheel to help understand these color models better.

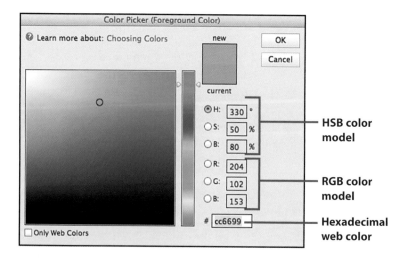

Overview of Color Models

Color models are used to represent colors based on how they are perceived and interpreted. Basically there are two models, one for how the human eye sees color and the other for how a computer interprets color. A computer assigns numeric values to colors and represents colors through a combination of three or four values. Photoshop Elements uses two modes for creating colors: RGB with numeric values of 1–255 and HSB with numeric values of 1–100%. For example, a computer represents white as RGB values of red—255, green—255, and blue—255. The HSB settings are hue—0%, saturation—0%, and brightness—100%. Learn more about color models and modes at http://en.wikipedia.org/wiki/Color_model.

Image Color Modes

Image color modes are used to determine the number of colors to be used in your photo; they affect the file size based on the number used. For instance, if you use Grayscale for your image mode, the colors in the image are represented by 256 shades of gray. Because 256 shades of gray are used, the physical file size is smaller than the original image that has millions of colors. Photoshop Elements also has four color image modes based on the computer color model:

- **RGB**—The color model for a computer monitor, with all colors represented by red, green, and blue, as well the various shades that can be achieved by the HSB color model. This can be millions of colors, and the image file size can be large. JPG and PNG images often use this color mode.

- **Bitmapped**—The bitmapped color mode uses two colors to represent the colors in an image: black and white. The file size for this type of image is small because only two colors are used for the image.

- **Grayscale**—The Grayscale color mode uses 256 shades of gray to represent all colors in an image. The file size is smaller because of using only 256 shades of gray.

- **Indexed color**—The indexed color mode is used often in web design and assigns each color in an image a color from a 256-color palette. If a color in the image is not represented by one of the 256 colors, it chooses the closest color from the color palette to represent this color. Although this creates some issues with image display quality, it does lower the file size, just like the Grayscale color mode.

You can set the color mode for your image through a menu bar command in the Photoshop Elements Editor by choosing the Image, Mode menu bar command. From the submenu, choose the Color Mode you want for your photo. The default color mode is RGB Color.

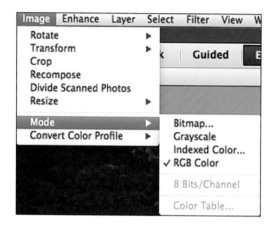

Photoshop Elements 13 Workspace

Photoshop Elements 13 workspace uses elements such as menu bars, tabs, taskbars, panes and panels that are commonly found in other software applications. Based on whether you're working with the Elements Organizer or the Elements Editor, the workspace is different. Each workspace has its own layout and workspace elements.

Overview of the Elements Organizer Workspace

The Elements Organizer is used for managing your digital media. Its workspace is developed for easy access to the functionality of tagging, rating, categorizing, and organizing. You can also make quick fixes to your photos and easily share and print your photos. Through Organizer you can create photo books, calendars, and other creative projects. To support all this functionality, Organizer has many common workspace elements such as a menu bar, a Viewer, panels and tabs, and an Options bar, as well as a few more that are specific to Photoshop Elements 13.

Menu bar **Options bar**

Albums
and
Folders
panel

Viewer

Taskbar

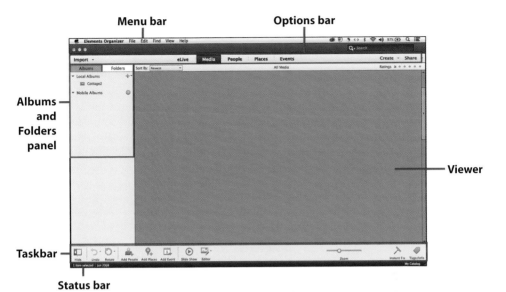

Status bar

Overview of the Elements Editor Workspace

The workspace of the Photo Editor is similar to the Organizer but is developed for making photo modifications, edits, and enhancements, as well as applying special effects. To support this functionality, it has a Viewer, menu bar, an Options bar, panels, panes, buttons, tabs, and a toolbox.

Panel bar displaying Adjustments pane

Options bar

Menu bar

Toolbox

Viewer

Taskbar

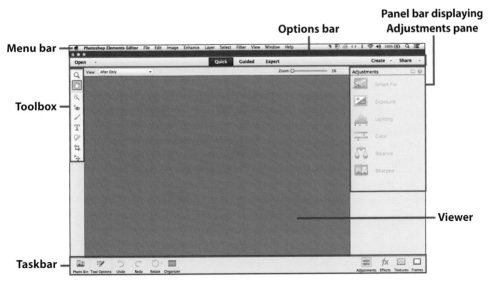

We cover all these elements and tools as you progress through the book.

Accessing Menu Bars and Menu Commands

Every command in Photoshop Elements can be found in a menu bar. Both the Organizer and the Photo Editor have a menu bar. Each menu bar contains menu commands grouped by topic.

The menu bar in Elements Organizer groups commands by topic in these menus: Elements Organizer, File, Edit, Find, View, and Help. Depending on whether you are using a Mac or a PC, the menu bar is slightly different. The first menu in the Organizer and the Photo Editor on the Mac is the Elements Organizer or Elements Photo Editor, whereas the Windows version's first menu is an icon of either the Organizer or the Photo Editor component. The menu commands under each menu are slightly different too.

Mac menu bar

Windows menu bar

Icon representing Elements Organizer menu

The menu bar in Elements Editor has a few more menus than the menu bar in the Organizer, but it works the same. The menu bar contains the Photoshop Elements Editor, File, Edit, Image, Enhance, Layer, Select, Filter, View, Window, and Help. Each menu is again grouped by topic. Again, the Mac menu bar is slightly different than the PC menu bar.

Mac menu bar

Windows menu bar

Icon representing Elements Editor menu

Overview of the Options Bar

Both the Organizer and the Photo Editor have an Options bar that contains frequently used buttons and tabs for accessing common functionality available in that component.

The Options bar in the Elements Organizer contains the Import button; the View tabs composed of eLive, Media, People, Places, and Events; and the Create and Share buttons. Click these buttons or tabs to access the functionality.

eLive and Views

The Options bar in the Photo Editor is a little different from the one in the Organizer because it contains the functionality needed to support photo editing and enhancements. It has an Open button, editing modes tabs, and the Create and Share buttons.

eLive and editing modes

| Open | · | | eLive | Quick | Guided | Expert | | Create | · | Share | · |

Using the Viewer

Both the Organizer and the Photo Editor have a Viewer. The Viewer displays photos for both components. Photos need to be imported into the Organizer first for the Viewer to display them. Importing is covered in Chapter 2, "Importing Photos and Videos." The Organizer displays your photos in thumbnail format in the Viewer.

Viewer with photos

The Photo Editor also has a Viewer, and it is used to display the active photo that you are working on for making enhancements and edits.

Viewer displaying active photo

Using Tabs

Tabs are used in both the Elements Organizer and the Elements Photo Editor in the Options bar and in panels. Each tab displays different elements, tools, and functionality. To access a tab simply click it.

The Organizer Views

The Organizer has five view tabs in the Options bar that let you view your digital media based on Media, People, Places, and Events, as well as view eLive. eLive, or Elements Live, is a new feature of Photoshop Elements 13 for learning more about Photoshop Elements and is what you see when you first open the Organizer. The other four views, Media, People, Places, and Events, sort and display your media by people in the photo, by the place the photo was taken, or by the event in which the photo was grouped. This topic is covered in more detail later in this book.

- **eLive**—View content and resources developed about and for the Elements Organizer. Elements Live, or eLive, is a new feature of Photoshop Elements 13 release and gives you access to videos, tutorials, helpful tips, and techniques for using Adobe Photoshop Elements.

- **Media view**—View and sort your media by file type, such as JPG, PNG, or video.

- **People view**—View your photos based on people in the photo. You can identify people in your photos and then click the People tab to see your photos grouped by people.

- **Places view**—Designate a location of a photo and then display your photos based on the identified locations. The world is your oyster here because you can use any destination in the entire world.

- **Events view**—View your photos based on events that you set up for organizing your digital media. By default, an event is set up based on the date you take your pictures.

The Photo Editor Modes

The Photo Editor Viewer has four mode tabs at the top. The first tab is again for eLive but this eLive focuses on information and resources for the Photo Editor. The other three tabs represent an editing mode: Quick, Guided, and Expert. Based on the tab that you select, Photo Editor displays a different workspace layout and editing features and tools. The first time you open the Photo Editor, eLive is the tab that is displayed.

- **eLive**—View content and resources developed about and for the Photo Editor. eLive gives you access to videos, tutorials, helpful tips, and techniques for using Adobe Photoshop Elements.

- **Quick mode**—Click this tab to access the Quick mode. The Quick mode lets you quickly apply commonly used modifications or enhancements to the active photo in the Viewer.

- **Guided mode**—Use this mode to be guided step by step through enhancements and edits for your photos. This mode is similar to a wizard application that guides you through a process for enhancing or editing your photos.

- **Expert mode**—This mode is for the person comfortable with photo editing and the tools of Photoshop Elements. You have access to the full array of photo editing commands in Photoshop Elements 13.

Which Mode Should I Use?

If you are new to Photoshop Elements, the Quick or Guided modes are a good place to start for your photo edits and enhancements.

Using the Toolbox

The Elements Photo Editor contains a Toolbox of tools and functionality for editing your photos. The Toolbox is only in the Photo Editor and is based on the mode in which you're working. The toolbox displays differently within Quick, Guided, or Expert modes.

Toolbox for Quick mode **Toolbox for Guided mode** **Toolbox for Expert mode**

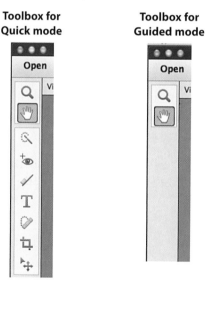
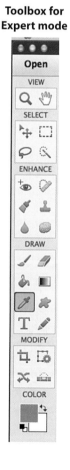

Tool Options Bar

When you select a tool from the Toolbox in either the Quick mode or the Expert mode of the Photo Editor, the Tool Options bar displays above the taskbar and it contains the tool options and settings. You can fine-tune your edit or enhancement by changing these options and settings. All tools in the Toolbox and their tool options are covered throughout this book.

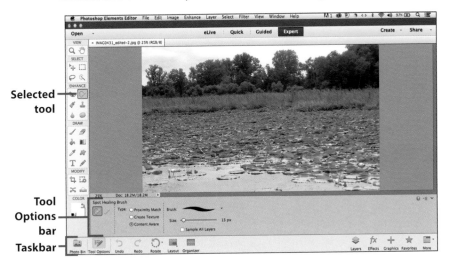

Selected tool

Tool Options bar

Taskbar

Using Panels

Panels are a common workspace element in many applications, and this is no different for Photoshop Elements. Both the Organizer and the Photo Editor use panels for grouping functionality and features into an easily accessible area.

Elements Organizer Panels

The Elements Organizer has three panels: the Albums and Folders panel, the Tags and Information panel, and the Photo Fix panel. The Albums and Folders panel is located on the left of the Organizer workspace and is the only panel automatically displayed in the default workspace layout.

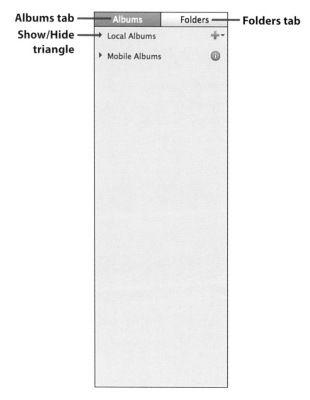

Albums tab —— Albums Folders —— **Folders tab**
Show/Hide —— Local Albums
triangle ▶ Mobile Albums

You'll see two tabs at the top of the panel: the Albums tab and the Folders tab. The Albums tab is the default display when you first open Organizer. Each tab displays a view of your media. You can also view your media on multiple locations: Local (your computer) or Mobile Albums (Adobe Revel online catalogs). You can create new photo albums and organize your albums in the Albums tab. You can show or hide your albums by clicking the Show/Hide triangle to the left of album name.

The Folder tab lists every folder that you have imported media from, even the ones from an external device such as a digital camera.

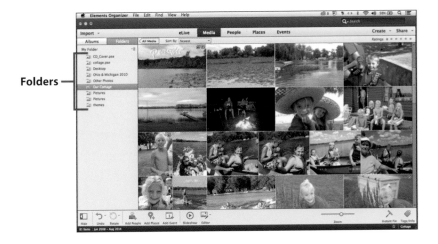

Folders

To access the other two panels, you need to click a button in the taskbar. On the right end of the taskbar are two buttons: the Instant Fix and the Tags/Info. When clicked, each button opens a panel.

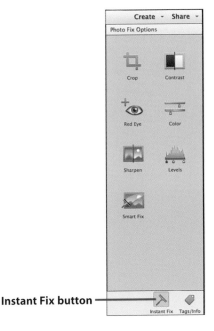

Instant Fix button

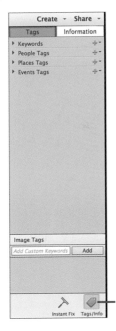

Tags/Info button

The Photo Fix Options panel displays the Instant Fix tools of the Organizer. You can perform common photo-editing fixes on your photos in the Organizer, such as cropping or fixing red eye.

Photo Fix tools **Photo Fix Options panel**

The Tags and Information panel also has two tabs: Tags and Information. Each tab displays information about your photos or videos in your Catalog.

Tags panel **Information panel**

Sticky Panels

Both the Photo Fix Options panel and the Tags and Information panel are sticky panels. This means that after you access them by clicking the button in the taskbar, the panel displays as an element in the Organizer workspace. You can close the panels by clicking either the Instant Fix or the Tags/Info button again in the taskbar.

Also, when you close the Organizer, the next time you open it, it remembers what panels were last opened and displays that workspace layout.

Elements Editor Panels

The Elements Editor also uses panels to group functionality for easy access. Both the Quick and the Guided modes have a panel bar on the right of the workspace. When you click either the Quick mode or the Guided mode tab, the panel displays and lists common fixes, enhancements, and effects for your photos based on functionality of that mode.

Quick mode panel **Guided mode panel**

All these panel bar common fixes and enhancements are covered later in the book.

Task Pane and Taskbar

At the bottom of the workspace in both Elements Organizer and Elements Editor is an area for tasks. In Elements Organizer this is called the Taskbar pane and contains buttons for common organizing, managing, and fixing your media.

The Elements Editor has a taskbar that contains common tasks and adjustments. When you select a mode—Quick, Guided, or Expert—the taskbar displays the common tasks and adjustments for that mode.

Status Bar

The final workspace element to cover is the Status bar. Only the Elements Organizer component has a Status bar, and it is located at the bottom of the workspace. The Status bar reflects the status of the Organizer based on what features are active, as well as what Catalog is active.

Status bar **Active Catalog**

Mobile Albums

Sharing your photos across the multiple mobile devices is a must in today's world. In the past, most people had only a computer that they used for storing and managing their photo and video catalogs. Today, most people have at least two, if not more, mobile devices that they use to access their computer's data and to capture their photos and videos. Photoshop Elements allows for this sharing functionality through Adobe Revel. You can learn more about Adobe Revel by visiting www.adoberevel.com/.

Adobe Revel is integrated into Elements Organizer and requires an initial setup. You must have an Adobe ID for using Revel, and this topic is covered in Chapter 14, "Sharing Your Photos," as well as in the online bonus content of this chapter at www.quepublishing.com/title/9780789753809.

Active tool
in toolbox

Preferences menu
command

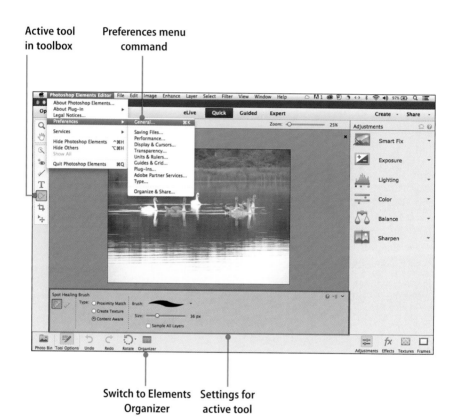

Switch to Elements
Organizer

Settings for
active tool

In this chapter, you learn how to launch Photoshop Elements 13 and how to switch between the Elements Organizer and the Elements Editor. Learn how to customize the workspace of Elements Organizer and how to access workspace elements, menus commands, and the tools in the toolbox. Also covered are the Preferences for both Elements Organizer and Elements Editor. Topics include the following:

→ Opening Photoshop Elements
→ Switching between Elements Organizer and Elements Editor
→ Accessing Adobe eLive
→ Accessing tools and menu commands
→ Customizing the workspace of Elements Organizer
→ Customizing the options and settings of Photoshop Elements 13 Preferences

Getting Comfortable with the Photoshop Elements 13 Workspace, Preferences, and Settings

The first step when learning a new software application is to become familiar with the workspace elements, tools, and menus. Understanding how menus are grouped and what menu commands are available will help you get started learning Adobe Photoshop Elements 13. Knowing how to switch between the Elements Organizer and the Elements Editor streamlines your workflow for

managing, modifying, and enhancing your photos. Visit the online bonus content for this chapter, at www.quepublishing.com/title/9780789753809, to explore the many Preferences of both the Organizer and the Photo Editor and learn how to customize these default options and settings.

Opening Photoshop Elements 13

As with any software, you need to open it to begin using it.

1. To open Photoshop Elements 13, double-click the Adobe Photoshop Elements 13 icon, which can be placed on your desktop during the software installation process.

Know Your Operating System

Based on your operating system, whether you are using a Mac or a PC, and the version of that operating system—Mac OSX, Windows 7, or Windows 8—you can launch an application through different techniques. Refer to your operating system's user guide for exact instructions on how to launch an application.

2. A window displays. Click the Please Select Your Country/Region menu and choose your country or region.

3. In the Welcome Screen, click either the Organizer or the Photo Editor button to launch that component.

Organizer button Photo Editor button

4. Based on the button selected, a blue bar displays, indicating that the component is launching.

5. When you first launch the Photo Editor, you'll see the Adobe Photoshop Elements 13 window that lets you know that Photoshop Elements 13 has a new feature for sharing information with Adobe that is turned on by default. Click the Click Here link to access the Photoshop Elements Preferences and turn off this feature if you do not want to share information.

6. Both components open with the eLive tab displayed. This is the default view for both the Organizer and the Photo Editor the very first time they are opened.

What Information Is Shared with Adobe?

If you keep your preferences set to share information with Adobe, you are sharing your system settings and other system information, such as what OS you are using, your screen resolution, and system memory. It also shares how often you launch Photoshop Elements as well as how often you use the various features and functionality of each component—the Organizer and the Photo Editor. No confidential or personal information is shared.

The Elements Organizer Versus the Elements Editor

Adobe Photoshop Elements 13 is made up of two components, the Elements Organizer and the Elements Editor, which is also referred to as the Photo Editor.

The Organizer is your digital media catalog of all your photos, videos, and even audio files. The Organizer is also a component of Adobe Premiere Elements 13, so it is shared between both Photoshop Elements and Adobe Premiere Elements. This book is focused on Photoshop Elements, so it covers how to work with the photo catalog features and functionality of Elements Organizer.

Use the Organizer to manage your digital media catalog, apply quick fixes to photos, and create photo and graphic projects.

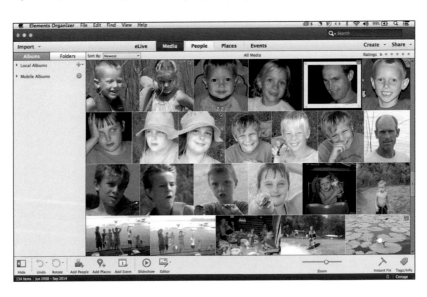

The Photo Editor is designed for photo editing and enhancements. It lets you create new images from existing photos, enhance and fix problems in a photo, modify or combine images in photos, and apply special effects and filters to photos. It is a powerful photo editor that lets you express yourself in images and make your photos come vividly alive.

**Elements Editor workspace
in Quick mode**

These two components are designed to work with each other; together, they're Adobe Photoshop Elements 13.

Switching to Photo Editor from the Organizer

Because you have a choice of opening either the Organizer or the Photo Editor when you open Adobe Photoshop Elements 13, you might be wondering how to access the other component. If you open the Organizer first, you can easily open the Photo Editor through a few techniques.

1. With the Elements Organizer open, choose one of the following techniques:

 • Click the Editor button in the taskbar.

- If you have imported photos or videos in the Organizer, right-click a photo in the Viewer, and from the context menu choose Edit with Photoshop Elements Editor.

- If you recently edited a photo in Photo Editor, you can reopen that photo and launch the Photo Editor by choosing File, Open Recently Edited File in Editor from the menu bar, and then click the recently opened file you want.

Active photo ①

Context menu

①

>>>Go Further
EDIT A PHOTO IN A DIFFERENT EDITOR

You can edit a photo from the Organizer in any photo editing application that you have installed on your computer. The default editor is Elements Editor. You can set a different photo editor as your external editor through the Organizer Preferences, which is covered in the online bonus content for this chapter, at www.quepublishing.com/title/9780789753809. After you have this setting in your preferences, it is accessible as a menu choice in the Editor button of the taskbar. To do this, first click a photo in the Viewer to make it active, and then click the triangle icon to the right of the Editor button in the taskbar. This displays the Editor menu. Choose External Editor to open the photo in the external editor. You can also open the photo in Photoshop by choosing Photoshop from the menu.

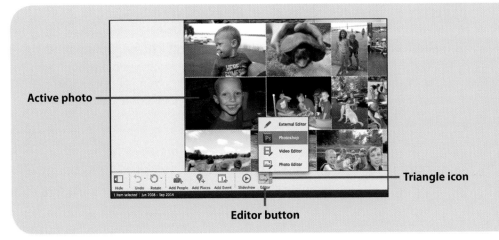

Active photo

Triangle icon

Editor button

Switching to the Elements Organizer from the Elements Editor

If you open the Elements Editor from the Welcome screen, you can open the Organizer with a click of a button.

1. With the Elements Editor open, click the Organizer button in the taskbar.

Work Between the Organizer and the Photo Editor

After you have both components opened, you can easily switch between them by clicking the appropriate button in the taskbar, either the Organizer or Photo Editor buttons.

Using the Toolbox and Menus

Many commands and tools in Photoshop Elements 13 can be found in either the menu bar or the toolbox. Both the Organizer and the Photo Editor have their own menu bar. Each menu bar contains menu commands grouped by topic. The Elements Editor has a toolbox that contains photo-editing tools for each of the three editing modes: Quick, Guided, and Expert.

Accessing the Organizer Menu Commands

The menu bar in Elements Organizer groups commands by topic in these menus: Photoshop Elements Organizer, File, Edit, Find, View, and Help.

1. Click to choose a menu.

2. In the drop-down menu, click to choose the menu command you want.

3. A menu command with a triangle on the right indicates that there is a pop-out submenu with more menu choices. Hover your cursor over the menu command to display the submenu of commands. Click the command you want from the submenu.

Photoshop Elements 13 for Windows Menu Commands

There are slight differences in the menu commands under each menu in the menu bar based on whether you are using a Mac or a PC. The menu commands differ due to the additional or lack of functionality in the operating system.

Triangle ③ Submenu

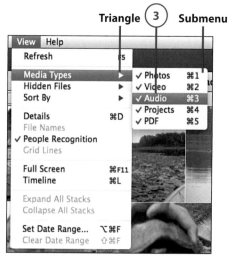

Accessing the Photo Editor Menu Commands

The menu bar in Elements Editor has a few more menus than the Organizer, but it works the same. The menu bar contains these menus: Photoshop Elements Editor, File, Edit, Image, Enhance, Layer, Select, Filter, View, Window, and Help. Each menu is again grouped by topic.

1. Click a menu to display the drop-down menu.

2. Click to select the menu item from the drop-down menu.

Menu Commands and Keyboard Shortcuts
Many menu commands have a keyboard shortcut you can initiate from your keyboard. You'll find this listed to the right for the menu command name. Press these keys on your keyboard to initiate the command. Not all menu commands have a keyboard shortcut.

Right-Click for the Context Menu
Many menu commands can be accessed by right-clicking a photo or panel item to display the context menu. Both Elements Organizer and the Elements Editor support right-clicking an item to access the context menu.

Accessing Tools in the Toolbox

The toolbox is available only in Elements Editor. Based on the mode you're working in,
Quick, Guided, or Expert, the toolbox displays different tools.

Toolbox **Quick mode**

1. Open or access the Elements Editor by either launching it from the Welcome Screen or
 by clicking the Editor button from the Elements Organizer taskbar as covered earlier
 in this chapter. By default it displays in the Quick mode.

Access a Tool with a Keystroke

Hover your cursor over a tool in the toolbox to display a Quick Tip listing the tool
name. To the right of the tool name is a letter. This is the keyboard shortcut for the
tool. Press that letter key on your keyboard to access the tool. In the following figure
example, pressing the "c" key on your keyboard initiates the Crop tool.

2. Click a tool to access it.

3. The Tool Options bar displays above the taskbar. Click to select options or click and drag sliders to adjust slider bar options. Click in text fields or boxes to type settings. Individual tool settings and options are covered later in the book.

Customizing the Organizer Workspace

Only the Elements Organizer workspace can be customized in its layout. The Elements Editor workspace can't be customized in the Quick or the Guided modes, but you can customize the layout in the Expert mode. See Chapter 9, "Advanced Photo Corrections." The Organizer workspace is also relatively set in its layout, but you can adjust the size of both the Albums and Folders panel and the Tags and Information panel. Adjusting the panel size aids in seeing more or less information in that panel.

1. In the Organizer, position your cursor over the right border of the Albums and Folders panel. Your cursor becomes a double-headed arrow.

2. Click and drag left or right to decrease or increase the width of the Albums and Folders panel.

3. Open the Tags and Information panel by clicking the Tags/Info button in the taskbar.

4. Click the Instant Fix button to replace the Tags and Information panel with the Photo Fix Options.

5. Position your cursor over the vertical left border of the Tags and Information panel (or the Photo Fix Options panel, depending on which you have opened). Your cursor becomes a double-headed arrow. Click and drag left or right to increase or decrease the width of the panel.

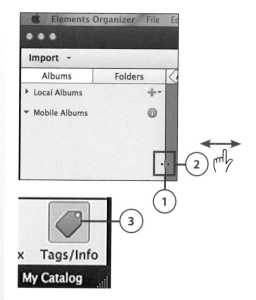

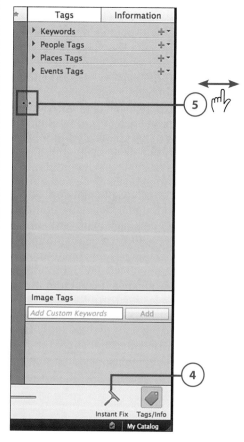

6. Position your cursor over the horizontal border between the Tags and Information panel (or the Photo Fix Options panel depending on which you have opened) and the Image Tags panel. Click and drag up or down to change the height of each panel proportionally.

7. Based on which panel you have open, the Tags and Information panel or the Instant Fix panel, click the associated button in the taskbar to close the panel.

Sticky Interface

Photoshop Elements 13 has a sticky interface. This means that if you rearrange your workspace and open panels, and then quit Photoshop Elements, the next time you open it, your workspace appears how you left it the last time you used it.

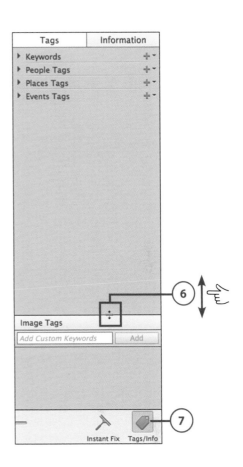

Customizing Preferences

Photoshop Elements 13 has preferences that you can customize. The preferences set default settings and options for how Photoshop Elements functions. There are separate preferences for both Element Organizer and the Elements Editor.

Elements Organizer Preferences

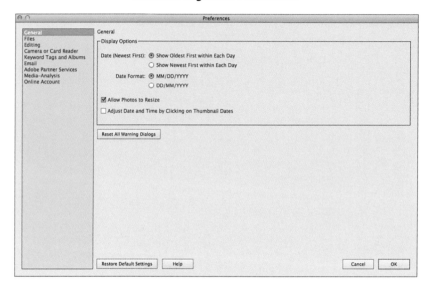

Elements Editor Preferences

Preference File Locations

Adobe Photoshop Elements stores preference files in different locations on your
computer based on your operating system and the preference file, either Elements
Organizer or Elements Editor. Visit this website for a complete list of where preference
files are located: http://helpx.adobe.com/photoshop-elements/kb/preference-file-
locations-photoshop-elements.html.

Setting Elements Organizer Preferences

The preferences for Elements Organizer let you set options and settings for how the Organizer functions. All preferences are grouped in categories, which are listed on the left. These options and settings are the default preferences for Organizer. When you change them, you're setting new default options and settings.

Preference categories

Options and settings

Mac Preferences menu command

Windows Preferences menu command

1. To open the Elements Organizer preferences on a Macintosh, click the Elements Organizer menu and click to choose Preferences. If you're on a PC, choose Edit, Preferences, and then the category you want.

2. In the Preferences window, click a category. General is the default category displayed when Preferences are first opened on a Mac.

Slight Difference in Preferences Between Mac and PC

The Preferences for Mac and PC vary when compared to each other. Based on the operating system, different features and functionality are available for Photoshop Elements to tap into, so the Preferences are slightly different for controlling this additional functionality. The Windows Preferences for the Organizer has two additional categories, the Scanner and Application Updates categories. These are not available in the Photoshop Elements Preferences on the Mac. Also note that the bottom buttons are in different locations in the Preferences window between the two platforms.

3. The Preferences window displays all options and settings for that category. Click to select check boxes and option buttons. Click and type in text boxes to set other options and settings.

4. Click Restore Default Settings to return to the original default settings of Elements Organizer.

5. Click Help to access the Organizer Help file.

6. Click OK to save the preference settings and close the Preferences window.

7. Click Cancel to cancel your modifications for the Preferences and return to the previously set preferences.

Using the Browse Button

The options and settings in the Preference window often have a Browse button that lets you locate a file or folder on your computer for establishing a new default location or file. When you click the Browse button, a Select window displays for you to locate the file or folder for the preference setting.

Resetting Preferences to Default

If your Adobe Photoshop Elements starts to behave weirdly, the preference file might be damaged. You can restore all preferences to the default setting by either of these two techniques:

- Launch Photoshop Elements and immediately after launch, press and hold Option-Command-Shift (Mac) or Alt+Control+Shift (PC). A message displays indicating that the Preference files for Photoshop Elements needs to be deleted. Click Yes.

- Choose Photoshop Elements, Preferences (Mac) or Edit, Preferences, General (PC) to open the Preferences. Under the General category click the Restore Default Settings button.

Be aware that you cannot undo the restore function after it is initiated.

Setting the Photo Editor Preferences

The Photo Editor also has its own preferences for customizing options and settings. These preferences focus on setting default options and settings for photo editing. There are slight differences between the Mac and Windows versions of the Photo Editor for Preferences categories and settings.

Preferences categories **Options and settings**

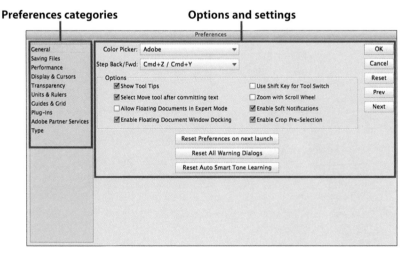

1. To access Elements Editor
Preferences, on a Mac click the
Photoshop Elements Editor menu
and click Preferences. In the pop-
out submenu click the Preferences
category that you want. On
Windows, click Edit, Preferences,
and then from the pop-out sub-
menu, click the Preferences cat-
egory that you want.

Mac Preferences menu command

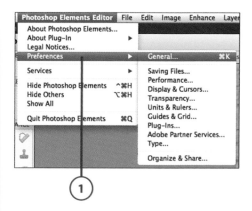

Windows Preferences menu command

2. In the Preferences window, click a category to select it.

3. Click the check boxes, option buttons, menus, and text fields to set the options that you want.

4. Click Next to proceed to the next category in the Preferences Category list.

5. Click Prev to access the previous category in the Preferences Category list.

6. Click Reset to reset the active category options and settings to the original default settings.

7. Click OK to set the customized options and settings for that category and close the Preferences window.

8. Click Cancel to close the Preferences window and leave the Preferences options and settings as previously set.

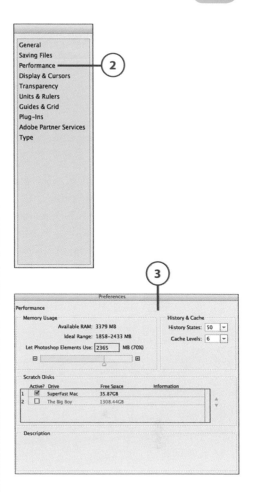

Using Elements Live

Elements Live, or eLive, is a new feature of Photoshop Elements 13. When you first open either the Organizer or the Photo Editor, eLive is the active view that you see. It is integrated right into the Organizer or Photo Editor workspace. This can be a little confusing when you first see it because you might think that you are in the wrong program, but fear not—you are in Photoshop Elements 13.

eLive is a great way to learn more about Photoshop Elements 13. This Adobe product provides tutorials, articles, videos, examples, and tips and techniques for using either the Organizer or Photo Editor. You must have an Internet connection to use eLive because it links to information on the Web and displays it through your web browser. It is constantly updated with new content and provides current information about Photoshop Elements 13.

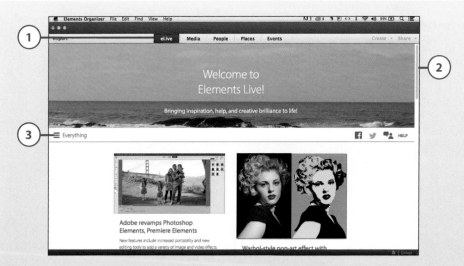

1. In either Organizer or the Photo Editor, click the eLive tab.

2. Click and drag the scrollbar to see all the topics on the opening page of eLive.

3. Click the Everything menu to access channels for viewing articles, videos, tutorials, tips, and techniques for Photoshop Elements 13.

Adobe revamps Photoshop Elements, Premiere Elements

New features include increased portability and new editing tools to add a variety of image and video effects.

4. Click one of the channels.

- **Everything**—This channel displays all channel information and is the default display.

- **Learn**—This channel displays articles, tutorials, and videos for learning Photoshop Elements 13.

- **Inspire**—This channel displays tips and techniques and cool effects or combinations of effects that you can attain in Photoshop Elements 13. It is meant to inspire you!

- **News**—See articles, news, and other posts on Photoshop Elements 13 in this channel.

5. Click a topic to learn more about it.

6. Your Web browser displays the topic.

Import
button

In this chapter, you learn how to import photos and videos into Elements Organizer and Elements Editor. You also learn how to customize the default settings for importing media. Topics include the following:

→ Understanding photo resolution
→ Importing photos to Elements Organizer
→ Opening photos in Elements Editor
→ Customizing Preferences and default settings for importing photos (online bonus content)

Importing Photos and Videos

You can import photos, audio, and videos into Adobe Photoshop Elements 13 from many sources, such as your computer, an external drive, or a network connection; you can import from flash drives, your digital camera, cell phone, and tablet, CDs or DVDs, and scan disk cards using card readers. Basically, if your media is in a digital format that Photoshop Elements can read and you can access it from your computer, it can be imported into Photoshop Elements.

Understanding Photo Resolution

Before importing your media, it is a good idea to understand photo resolution. Digital photos are made up of pixels. A pixel is a tiny colored dot that together with many other dots creates the image in your photo.

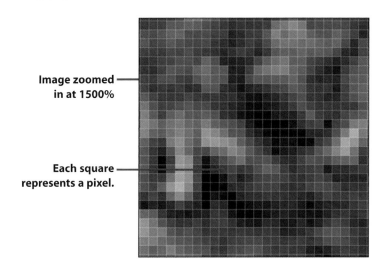

Image zoomed in at 1500%

Each square represents a pixel.

The more pixels in an image, the higher the resolution of the photo. Photos with a high resolution are better in clarity and detail. Resolution in a camera is measured in megapixels (MP). 1MP is really 1 million pixels in a square inch. Your digital camera is set to take pictures based on a resolution, such as 5MP, or 5 million pixels per square inch. Be aware that a high-resolution photo is large in physical file size. Based on the memory capacity of the camera/memory card, you can store only so many photos. If needed, you can usually set the resolution lower in your camera settings so you can store more images.

Printing High-Resolution Photos

A high-resolution photo prints better than a low-resolution photo, especially if you print a poster or large sign. This is because of the amount of information (pixels) represented in one square inch of the photo. If your photo has a low resolution, it can be printed only at a certain size to maintain the image clarity and detail. If you choose a print size that is too large for the photo's resolution, your printed image appears blurry.

Images on a website are usually very low in resolution: 72–96DPI, or dots per inch, which is another measurement for resolution in photo-editing software. These images have been optimized to a low-resolution so that the image is small in file size, which allows the image to load and display quickly when the web page is accessed. If you use an image from the Web, it will display as a blurry image the larger you make it.

Import Photos to Organizer

Adobe Photoshop Elements lets you import images through the Organizer. The Photo Editor can open photos, and they are automatically added to the Organizer Catalog. The Organizer catalogs and manages all photos regardless of which component it came from. You can import photos from your computer, camera, external hard drive, network location, mobile device, scan disks, and portable memory sticks. On a Mac, you can even import from other photo libraries such as iPhoto. If you are using a PC, you can import directly from a scanner.

Organizer can import most common image and video format files used today—JPG, GIF, PNG, TIFF, MOV, MP4, and MP3. Organizer can also import PDF and Photoshop files. The following are file formats that Organizer can't understand and, therefore, can't import:

- JPEG 2000

- Filmstrip (FLM)

- Wireless BMP (WBM, WBMP)

- PCX

- Targa (TGA, VDA, ICB, VST)

- Photoshop RAW (RAW)

- PICT File (PCT, PICT)

- Scitex CT (SCT)

- Photoshop EPS (EPS)

- EPS TIFF Preview (EPS)

- Generic EPS (AI3, AI4, AI5, AI6, AI7, AI8, PS, EPS, AI, EPSF, EPSP)

- IFF Format (Mac Only)

- Photoshop 2.0 (Mac Only)

- Alias PIX (Mac Only)

- PICT Resource (Mac Only)

Import Wizard—PC Only

Photoshop Elements 13 for Windows has an Import Wizard that guides you through the import process when you first install and launch the Organizer, and the Mac does not. This wizard automatically displays the first time you open Organizer for Windows. Click the Import menu and choose the import method based on the device that contains your media. Each import method is covered in detail next.

Using the Import Button

You can import photos into the Organizer through the Import button in the Options bar. Both the Mac and Windows versions of Organizer have an Import button, but the drop-down menu offers different choices. Also, the import process is slightly different for importing media. Follow the instructions below for either Mac or PC for the correct import process.

1. In the Organizer, click the Import button.

2. The Import menu displays, and based on your operating system, you'll see options as shown in the Mac or Windows figure on the right.

3. Click an Import option from the menu. Each menu option is covered next.

Mac Import Menu

Use a Menu Bar Command to Import Photos

You can also use a menu command to import your digital media. Choose File, Get Photos and Videos from the menu bar. This menu command offers the same Import options as the Import button.

Windows Import Menu

Importing Files on a Mac

Follow these steps to import files on a Mac.

1. Click the Import button in the Options bar.

2. Click the From Files and Folders menu option.

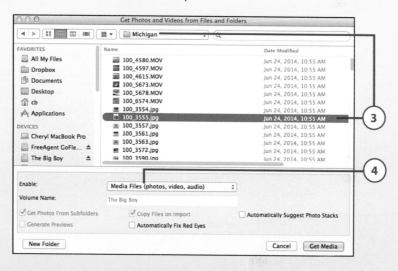

3. In the Get Photos and Videos from Files and Folders window, navigate to the file or folder that you want to import, and click to select it.

Selecting Multiple Files or Folders

You can select multiple files or folders for importing through either the Shift+click technique or through the Command-click technique. The Shift+click technique selects files that are sequential in a list. Click the first file in the list and then, holding the Shift key down, click the last file in the list. All files are selected between the first and the last file. The Command-click technique lets you select non-adjacent files. Click the first file you want to select and then hold down the Command key and click any other file(s).

4. Click Media Files (photos, video, audio).

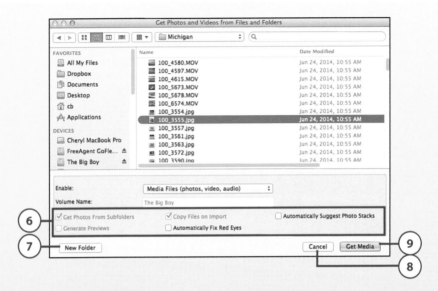

5. In the pop-out menu, choose a specific type of file to import. The default is Media Files (photo, video, audio). The other options are .pdf, .pse, or all file types.

6. Click to select the automatic options you want. These are toggle options; click once to select, and click again to deselect.

 - **Get Photos from Subfolders**—Select this option to import any media from subfolders in the designated import folder.

 - **Copy Files on Import**—Select this option to make a copy of the files in the Pictures/Adobe/Organizer folder.

 - **Automatically Suggest Photo Stacks**—Select this option to have Photoshop Elements analyze your photos for similarities, such as date taken, faces, objects, and color.

 - **Generate Previews**—Select this option to show a preview image of each photo as it imports.

 - **Automatically Fix Red Eyes**—Select this option to have Photoshop Elements analyze the photos to be imported and automatically apply Red Eye correction during the import to the images that need it.

7. If you want to create a new folder for the photos to be stored in, click New Folder.

8. Click Cancel if you want to cancel the import.

9. When your options and settings are selected, click Get Media to import the selected media.

Where Does Organizer Save Imported Files?

When you import photos to Organizer from a disk drive, such as your computer hard disk or a network location, it creates a link to the photo. It does not copy the photo to your computer's disk drive. You can make a copy of the file by selecting the Copy Files on Import option of the Import Files and Folders window, and Organizer places a copy of the photo in the Pictures/Adobe/Organizer folder on your computer. This is Organizer's designated default folder for storing digital media.

Importing Files on a Windows Computer

Follow these steps to import files on a Windows Computer.

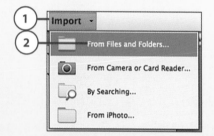

1. Click the Import button in the Options bar.

2. Click the From Files and Folders menu option.

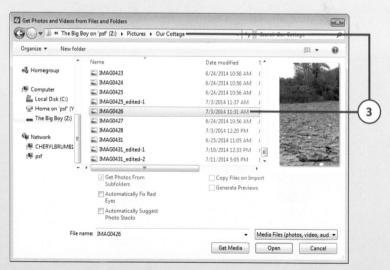

3. In the Get Photos and Videos from Files and Folders window, navigate to the file or folder that you want to import, and click to select it.

Selecting Multiple Files or Folders

You can select multiple files or folders for importing through either the Shift+click technique or through the Control+click technique. The Shift+click technique selects files that are sequential in a list. Click the first file in the list and then, holding the Shift key down, click the last file in the list. All files are selected between the first and the last file. The Control+click technique lets you select non-adjacent files. Click the first file you want to select, and then hold down the Control key and click any other file(s).

4. Click Media Files (photos, video, audio).

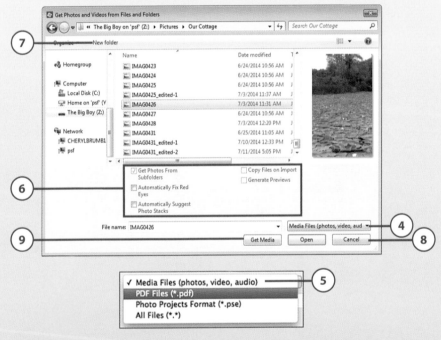

5. In the pop-out menu, choose a specific type of file to import. The default is Media Files (photo, video, audio).

6. Click to select the automatic options you want. These are toggle options; click once to select, and click again to deselect.

 - **Get Photos from Subfolders**—Select this option to import any media from subfolders in the designated import folder.

 - **Copy Files on Import**—Select this option to make a copy of the files in the Pictures/Adobe/Organizer folder.

 - **Automatically Fix Red Eyes**—Select this option to have Photoshop Elements analyze the photos to be imported and automatically apply Red Eye correction during the import to the images that need it.

 - **Generate Previews**—Select this option to show a preview image of each photo as it imports.

 - **Automatically Suggest Photo Stacks**—Select this option to have Photoshop Elements analyze your photos for similarities, such as date taken, faces, objects, and color.

7. If you want to create a new folder for the photos, click New Folder.

8. Click Cancel if you want to cancel the import.

9. When your options and settings are selected, click Get Media to import the selected media.

>>>Go Further

UNDERSTANDING HOW ORGANIZER IMPORTS FILES AND FOLDERS

When you import photos from another drive location to Organizer, it creates a link to the location of the photo. It does not place a copy on your computer. It does make a preview copy of the photo and it is created with a lower resolution setting; the default is 640×480px. This preview copy is what the Viewer displays, and it is used for the thumbnail image. If you delete an imported photo from the disk drive it is stored on, this breaks the link between Organizer and the file. The thumbnail preview copy of the file still displays in the Viewer, but now it shows a question mark icon in the upper-left corner of the thumbnail. This indicates that the linked photo is missing or can't be found.

To reconnect the thumbnail with the file, do the following:

In Organizer, click File, Reconnect, All Missing Files from the menu bar.

Also, when you first open Photoshop Elements, it automatically checks all photo links in the Catalog for missing files and prompts you to manually locate them. Learn more about the Organizer Catalog in Chapter 3, "Using Elements Organizer: Organizing with Catalogs, Albums, and Folders."

Import from Camera or Card Reader

The second choice in the Import menu for both Mac and PC is to import From Camera or Card Reader. This option realizes that the digital media is on a mobile device and imports the media by downloading and making a copy of the media in the default download folder—Pictures/Adobe/Organizer folder.

1. Connect the Camera, mobile phone, or insert the scan card into the card reader that is connected to your computer.

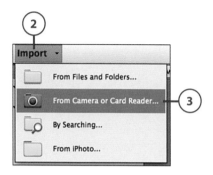

Windows AutoPlay Dialog Window

If you are using a computer with Windows as the operating system, you'll see the Windows AutoPlay Dialog Window display when you connect your camera or flash drive/scan card. It lists options for displaying or playing your media. Select the Elements Organizer option from the list.

2. In Organizer, click the Import button.

3. Click From Camera or Card Reader to choose it from the drop-down menu.

4. A message displays, indicating that Organizer is searching for media connected to your machine. If you need to stop the search, click Stop.

5. Organizer displays the Photo Downloader window when finished with the search. In the Elements Organizer–Photo Downloader window, click the Get Photos From menu to select a mobile device.

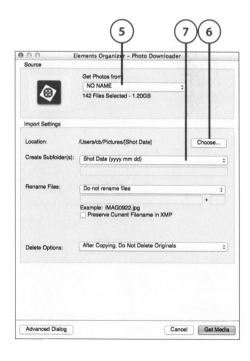

6. Under Import Settings, click the Choose button to locate the digital media and select it.

7. Click the Create Subfolder(s) menu and choose a Shot Date format for new subfolders. Organizer automatically creates subfolders for the imported photos based on the date the photo was taken for organizing the imported photos on your computer.

8. Click the Rename Files menu and choose the filename convention. If you want to create a custom file naming convention, click Custom from the list and type the filename to be used for imported photos. The default is to not rename the photos and to use the original filenames from the mobile device.

9. Click the Preserve Current Filename in XMP option to preserve any metadata attached to the media being imported.

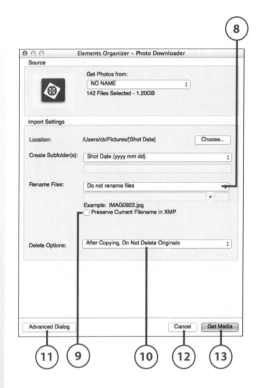

What Is XMP?

Adobe's Extensible Metadata Platform or XMP is technology that labels files through metadata that is embedded into the file itself. Metadata can be any type of information that you want to attach to a file. You have the option to preserve this information when you import files by checking the Preserve Current Filename in XMP option.

10. (Mac Only) Click the Delete Options menu to choose how you want to handle deleting the original photos from the mobile device. The default is to not delete original files.

11. Click the Advanced Dialog button to access the advanced settings for importing your photos.

12. Click the Cancel button to cancel the import.

13. Click the Get Media button to import the digital media based on the settings and options you have selected.

Import By Searching

Elements Organizer also has a search feature for finding digital media on other disk drives or mobile devices attached to your computer. Again, you access this feature through the Import menu.

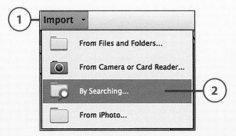

1. Click the Import button in the Options bar (Mac version is shown in the figure).

2. Click the By Searching menu command.

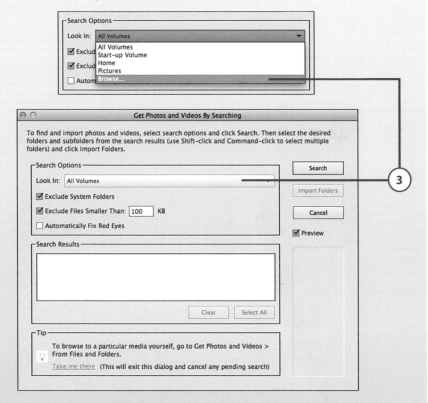

3. This opens the Get Photos and Videos by Searching window. In the Search Options click the Look In menu and select the location to search. All Volumes is the default option.

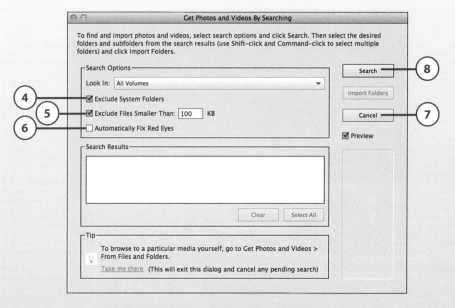

4. Click Exclude System Folders to exclude system folders from the search.

5. Click Exclude Files Smaller Than and type a file size in the text field. Organizer ignores any files lower than the file size you set for the search.

6. Click Automatically Fix Red Eyes to automatically apply the Red Eye fix to any images in your photos that need this during the import.

7. If needed, click Cancel to cancel out of the search and close the window.

8. Click the Search button to search your computer and all attached devices for any digital media files.

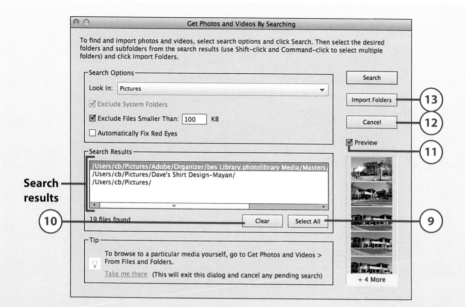

Search results

9. Search Results displays any digital media files that Organizer finds based on your search settings and options. Click Select All to select all the files or click to select individual files.

Manually Select Multiple Photos for Import
You can use the Shift-click or Command-click (Mac)/Control+click (PC) technique to choose multiple photos in Search Results.

10. If needed, click the Clear button to clear the Search Results list so you can select different options to initiate another search.

11. The Preview option is selected by default, and your search results files display in this area. If there are many files, the preview image feature can slow down the import. Turn this Preview off by clicking this option to deselect it.

12. If you want to cancel out of the Get Photos and Videos by Searching window, click Cancel to cancel the search and close the window.

13. After you have the files identified and selected in the Search Results field, click Import Folders to import the media.

Import from iPhoto (Mac Only)

Another Import option is to import digital media from iPhoto. iPhoto is a Mac only photo-editing product, so these instructions are for Macintosh users. If you are using a PC you can still import photos from other photo-editing products; you just need to use the From Files and Folders Import menu (as shown in a task previously in this chapter) and browse to the library or folder that contains the digital media for that photo-editing software.

1. Click the Import button in the Options bar.

2. Click the From iPhoto option.

3. Organizer opens the Elements Organizer window showing the progression of the media import from the iPhoto Library. Click Stop if you need to stop the import.

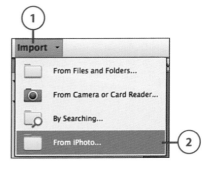

iPhoto To Become Photos

Apple is upgrading iPhoto and Aperture to a new Photos app for the Mac in 2015. The new Photos app is a cloud-based product that lets you view your photos across all your Mac devices. It should be released in early 2015.

Import Scanner (Windows Only)

You can import media directly from a scanner in Photoshop Elements 13 for Windows. You must have a scanner connected to your computer to scan images through Organizer.

1. In Organizer for Windows, click the Import button.

2. In the drop-down menu choose From Scanner.

3. In the Get Photos from Scanner window, click the Scanner menu and choose a scanner.

4. Click the Browse button to choose a different folder to save the new scanned photos. By default, this is set to the Pictures\Adobe\Scanned Photos folder.

5. Click the Save As menu and choose a file type.

6. Click and drag the slider to set the Quality.

7. Click OK to begin scanning the photo directly from Organizer for Windows.

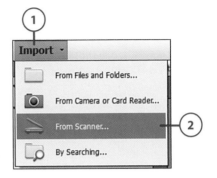

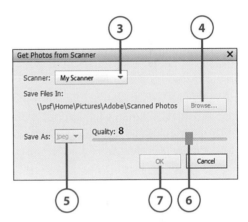

Importing Video

Although this book is about using Photoshop Elements, you can also import video into Elements Organizer. Using any of the techniques covered so far, import your video to the Organizer Catalog. Video files need to be in the correct file format, such as .mov or .mp4.

Importing Photos That Are Already in the Catalog

During an import, Organizer checks to make sure the file you are importing is unique to the Catalog. If it is not, a message displays listing the duplicate file(s), and Organizer does not import the file(s). Click OK to close the message window. You can set how the Organizer handles duplicate files in the Files Preferences, which is covered in the online bonus content.

Opening Photos in Elements Editor

In a roundabout way, you can import images into the Organizer through Elements Editor, also referred to as the Photo Editor. When you open an image in the Photo Editor, it's automatically added to the Organizer Catalog.

1. Open Elements Editor by launching Photoshop Elements 13 and clicking the Photo Editor button, or if you have the Elements Organizer open, click the Organizer button in the taskbar. (See Chapter 1 for how to open the Photo Editor).

2. In the Elements Editor, click to choose File, Open from the menu bar.

3. In the Open window, navigate to the file(s) you want to open and click to select it.

4. Click Open.

5. Click Cancel if you want to cancel out of the Open window.

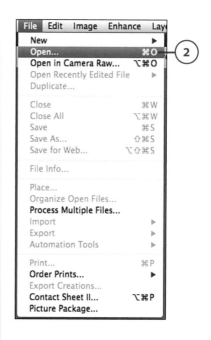

Setting Preferences for Importing

Learn how to customize the preferences for importing files into Photoshop Elements 13. Visit the online bonus content of this chapter at www.quepublishing.com/title/9780789753809 for complete instructions on how to customize the preferences for importing files.

Deleting a Photo

If you do not want a photo or video that you imported, you can delete it.

1. In the Viewer of the Organizer, click to select the thumbnail you want to delete.

2. Press the Delete key on your keyboard.

3. A message displays. If you want to delete the file from just the Catalog, click OK. This deletes the thumbnail and the link to the media.

4. If you want to delete the actual file from the disk drive that it's stored on, click the Also Delete Selected Item(s) from the Hard Disk before clicking OK.

5. If you want to cancel the Delete, click Cancel.

Active album

Viewer displaying
active album photos

Album categories
and albums

In this chapter, you learn how to organize photos based on Catalogs, albums, and folders. Learn to use the Albums and Folder panel, and how to work with multiple Catalogs. Organize your photos in the Viewer, too. Topics include the following:

→ Creating and managing Catalogs
→ Backing up and restoring Catalogs
→ Converting a Catalog from a previous version of Photoshop Elements
→ Creating and managing albums
→ Using folders to manage photos
→ Viewing photos in the Viewer

Using Elements Organizer: Organizing with Catalogs, Albums, and Folders

The Elements Organizer is a powerful catalog management program for your digital media. Organizer automatically creates a Catalog file when it is first installed. This is the default Catalog and anytime you import media, it is stored in the Catalog file. You can set up more than one Catalog for your photos, such as one for your vacation photos and one for your home photos. You can also set up albums to further organize your media in each Catalog. Use the Folders view to see where your photos and video came from on your computer.

Managing Catalogs

When you install Photoshop Elements 13, it creates a Catalog file for storing your photos, audio, or video. A Catalog is like a database in that it stores information about your digital media. When you

import media into Elements Organizer, it creates a link to media on your computer and external disk drives and devices in the Catalog that records the name of the digital media and the file path.

Organizer also records other basic file information in the Catalog, such as orientation of the photo, as well as any metadata like captions, notes, keyword tags, and keyword categories. When you make quick fixes or edits to your photos, the Catalog records this too. It is a very important file for the management functionality of Organizer. You can locate where your Catalog is on your computer through the Help menu in Elements Organizer.

1. Choose Help, System Info from the menu bar.

2. The System Info window displays, showing the location to your Catalog file. Click Copy to copy the information. You can paste the copied information into a word processor or text document and then save it.

3. Click OK to close the window.

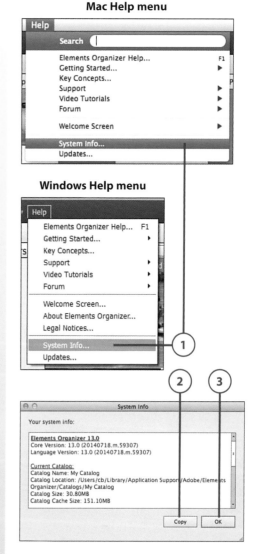

Creating a New Catalog

As you work in Elements Organizer, you might want to have multiple Catalogs for your photos. For instance, you could have a Catalog for all work photos and one for your personal photos. You can create a new Catalog, and then move or import your photos to the new Catalog. You access the Catalog through the Catalog Manager window. The Catalog Manager lets you create new Catalogs as well as manage existing ones.

1. Choose File, Manage Catalogs from the menu bar.

2. If you want to save the Catalog file to a new location on your computer, click Custom Location.

3. Click Browse to set the new location.

4. To create a new Catalog, click New.

5. Type a name for the new Catalog.

6. Click the Import Free Music into This Catalog option if you want to use free music with your photo or video projects.

7. Click Cancel to cancel the New Catalog process.

8. Click OK to create the new Catalog.

Rename and Delete a Catalog

You can rename a Catalog by first selecting it in the Catalog Manager and then clicking the Rename button. Type the new name in the Rename window. To delete a Catalog, again select it in the Catalog Manager and click the Remove button. In the message window click Yes to remove and delete the Catalog.

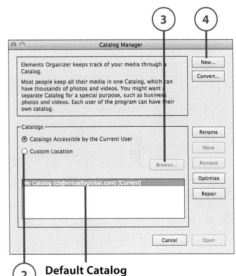

Default Catalog

Switch Between Catalogs

After you have multiple Catalogs created, you can switch between them and import or move your digital media to each Catalog to start organizing your photos and videos.

1. Open the Catalog Manager by choosing File, Manage Catalogs from the menu bar.

2. If needed, navigate to the Catalog you want to open by clicking Custom Location, and then click Browse to locate the Catalog.

3. Click to select the Catalog.

4. Click Open.

Double-Click to Open a Catalog

You can also double-click a Catalog in the Catalog Manager to open the Catalog.

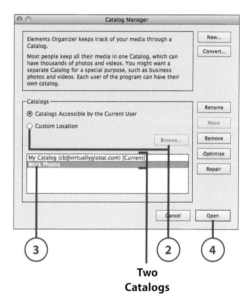

Two Catalogs

Adding Photos and Videos to Catalogs

When you have two or more Catalogs created, you can begin to import and/or copy your digital media between Catalogs. To import new media, first open the Catalog, and then follow the Import Photos topic in Chapter 2, "Importing Photos and Videos." You can also move existing photos and video from one Catalog to another. You need to work between the two Catalogs by opening one and copying the photos you want to move, and then open the other Catalog and repeat the import or move process.

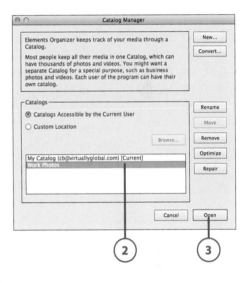

1. Open the Catalog Manager by choosing File, Manage Catalogs from the menu bar.

2. Select the catalog that has the photos and videos that you want to move.

3. Click Open.

4. In the Viewer, select the digital media that you want to move to a new Catalog. To select multiple photos, use the Shift+click or the Command-click (Mac)/ Control+click (PC) techniques.

Use the Marquee to Select Multiple Photos or Videos

You can also use the marquee technique to select multiple photos or videos in the Organizer Viewer. In the Viewer, click and drag in the gray area of the Viewer and pull out a rectangle shape. Any photo or video that the rectangle passes through is included in the selection. If you start your marquee by clicking in a thumbnail image, you'll move the photo, not pull out a marquee.

Selected photos

5. With the media to move selected, choose File, Move from the menu bar.

6. Click Browse to navigate to the folder where you want to move the media.

7. Click OK to move the images to this folder.

8. To add these files to another Catalog, open that Catalog Manager and choose a catalog, as shown earlier in steps 1 and 2.

9. Click Import, and choose From Files and Folders.

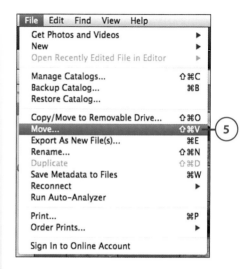

10. Navigate to the folder with the media and either select the entire folder or click individual files in the folder.

11. Click Get Media.

12. Organizer displays a window showing the progression of the Move process. The selected media is being copied to the new folder location. If you need to stop the Move process, click Cancel.

Working with Catalogs

You can work with only one Catalog at a time, but you can add your photos and videos to any and all Catalogs. You can include any photo(s) in multiple Catalogs.

Backing Up a Catalog

It is wise to back up your Catalog(s) in Photoshop Elements 13. Remember that the Catalog records information about your digital media, such as location, tags, and metadata. When you make a backup of your Catalog, it copies this file and any of the files that Organizer copied from mobile devices. It also creates other files that together compose your complete Catalog.

1. Choose File, Backup Catalog from the menu bar.

2. In the Backup Catalog to Hard Drive window, select either Full Backup to back up the entire Catalog or Incremental Backup to copy the current Catalog and all new or modified files since the last backup.

3. Click Next to go the next screen in the Backup Catalog process.

4. Set the location for the backup by selecting the Destination Drive.

5. In the Name field, type a name for the backup.

6. In the Backup Path field, click Browse to set the location of the backup on a different disk drive or folder.

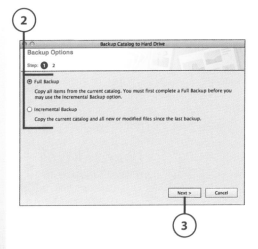

Backup Catalogs on Another Disk Drive

Typically, backup files are stored on a CD/DVD, an external hard disk, or a network location. This protects you if your computer crashes; your backup is on another drive, safe and sound.

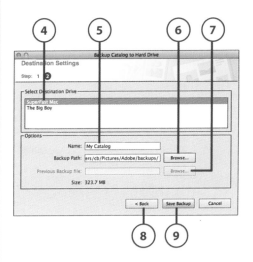

7. If you previously made a backup of the Catalog, locate the file for the Previous Backup File field by clicking Browse and navigating to that file.

8. If needed, click the Back button to return to the previous screen.

9. Click Save Backup to back up your Catalog.

10. Elements Organizer displays a progression window showing the progression of the backup. If your Catalog has lots of digital media, this can take a bit of time. If necessary, click Cancel to cancel the backup process.

11. When the backup is finished, a window displays. Click OK to close the Elements Organizer window.

Explore the Backup Files in the Backup Folder

Organizer creates a backup of your Catalog in a folder. This folder contains all the files needed to re-create your Catalog upon restore. If you open this backup folder you'll see many files in many formats. These files were specifically created for your restoring your Catalog. They might not make sense to you, but Organizer understands them.

Backup Reminders

After you have imported media, the next time you launch Organizer, you may see a Backup Reminder message. Click Backup Catalog to back up your Catalog or click Remind Me Next Time to close the window. Click the Don't Show Again to disable this message.

>>>Go Further
PREPARATION BEFORE BACKING UP CATALOG

Before you back up your Catalog, it is a good idea to perform two tasks to ensure a clean and successful backup. The first is to make sure all your media is connected to the linked file; the second is to run a Repair on your current Catalog. Choose File, Reconnect, All Missing Files from the menu bar to make sure all your photos and videos are correctly linked to their associated media files.

To make sure your current Catalog is clean and working as it should, open the Catalog Manager by choosing File, Manage Catalog. In the Catalog Manager select the Catalog to repair and click Repair.

A window displays letting you know that the Catalog is being checked for errors and that the Repair might take several minutes.

When the repair is complete, Organizer displays a message letting you know the results. If any errors exist, click the Re-Index Visual Similarity Data to run the Auto-Analyzer so that all photos are re-indexed based on visual similarities in them, and then click OK. Then, click Repair Anyway to let Organizer re-index the Catalog and run a repair on the re-indexed Catalog. Click OK to close the window when you are done.

Restoring a Backup Catalog

In the world of computers, there is always the risk for hardware failure. If you ever have had a hard drive crash or dropped a laptop, you probably were extremely happy to have a backup of your information or extremely sad if you did not. Always back up your data, and this includes the Catalog of Elements Organizer. After you back up your Catalog, you can easily restore your Catalog to a new computer or external disk drive.

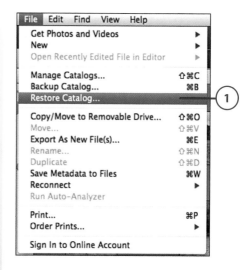

1. In Organizer, choose File, Restore Catalog from the menu bar.

2. Under Restore From, click the Browse button to locate the Catalog backup folder.

3. Under Restore Files and Catalog To, click one of the two options:

 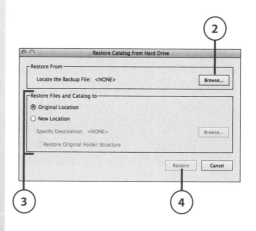

 - **Original Location**—Click this to restore the Catalog to its original location.

 - **New Location**—Click this to restore the Catalog to a new location that you specify by clicking Browse and navigating to the new location. If you click the Restore Original Folder Structure, Organizer re-creates the Original Catalog Folder structure for the new Catalog.

4. Click Restore to restore your Catalog.

Moving a Catalog to Another Computer

If you buy a new computer and need to move your Catalog to this new machine, you can easily do this. You must first back up your Catalog on an external drive. Then restore the Catalog on the new computer. You must have Photoshop Elements installed on the new computer to restore your Catalog.

Convert a Catalog from a Previous Version of Organizer

If you have used previous versions of Photoshop Elements, such as version 12 or 11, your Catalogs are created for that version of Photoshop Elements and must be converted to work with Photoshop Elements 13. The Catalog Manager has a Convert feature for converting your older Catalogs to this latest release.

1. Open the Catalog Manager by choosing File, Manage Catalogs from the menu bar.

2. Click Convert.

3. The Convert Catalog window displays and Photoshop Elements searches your computer for older Catalogs. Any older Catalogs found are automatically displayed in the Select a Catalog from the List to Convert field.

4. If Organizer doesn't display your Catalog, click the Find More Catalogs button to navigate to the Catalog yourself.

5. Click to select the Catalog to convert.

6. Click Convert and a message window displays, showing the progression of the conversion.

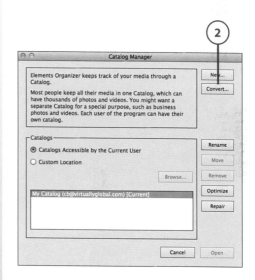

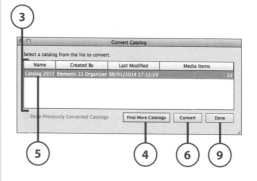

7. If needed, click Cancel to stop the conversion; otherwise, wait for the conversion to complete.

8. Organizer displays a Conversion Complete window indicating that the older Catalog has been successfully converted. Click OK to close the window.

9. Click Done to close the Convert Catalog window.

10. Click the Close button to close the Catalog Manager window.

Albums Versus Folders

Photoshop Elements uses both albums and folders for managing and grouping your digital media in a Catalog. Each is used to organize, group, and display your photos. You can find both under the associated tab in the Albums and Folders panel. Click the Albums tab to see the albums in your Catalog, or click the Folders tab to see the folders where your media is located. You create albums to group and display your photos as you want, and use the Folders view to find where the original file of a photo or video is located on your computer. They each have their own use in Photoshop Elements 13 for managing your photos.

1. By default, the Albums view is the active view when you first open Elements Organizer. Click the Albums tab if you are in the Folders tab.

2. To switch to the Folders view, click the Folders tab.

3. Switch back to the Albums view by clicking the Albums tab.

4. Click a folder or album and the Viewer displays the media grouped in that folder or album.

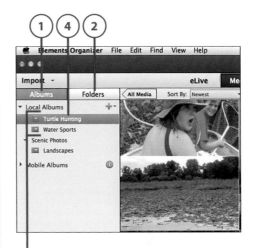

Albums

Two Displays for the Viewer

New to Photoshop Elements 13 is the Adaptive Grid display in the Viewer. This display organizes the photos flush with each other, filling the Viewer window. You can switch back to the legacy display of the Viewer by choosing View, Details from the menu bar. This is a toggle menu; select View, Details again to switch back to the Adaptive Grid display in the Viewer.

Folders

Creating Albums

An album in Organizer can be compared to a physical photo album that you use to group and display your photos. You can create, rename, and delete albums. You can add photos and video to an album through a simple drag and drop.

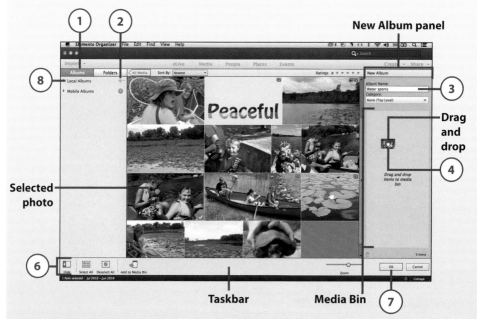

1. If you are not in the Albums view, click the Albums tab.

2. Click the green plus sign to the right of Local Albums. This opens the New Album panel.

3. Type a name for the album in the Album Name field.

4. In the Viewer, click and drag a photo into the Media Bin of the New Album panel.

Multiple Item Selection Techniques

Don't forget about the multiple item selection techniques. You can also drag and drop multiple items to an album. Use Shift+click to select sequential photos, or use Command-click (Mac)/Control+click (PC) to select photos that are not next to each other. You can also pull out a marquee to select a group of photos next to each other. Then drag and drop the selection to the Media Bin.

5. To delete a photo you mistakenly added to the Media Bin, select the photo and click the Trash Can icon.

Selected Photos

6. The taskbar also displays buttons for managing your photos in either the Album or Folder views. Click the buttons to initiate that button's functionality.

 • **Hide**—The Hide button hides the Albums and Folders panel, allowing the Viewer to display more thumbnail images of your media.

 • **Select All**—This button selects all the media in the active view.

 • **Deselect All**—The Deselect button deselects the active selection in the Viewer.

 • **Add to Media Bin**—This button adds any photos you have selected to the Media Bin through a click of a button, not a drag and drop.

7. Click OK to save the album.

8. The new album is now added under Local Album. Click the Show/Hide triangle to expand Local Albums and see your new album.

Adding Media to Albums

After you have an album created, you can add other photos and videos to that album.

Drag to an album **Selected photos**

1. Click the Albums tab.

2. In the Viewer, click to select the photo(s) you want to add to an album.

3. Drag the selection to an album.

4. Click the album to display its media.

5. Click All Media to view all imported media or click another album to see its media.

>>>Go Further

ADD MEDIA TO MULTIPLE ALBUMS

You can also add media to multiple albums at the same time. If needed, click the All Media button to view all your imported media for the active Catalog. Then select multiple Albums by Command-clicking (Mac)/Control+clicking (PC) to select the albums you want to add to the same media.

In the Viewer, click the photo(s) you want to add to multiple albums at the same time. Then drag them to any one of the selected albums. Organizer adds the photo(s) to each selected album.

Creating Album Categories

You can also create Album Categories for grouping your photos. For instance, you can have an Album Category named Scenic Photos and then further group your photos by creating albums in this category for Landscapes, Portraits, Flowers, and City Scenes. The Album Category doesn't contain any photos—it is just a category that you can add other albums to, or you can further categorize your media with other Album Categories.

1. Click the Albums tab to switch to this view.

2. To create an Album Category, click the triangle next to the green plus sign to the right of the Local Albums.

3. Click New Album Category from the drop-down menu.

4. The Create Album Category window displays. Type a name into the Album Category Name field.

5. Click the Parent Album Category pop-out menu and choose a Parent Album Category. You can create categories within categories. The default setting is None (Top Level).

6. Click OK to close the window and create the Album Category.

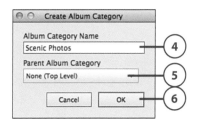

Using Mobile Albums

The Albums pane of the Albums and Folders panel also contains Mobile Albums, which lets you create Albums and Album Categories for sharing with others. Photoshop Elements 13 uses Adobe Revel for creating and sharing albums that can be shared and viewed by others. Chapter 14, "Sharing Your Photos," covers how to set up Adobe Revel and share your photos online through Photoshop Elements. To learn more about Adobe Revel, visit www.adobe.com/products/revel.html.

Switching Between Albums

After you have Albums and Album Categories created, you can easily switch between them to see the photos you have grouped in each album.

1. Click the Albums tab.

2. Click the Show/Hide button (triangle) to the left of Local Albums or an Album Category to expand the album list. Click the Show/Hide triangle again to collapse the album list.

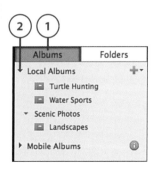

3. Click an album. The Viewer displays the photos in that album.

4. Click another album to see its photos.

5. To return to All Media view, click the All Media button at the top of the Viewer.

Photos grouped in album

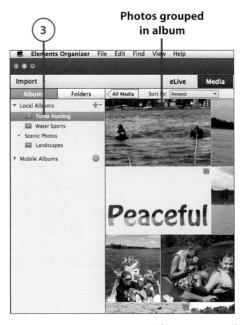

Using the Folders Tab

The Folders tab groups your photos differently because it is based on where the original photo is located on your computer. There are two folder views you can use for displaying photos: List or Tree.

Photos grouped in album

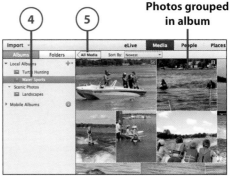

1. Click the Folders tab.

2. The Albums and Folders panel displays the Folder Tree view of all the folders that contain your imported digital media. Folder Tree is the default view. Click the Show/Hide button to the left of a folder to expand it.

3. Click the Show/Hide button to the left of the folder to collapse it.

4. Click to select a folder, and the Viewer displays the photos in that folder.

Default Folder Tree view

5. To change to the Folder List view, click the Folder View button to the right of My Folder.

6. Select View as List from the pop-out menu.

7. Click to select a Folder in this Folder List view, and the Viewer displays the photos in that folder.

8. Click All Media to view all photos and videos.

Move Photos Between Folders

You can move your digital media between folders in the Folders tab of the Albums and Folders panel. Expand the folder with the photo or video that you want to move, and then click and drag the media that you want to move to a new folder. This physically moves the original file to the new folder on your computer.

Working in the Viewer

The Viewer in Organizer is where your photos and video are displayed. It can also be used to organize and manage your photos. Your media is displayed in thumbnail images in a grid. Videos have a video clip icon in the upper-right corner of the thumbnail for easy identification. You can increase the size of the thumbnails to get a better view of each photo or video, and you can decrease the size of the thumbnails to see more of your media in the grid by using the Zoom slider. You can also open any photo or video into a larger preview.

Video thumbnail

Photo Shot Date displayed as you scroll

Viewer

Zoom slider

1. Click an album or folder and the Viewer displays the grouped media in that album or folder.

Identifying Video in the Viewer

Videos have a video clip icon in the upper-right corner of the thumbnail for easy identification.

2. Click and drag the vertical scrollbar to scroll through your thumbnails.

3. Double-click a photo thumbnail in the Viewer to open a preview of the photo.

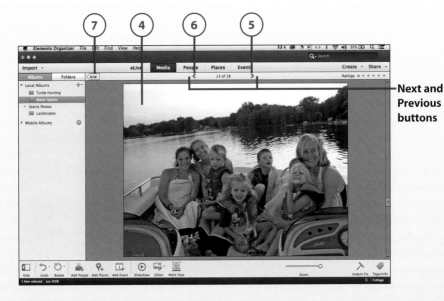

Next and Previous buttons

4. A larger preview of the photo is displayed.

5. Advanced to the next photo by clicking the Next button.

6. View the previous photo by clicking the Previous button.

7. Click Grid to return to the thumbnail view of your album or folder photos.

Preview a Video

If you double-click a video, it opens in a video player window. You can preview the video by clicking Play. You can jump to the end of the video by clicking End or jump to the beginning of the video by clicking Start. To advance through the video, click and drag the Playback slider. To close the video preview window, click the Close button.

Default Preview File Size

You can control the preview size or dimensions of a photo in the Organizer Preferences. Under the Files category of Preferences, you'll find Offline Volumes. The default preview size is set to 640×480 pixels for all media that you import from an external or mobile device. Remember that Organizer makes a copy of all media that it imports from an external device, and it creates a link to the media on your computer disk drive(s) or network. So this preview file size is a setting for the display of any media from offline volumes. You can change this by clicking the Preview File Size drop-down menu and choosing a new size.

Organizing Photos

You can control the order of your digital media in the Viewer through the Sort By menu.

1. Click the Albums tab to view the photos in an album.

2. Click an album.

3. Click Sort By to display the drop-down menu. Select one of the menu choices. The default setting is to display the newest photos first.

 - **Newest**—Sort your media by newest to oldest based on the date the photo was taken.

 - **Oldest**—Sort your media by oldest to newest based on the date the photo was taken.

 - **Name**—Sort by name of the media.

 - **Import Batch**—Sort by the date that you imported your photos.

 - **Album Order**—Select this option to manually rearrange the photos in the Viewer based on the album you are viewing.

4. Select Album Order to manually rearrange your media.

5. Numbers display in the upper-left corner of each thumbnail. Click to select a photo.

6. Click and drag a photo thumbnail to a new location in the grid.

Selected thumbnail

Using Zoom

You can change the size of the thumbnails in Viewer so that they are larger or smaller. If you make them larger, you can see more detail in the thumbnail image. If you make them smaller, you can see more thumbnails in the grid. The Zoom slider controls the size of the thumbnails in the Viewer.

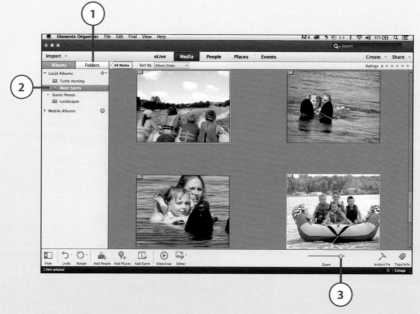

1. Click the Albums tab from the Albums and Folders Panel.

2. Click an album.

3. Click the slider in the Zoom slider and drag it left or right. Dragging left decreases the size of the thumbnails, displaying more in the grid. Dragging right increases the size of the thumbnails, displaying a larger view of each thumbnail image.

Use the View Menu

The Organizer also has a View menu that has other menu commands for viewing your photos in the Viewer.

- **Refresh**—Refreshes the Viewer.

- **Media Types**—View your Catalog of media by media type of Photos, Video, Media Type, Projects, and PDFs.

- **Hidden Files**—Hide and Show Hidden Files. Also view all files.

- **Sort By**—Sort media by Oldest, Newest, or Name.

- **Details**—Switch between the Adaptive Grid view or the legacy view for the Viewer display of media.

- **File Names**—View File Name under media thumbnails in the Viewer. You must be in the legacy view for the Viewer to display File Names.

- **People Recognition**—Set the Auto-analyzer to apply People Recognition to your media.

- **Grid Lines**—Display grid lines in the Viewer.

- **Full Screen**—Display the Organizer in Full Screen View. Press ESC from the Keyboard to exit Full Screen display.

- **Timeline**—View Photos based on a timeline of when they where taken. This menu is a toggle menu, to exit the Timeline view, choose this menu command again.

- **Expand All Stacks**—Expand all Photo Stacks.

- **Collapse All Stacks**—Collapse all Photo Stacks.

- **Set Date Range**—Set a Date Range for finding and viewing photos based on Shot Date.

- **Clear Date Range**—Clear the Date Range you set with the Set Date Range menu command.

Default Viewer Preference Settings

Learn how to customize the preferences for the Viewer into Photoshop Elements 13. Visit the online bonus content of this chapter at www.quepublishing.com/title/9780789753809 for complete instructions on how to customize the preferences for the Viewer.

Selected photo Media view active

Metadata for
selected photo

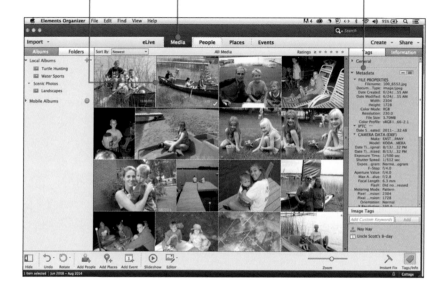

In this chapter, you learn how to attach meta-
data, tags, and ratings to your digital media.
Learn how to find a certain photo or video
based on the metadata, tag, or rating that you
attached. You also learn how to create multiple
search criteria and use this to find your media:

4

→ Creating and attaching metadata to your digital
 media
→ Organizing your media with keyword categories
 and keyword tags
→ Setting People, Places, and Events tags to media
→ Attaching Information tags to media
→ Attaching captions and notes to media
→ Applying ratings to media
→ Searching and finding media based on metadata
→ Using the View menu commands to find media

Attaching Metadata, Tags, and Ratings in the Organizer

As you build your digital media Catalog with photos, videos, and
audio, your Catalog can get quite large. Finding the media that
you want can be a challenge. Organizing by albums and folders
helps, but Elements Organizer also offers other strategies for find-
ing similar or specific media. Organizer lets you tag your media with
keywords and captions. You can rate your media as well. Organizer
has several views built right in to the workspace that you can access
with a click. You can also explore your media based on People,

Places, and Events. This chapter covers how to tag your photos, videos, and audio with keywords, captions, and ratings and then use these tags to find similar photos, videos, and audio.

Adding Metadata—Keyword Tags

Elements Organizer lets you manage your digital media by applying metadata to each photo, video, and audio file in your Catalog. Metadata can be keywords, captions, notes, and even audio files that are used to describe your media. This lets you quickly find photos, videos, and audio files. Keyword tags can be a single word or a multiword phrase that describes the media. You can create custom keyword categories or keyword tags that are based on people, places, and events. For instance, if you want to be able to identify all photos that have a certain person in the image, apply a People keyword to that photo. Captions, notes, and audio files also can be added, and these can be anything you want to describe your media.

Use of the Adaptive Grid

This chapter covers the Organizer metadata and search functionality through the use of the Adaptive Grid display. This Adaptive Grid feature is new to Photoshop Elements 13. It can be toggled on and off by pressing Command-D (Mac)/Control+D (PC) or by choosing View, Details from the menu bar. When Adaptive Grid is toggled off, the legacy view of earlier versions of Organizer displays media in the Viewer.

The Tags and Information panel lets you create keywords and keyword categories as well as attach the metadata to your digital media. It has two tabs, the Tags tab and the Information tab.

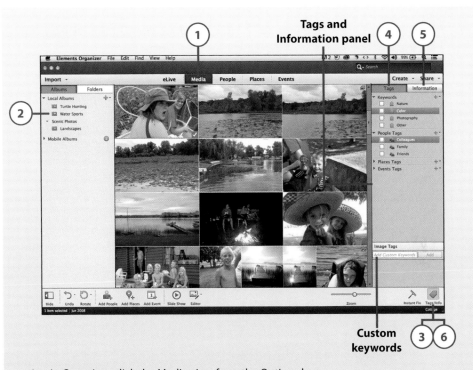

Tags and Information panel

Custom keywords

1. In Organizer, click the Media view from the Options bar.

2. If needed, click an album or folder to view the photos and videos grouped in it.

3. To display the Tags and Information panel, click the Tags/Info button in the taskbar.

4. The Tags tab displays by default. You can access this panel anytime by clicking the Tags tab.

5. Click the Information tab to display this tab.

6. To close this panel, click the Tags/Info button again in the taskbar.

Setting Keywords Tags

The Tags pane of the Tags and Information panel is divided into four keyword categories: Keywords, People Tags, Places Tags, and Event Tags. Each keyword category is composed of default keyword tags. You can apply or "tag" your photos with these keywords tags. You can also change the keyword categories and default keyword tags to whatever you like, as well as create your own keyword categories and keyword tags.

1. Click the Tags tab.

2. Click the Show/Hide triangle to the left of the keyword category to show the keyword tags for each category. Click it again to hide the category.

3. To apply a keyword tag to a photo, click and drag a photo thumbnail from the Viewer on top of the keyword tag.

4. You can also click and drag a keyword on top of a thumbnail in the Viewer to apply the keyword to that photo.

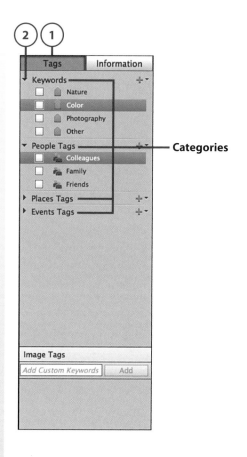

Categories

Don't Forget About Multiple Selection Techniques

You can use the Shift+click and the Command-click (Mac)/Control+click (PC) techniques to choose multiple photos and/or videos and then add a keyword tag to all the photos at once. You can also choose multiple keyword tags and tag a photo in the Viewer with all the keyword tags at one time.

Organizing with Keyword Categories and Keyword Tags

The default keyword categories and keyword tags are general tags you can attach to your media. You might want to customize these as you organize your media. You can change the default keyword categories and keyword tags, as well as create your own. You can also import keywords tags from other photo catalogs or libraries.

1. To create your own keyword tags, do one of the following:

 • Click the green plus sign to the right of Keywords.

 • Click the triangle to the right of the green plus sign icon and choose New Keyword Tag from the menu.

2. In the Create Keyword Tag window, click Edit Icon to import a custom image to be used as the icon for the new keyword.

3. Click the Category pop-out menu and choose a default keyword category to assign the new keyword tag.

4. Click in the Name field and type a name for the keyword tag.

5. Click in the Note field and type a note to further describe the keyword tag.

6. Click OK to close the Create Keyword Tag window.

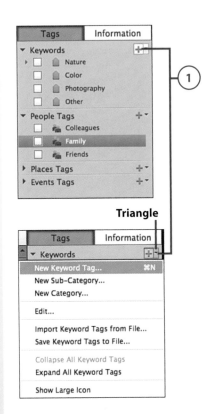

Triangle

7. The new keyword tag displays in the Tags pane. You can now add this tag to your media.

8. To create your own keyword category, click the triangle to the right of the green plus sign.

9. Choose New Category.

Create Subcategories

If you choose the New Sub-Category command from the keyword category pop-out menu, you can create a subcategory under a Keyword Category to further group and organize your photos and videos.

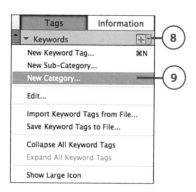

10. In the Create Category window, click Choose Color to choose a color using the Color Picker.

11. Click in the Category Name field and type a new category name.

12. Click and drag the slider left or right to see all default icons.

13. Click to choose the one you want for your keyword category.

14. Click OK to close the window. The new keyword category displays in the Tags pane.

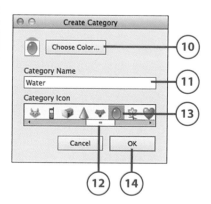

Quickly Create a Keyword Tag

The Image Tags pane at the bottom of the Tags and Information panel lets you quickly create and add a custom keyword tag. Select the photo thumbnail in the Viewer that you want to tag and then type the keyword tag in the Add Custom Keywords field. Click Add to create and add the keyword tag to the photo.

The new keyword tag is automatically assigned to the Other keyword category and displays below this category.

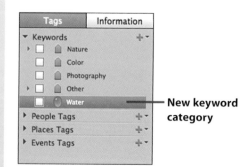

New keyword category

Saving and Importing Tag Sets

You can also save and import Tag Sets for use in organizing your media. Visit the online bonus content for this chapter at www.quepublishing.com/title/9780789753809 for more information.

Rename a Keyword Tag or Keyword Category

All keyword tags and/or keyword categories can be renamed, and their other assets can be modified, like the icon used or the color for the icon.

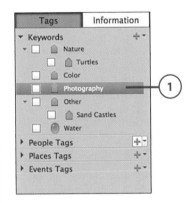

1. Click to choose a keyword tag or keyword category in the Tags pane of the Tags and Information panel.

2. Click the triangle next to the green plus sign to the right of the associated keyword category.

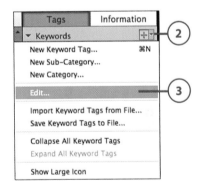

3. Click Edit from the drop-down menu.

4. In the Edit Category window, click Choose Color to choose a color using the Color Picker.

5. Click in the Category Name field and type a new category name.

6. Click and drag the slider left or right to see all default icons.

7. Click the icon you want for your keyword category.

8. Click OK to close the window.

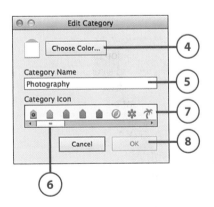

Right-clicking to Choose Commands

Photoshop Elements 13 makes use of right-clicking to access commands and functionality too. Try right-clicking a keyword tag or keyword category to access a context menu of all the commands specific to the item that you right-clicked.

Setting People Tags

A really useful feature for organizing your photos is to apply People tags to the people in the photos. There are two processes for doing this: one is manual, where you assign People tags to your photos, and the other is automatic, where the Auto-analyzer of Organizer assigns People tags to faces that it identifies when analyzing your photos. Through a combination of both techniques, all people in your Catalog can be tagged so that you can quickly find all photos of each person.

Assigning People Tags Using the Auto-analyzer

When you first import your photos into Organizer, you can turn on the Auto-analyzer to identify people in your photos. It analyzes the entire Catalog and automatically assigns People tags. You can also choose a group of photos to analyze.

1. To use the Auto-analyzer to automatically tag photos with People tags, click the People view from the Options bar.

2. Click the Add People button in the taskbar.

3. In the People Recognition—Label People window, click each Who Is This? field to assign a People tag to the photos.

Download or Update People Tags with Facebook Friends List

You can click the Download/Update Facebook Friends' List to Name People button to download your Facebook Friends tags to your Photoshop Elements Catalog. Photoshop Elements 13 has new Facebook integration and functionality. For more information, see Chapters 13 and 14.

4. Click Save.

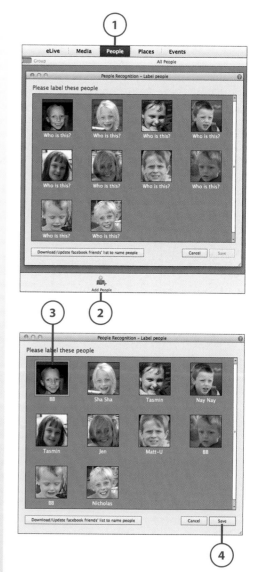

5. Organizer proceeds through a series of windows showing people it did not recognize. First it asks you to exclude any people from each people group. Click any people that do not belong in the displayed groups.

6. Click Save to close the window and move on in the Auto-analyzer process.

7. Next, label individual people that need more identification in your photos. Click the Who Is This? field below each person to type the name of the person or click the name from the Suggestion bar.

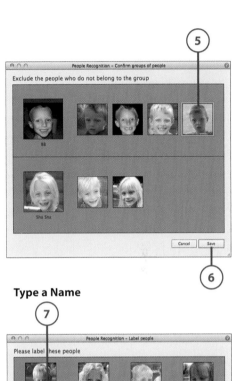

Type a Name

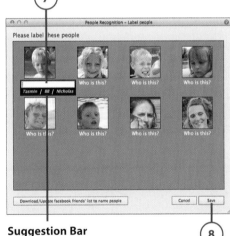

Suggestion Bar

Auto-analyzer Learns from Your Choices

As you work through the People Tag Auto-analyzer process, it identifies people who have not been tagged. Many of these people will already have had a People tag created, and this tag just needs to be assigned to that image. If the People tag does not display in the Suggestion bar, type the name you want to use. If a similar tag is already created, it displays in a drop-down menu. Click to choose the existing tag for labeling the image or type a new People tag if the image is a new person.

8. Click Save to close the window and move on in the Auto-analyzer process.

9. Sometimes an image is displayed that is not a person. If you hover your cursor over the image, an icon displays in the lower-right corner; click this icon to display a pop-out menu. Click Not a Person or Ignore from the menu.

10. Finally, label photos that Auto-analyzer thinks might be of a person. Click to select the images that are people, and then click Save.

11. When the People tagging process is complete, the Elements Organizer window displays. Click OK.

Run Auto-analyzer Anytime

The Auto-analyzer can be run anytime you need to tag people in your photos. First choose an album, a folder, or a group of photos, or click the All Media button to analyze all photos in your Catalog. Then click the Media view in the Options bar and then the Add People button from the taskbar. The Auto-analyzer is initiated and analyzes your selection or Catalog of photos.

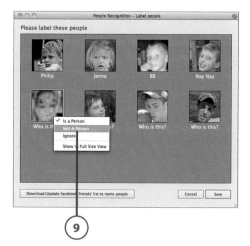

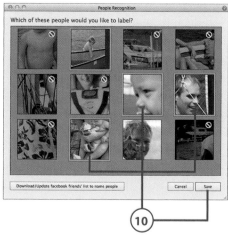

Modifying People Tags

After you tag your media with People tags, you can rename any tag and add and delete photos from the People tag.

1. In Organizer, click the People view.

2. To rename a People tag, do one of the following:

 • Right-click the photo stack of the person you want to rename and choose Rename.

 • Click to select a photo stack, and click the Rename button in the taskbar.

3. In the Rename window, type the new name.

4. Click OK.

5. To remove a photo from the People tag, double-click a photo stack.

6. This opens all the photos of people in the photo stack. Click the photo you want to remove from the stack.

7. To remove the photo do one of the following:

 • In the taskbar, click Remove.

 • Right-click the photo and choose Remove.

8. To add a photo, click Find More.

9. In the People Recognition window, right-click the photo to add and choose an existing People tag. If this is a new person, click to select the thumbnail.

10. Click Save.

11. Based on the number of photos not tagged, Organizer advances through a series of screens for identifying photos for tagging. Repeat steps 9–10 until this screen displays. Click OK to close the window and end the People recognition process.

Explore Photos in a Photo Stack

You can see a preview of each photo in a photo stack. If there are multiple photos in the photo stack, position your cursor in the picture area of the photo stack and then cycle forward and backward through them by moving your cursor right and left in the picture area. If you want to change the Profile picture that displays in the photo area of the photo stack, cycle through the images until you see the one you want, then right-click and choose Assign as Profile Picture from the menu.

Create Your Own Custom Photo Stack

You can also create your own custom Photo Stack for use in organizing your media. Visit the online bonus content for this chapter at www.quepublishing.com/title/9780789753809 for more information.

Deleting People Tags

You can delete a People tag, which removes only the tag from all the tagged photos. This does not delete the photos from the Catalog.

1. In Organizer, click the People view.

2. Click to select a photo stack.

3. Click the Remove button from the taskbar.

4. In the Confirm People Removal window, click Yes.

Creating People Tag Groups

You can also create People tag Groups to use in organizing your media. Visit the online bonus content for this chapter at www.quepublishing.com/title/9780789753809 for more information.

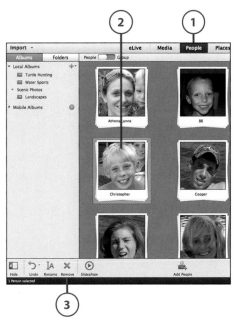

Manually Add People Tags

You can manually add a People tag to any photo. You do not need to use the Auto-analyzer, although it is much quicker to let the Auto-analyzer tag your photos first. You can use the manual process for any new imports or photos that did not get tagged automatically.

1. Click the Media view button.

2. Double-click a thumbnail to open it in a larger display.

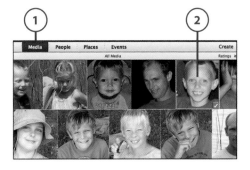

3. Organizer automatically displays a Mark Face box around any people it identifies in the photo. You can also click the Mark Face button in the taskbar to display this box.

4. Type in a People tag in the Who Is This? field, or choose an existing People tag from the drop-down menu that displays. If you do not want to label the person, do not add a name in the Who Is This? field.

5. Click the Close button to apply the changes.

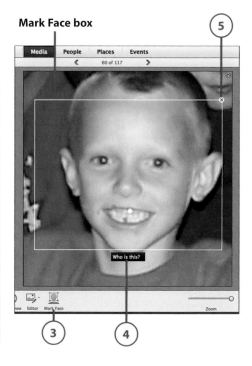

Mark Face box

Setting Places Tags

Photos can also be tagged based on the location or place that the photo was taken. Many mobile devices today automatically attach location tags to photos based on the device's GPS feature. These tags are attached in the metadata for the photo. The Places view displays photos based on the location tag. Adobe Photoshop Elements 13 also lets you add location tags to photo(s). You can tag by country, state, city, and street address, which lets you find your photos based on where the photos were taken.

Attach Multiple Tags to Your Media

Multiple tags can be attached to a photo. For instance you can attach People tags to a photo as well as a Place tag and/or an Event tag. Tags help you organize your photos so that you can easily find the photo that you are looking for in your Catalog.

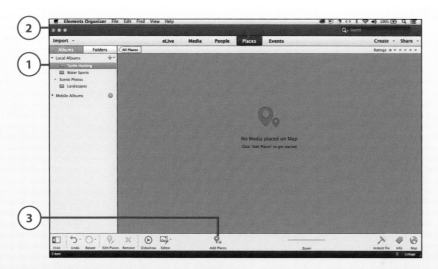

1. In Organizer, click an Album or Folder.

2. Click the Places view in the Options bar.

3. Click the Add Places button in the taskbar.

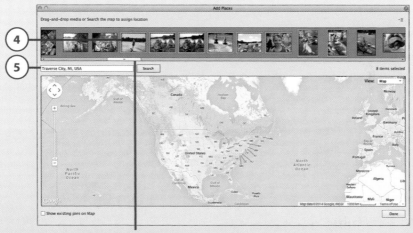

Horizontal scrollbar

4. The Add Places window displays. In the Drag-and-Drop Media scrolling area, click to select a photo, or use Shift-click or Command-click (Mac)/Control+click (PC) to select multiple photos. Use the horizontal scrollbar to scroll through your photos.

5. To find the place or location, click in the Search field and type the country, city, and/or address, and then press Return (Mac)/Enter (PC).

Drop-down menu (6)

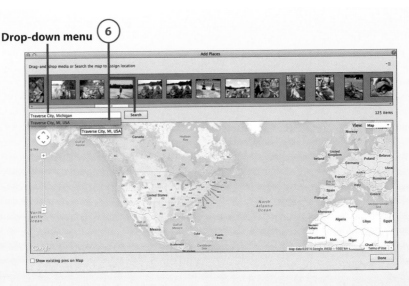

6. Organizer confirms your location by displaying a drop-down menu with suggested locations. Click to select the location from the menu and then click Search.

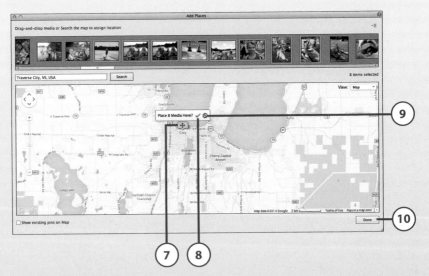

7. Organizer displays your location on the map, and the Place Media Here message displays. If needed, click and drag the location pin to a new location to manually position the pin.

8. Click Confirm to add the photo(s) to that place on the map.

9. If needed, click Reject to cancel out of the location tag and close the Place Media message.

10. Click Done to close the Add Places window.

Use the Map Tools to Set a Place

Use the Map tools in the upper-left corner of the map to set a location. Click the Direction tool to scroll up, down, left, or right on the map. Use the Zoom slider to zoom in or out on the map. You can also use your mouse and the scrolling wheel to zoom in or out of the map. Change the type of map display by clicking the View menu in the upper-right corner of the map and choosing the view you want for the map display.

Drag and Drop to Add a Place Tag to Photos

You can also drag and drop photo(s) directly to a location on the map. Select the photos that you want to tag with a place, and drag them from the Drag-and-Drop scrolling area directly to a location on the map. Click Done to close the Add Places window.

Modifying Place Tags

After you set a Place tag, you can modify the pin location on the map as well as the photos it tags.

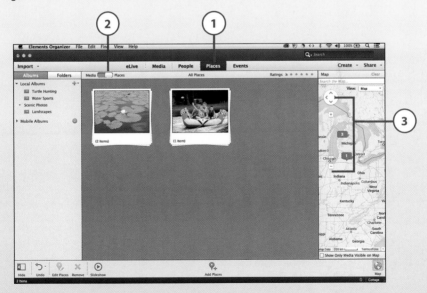

1. In Organizer, click the Places view.

2. Click Media/Places so that Places is active.

3. Zoom in or out or move left, right, up, or down to adjust the zoom on the map using the Map tools. Place pins display based on the amount of zoom.

Understand How the Map Zoom Works with Place Pins

If you have multiple Place pins set for a city or particular location, as you zoom in to the city, they display. If you zoom out, they are all grouped in one pin with a number indicating the number of pins set in that place.

Linked photo stack

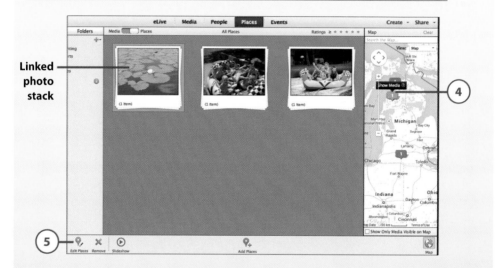

4. To reposition a Place pin, click to select it. It turns blue, indicating that it is selected, and the photo stack it is linked to is highlighted in the Viewer.

5. Click Edit Places in the taskbar.

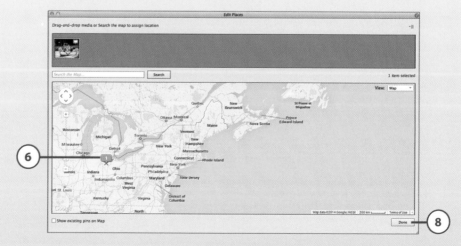

6. In the Edit Places window, click and drag the pin to a new location on the map.

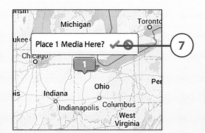

7. A Message window displays. Click Confirm to position the media at the new pin location.

8. Click Done to save the new location and close the window.

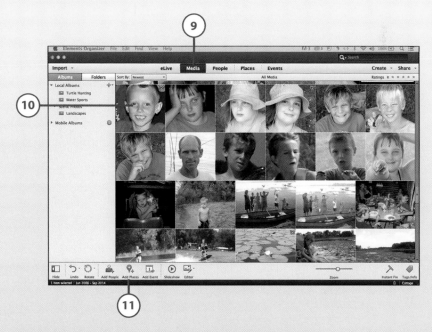

9. To add new photos to a Place pin, click the Media view.

10. Click to select the photo(s) you want to add to a Place tag.

11. Click Add Places from the taskbar.

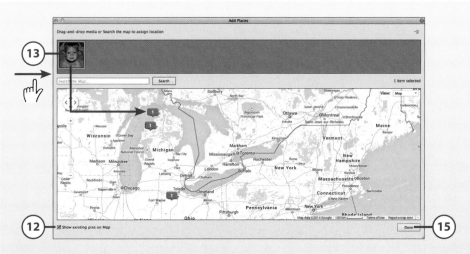

12. In the Add Places window, click the Show Existing Pins on Map option.

13. Click and drag the thumbnail to the pin.

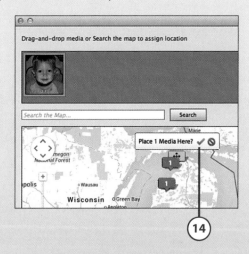

14. Click Confirm to add the photo to the existing Place tag represented by the pin.

15. Click Done to save the changes and close the window.

Deleting Place Tags and Photos

You can delete a Place tag that you have created if you no longer need it. Deleting the Place tag does not delete the photos that it groups. You can also delete a photo from a Place tag.

1. In Organizer, click the Places view.

2. Click the Media/Places option so that Places is active.

3. To delete a photo from a Places tag, double-click the photo stack that groups the photo to delete.

4. Click to select the photo to delete.

5. Click Remove.

6. In the Remove Place Information window, click OK.

7. To delete a Place tag, click the Places view.

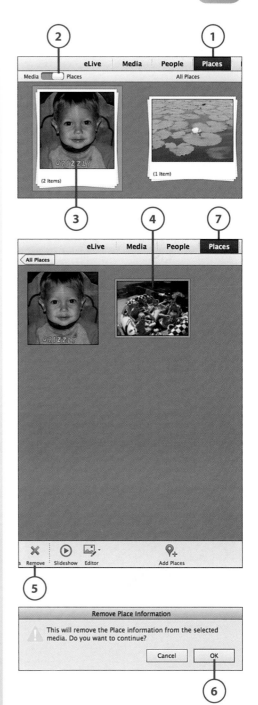

8. If necessary, click to select the Media/Places option so that Places is active.

9. Click the photo stack that you want to remove the Place tag.

10. Click Remove.

11. In the Remove Place Information window, click OK. The photo stack and the pin are deleted.

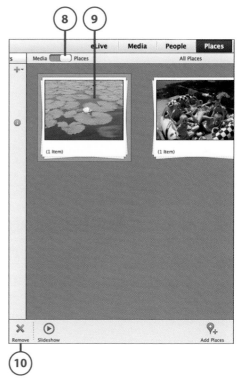

Setting Events Tags

Another nice feature that Organizer offers is to tag your media by events. An Event can be the date or time the photo or video was shot, or it can be a specific date chosen from a calendar that you want to attach as a tag. Organizer helps you with this process with a feature called Smart Events that automatically tags your media with a Smart Event based on the date the media was shot or recorded. The Event tag helps you categorize and tag your media so you can easily locate similar photos, videos, or audio files in your Catalog.

1. In Organizer, click the Events view.

2. Click the Events/Smart Events
 option to switch to Smart Events.

3. Organizer automatically groups
 your media based on date. To
 see your media based on a time
 frame, click the Time option.

4. You can lengthen or shorten the
 time frame by dragging the Time
 slider left to increase the time
 frame or to the right to shorten it.
 Organizer displays more or fewer
 photo stacks based on the time
 frame.

5. To create your own Event tag,
 click the Events/Smart Events
 option to switch back to Events.

6. Click the Add Event button in the
 taskbar.

7. The Add New Event pane displays. Type an event name into the Name field.

8. Click the Calendar icon for both the Start and End date to set the time frame for the event.

9. This displays a calendar. Do the following to set the date:

 • Click the month and choose the month from the drop-down menu.

 • Click the year and choose the year from the drop-down menu.

 • Click a day from the calendar.

10. Click the Group menu and click a group.

11. Click in the Description field and type a description for the Event tag.

12. Drag and drop media from the Viewer into the Media Bin to attach an Event tag to the media.

13. Click Done.

14. If you want to cancel the Event, click Cancel.

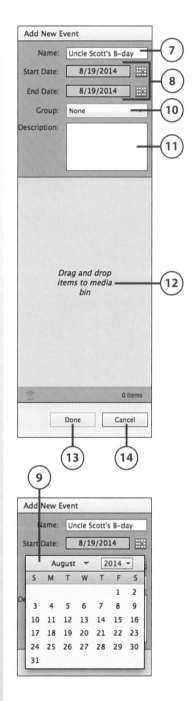

Adding and Deleting Event Tagged Media

After you have created an Event, you can add and remove media from it and edit the
Event information.

1. In Organizer, click the Events view.

2. If necessary, change the Events/Smart Events option to Events. You cannot edit Smart
 Events.

3. Click to select the Event to edit.

4. Click Edit Event.

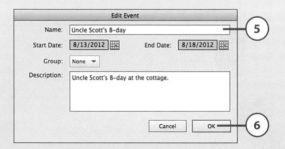

5. In the Edit Event window, click in any of the fields to edit the existing information.

6. Click OK to save the changes for the Event info and close the window.

7. To delete a photo or video from the Event, double-click the Event photo stack to
 open it.

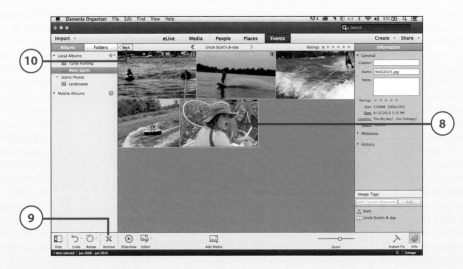

8. Click to select the photo you want to remove.

9. Click Remove.

10. To return to the display of all Events, click Back.

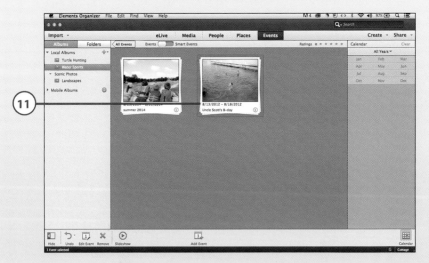

11. To add new media to an existing event, double-click an Event.

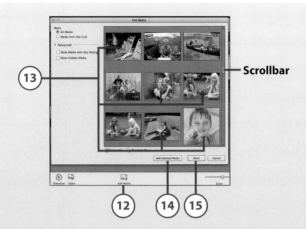

Scrollbar

12. Click Add Media.

13. Use the scrollbar to scroll through your media and click the thumbnails you want to add.

14. Click Add Selected Media.

15. Click Done to close the window.

Deleting an Event

You can also delete an Event. This deletes only the Event, not the media in your Catalog.

1. In Organizer, click the Events view.

2. If necessary, click the Events/Smart Events option to Events. You cannot edit Smart Events.

3. Double-click an Event photo stack to open it.

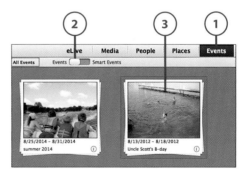

4. Scroll through the media and click the media you want to delete.

5. Click Remove.

6. In the Confirm Media Removal window click OK.

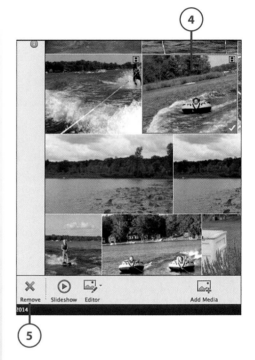

Setting Information Tags

The Information tab of the Tags/Information panel lets you set tags, too. It is divided into three categories: General, Metadata, and History. Each of these categories provides information about your photos. You can apply Information tags in the General category to further organize and manage your media. You can type whatever you like for an information tag.

1. In Organizer, click the Media view.

2. Click to select a photo in the Viewer.

3. If necessary, click the Tags/Info button in the taskbar to display the Tags and Information panel.

4. Click the Information tab.

5. Click the Show/Hide triangle to the left of the General category to expand this category.

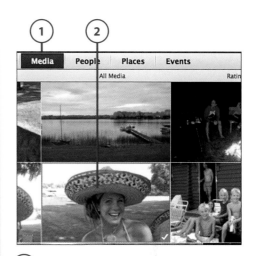

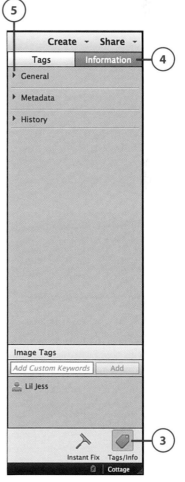

6. Click in the Caption field and type your caption. This can be whatever you like.

7. To change the filename, click the Name field and change just the filename, leaving the extension as it is. Do not delete or change the file extension because this will create problems with Photoshop Elements recognizing this photo.

8. Click in the Notes field to type more information about the photo.

9. Click the star icon in the Ratings to apply a star rating of 1 to 5.

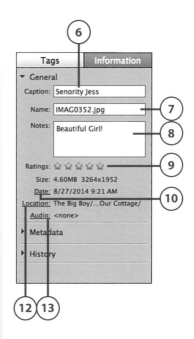

Apply Ratings to Multiple Photos

To apply a rating to multiple photos at once, you first must select all the photos to apply the rating. Then, right-click one of the selected photos and choose Ratings, and set the star rating.

10. Click the Date link to change the date.

11. In the Adjust Date and Time window, click one of the three options and then click OK.

12. Click the Location link to change the media file location on your computer's disk drive.

13. Click the Audio link to attach an audio file as an audio caption to your media.

14. In the Select Audio File window, click File, and then click Browse to browse for an audio file to attach to the selected media.

15. Click the Play controls to play the audio.

16. Click the Volume slider to adjust the volume playback for the audio file.

17. Click the Open Keywords Tag button to attach a keywords tag to the audio file.

18. Click a Keyword category.

19. Click Add a Person to add a People tag.

20. In the Add a Person window type a People tag. If this is an existing People tag, Organizer displays matches as you type.

21. Click Add to attach the tag.

22. Repeat step 21 to add another People tag or click the Close button to close the Add a Person window.

23. Click the Close button to close the Select Audio File window.

24. If you are using a PC, you will see one more window confirming the addition of the new audio caption. Click Yes to close this window.

Apply Multiple Tags to Multiple Photos

You can also apply multiple tags to a selection of multiple photos. To do this, select the photos you want to tag. In the Information tab click the Edit IPTC Information button. IPTC stands for International Press Telecommunications Council. They created this metadata scheme to standardize the transfer of basic metadata values from IPTC fields, which photography equipment uses for tagging photos, into the XMP fields and framework that most photo library and cataloging software use for metadata tags. In the Edit IPTC information window, set your settings and click Save.

Viewing Metadata Attached to a Photo

At times you will need to review what metadata has been attached to your media. You can do this through the Information tab of the Tags and Information panel.

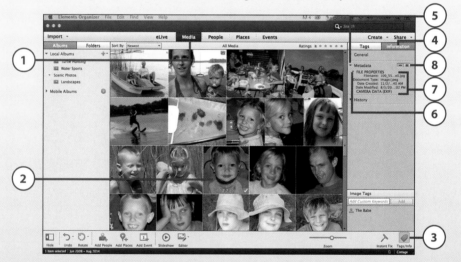

1. In Organizer, click the Media view.

2. Click to select a photo in the Viewer.

3. If necessary, click the Tags/Info button in the taskbar to display the Tags and Information panel.

4. Click the Information tab.

5. Click the Show/Hide triangle to the left of Metadata category to expand this category.

6. Click the Show/Hide triangle to the left of File Properties subcategory to expand this subcategory.

7. Review the Metadata information; by default, this is displayed in the Brief view.

8. Click the Complete button to see the complete view of all metadata attached to your selected media.

Viewing the History of a Photo

Another nice feature of Organizer is to view the history of a media file. For instance, if you need to review when a media file was last edited, you can view this information in the History category of the Information panel.

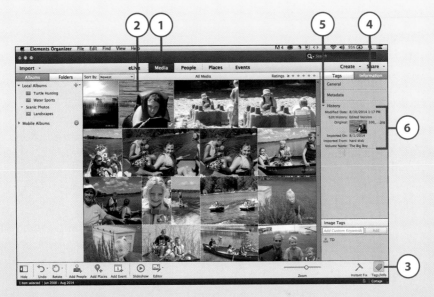

1. In Organizer, click the Media view.

2. Click to select a photo in the Viewer.

3. If necessary, click the Tags/Info button in the taskbar to display the Tags/Information panel.

4. Click the Information tab.

5. Click the Show/Hide triangle to the left of the History category to expand this category.

6. Review the History information.

Applying Ratings

Organizer has a star rating system to help you organize and manage your digital media. You can apply a rating to your photos based on 1 to 5 stars.

1. In the Viewer, click to select the media you want to rate.

2. Choose Edit, Ratings, and select a star rating.

Apply Ratings in General Category of Information Tab

You can also use the Tags and Information panel to apply ratings to your media. This was covered in "Setting Information Tags" earlier in this chapter.

Finding Photos

After you have your photos organized through albums, folders, and have attached metadata, you can easily find individual photos or groups of photos and videos in the active Catalog. You can find your media through a variety of ways, based on People, Places, or Events, and through the star rating you applied. You can also find media through Information tags that were applied. Restrict your photos to search based on an album or a folder, or search your entire Catalog. You can also sort your photos in the Viewer based on different criteria, such as the date the photo was taken or the batch number.

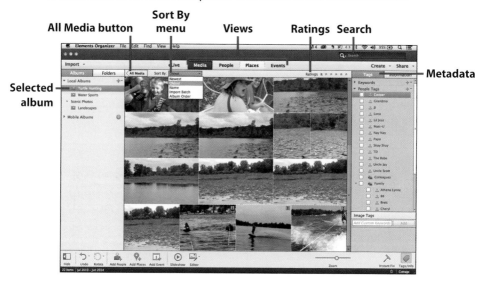

Using Search

Organizer has a Search feature that finds media based on your search term. You can type a keyword or phrase into the Search field and then search your entire Catalog of media for any photos that match the search.

1. Click the Search field.

2. Type a keyword or phrase, or type a person's name, a place, or an event. Organizer displays a drop-down menu with matches for any existing metadata. Click a menu match.

3. Press Return (Mac) or Enter (PC) to initiate the search.

4. The Viewer displays the media that matches the search criteria. Click the Sort By menu to organize the Viewer media based on Date, Name, or Import Batch.

Finding People, Places, and Events

You can manually find a photo or video in the Viewer. Based on whether you are looking at all your media or have selected an album or folder, you can then narrow the range of media the Viewer displays by clicking one of the four views: Media, People, Places, or Events.

1. In Organizer, click an album or folder from the Album or Folders panel. If you want to search through your entire Catalog of media, click the All Media button.

2. Click a view.

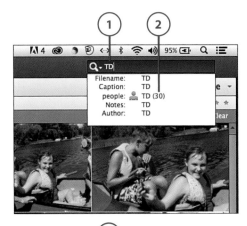

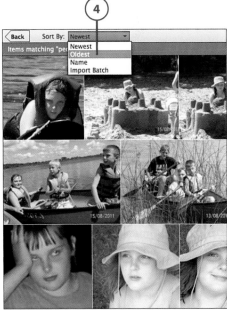

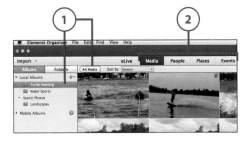

Finding Media Through Metadata

You can also use the Metadata tags in the Tags tab of the Tags/Information panel to find certain photos that have Metadata tags attached to them.

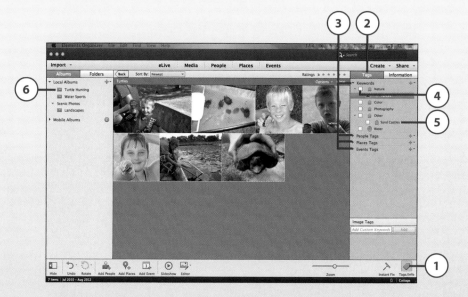

1. In Organizer, display the Tags and Information panel by clicking Tags/Info from the taskbar.

2. If necessary, click the Tags tab.

3. Choose the keyword category(s) for the search by clicking the Show/Hide triangle to the left of the four keyword categories.

4. Click a check box (or boxes) next to a category or subcategory. This is a new feature of Photoshop Elements 13.

5. Narrow your search by clicking other categories or subcategories.

6. Narrow your search further by clicking an album or folder.

Using Ratings to Find Media

If you have applied ratings to your media, you can quickly display photos based on the rating, 1 to 5 stars. You can even apply logic, such as greater than or less than, to further manipulate the criteria of your search.

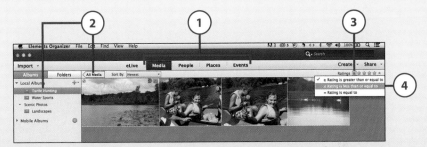

1. In Organizer, click a view.

2. Click the album or folder to search. To search your entire Catalog of media, click All Media.

3. Click the Greater Than or Equal To button.

4. Choose the search criteria from the menu. The default is Greater Than or Equal To.

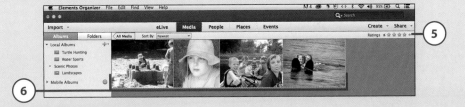

5. Click a star icon to set the star rating.

6. The Viewer displays all pictures with that star rating based on your criteria.

Using Menu Commands to Find Media

Organizer has a Find menu that offers other ways to search for your media. You can perform a multiple criteria search, for instance, and search for media based on a filename that contains only certain letters or partial names and has a 4-star rating. You can also find media that might not have been analyzed by the Auto-analyzer or find doubles of any media. The Find menu commands search your entire Catalog and are quite robust!

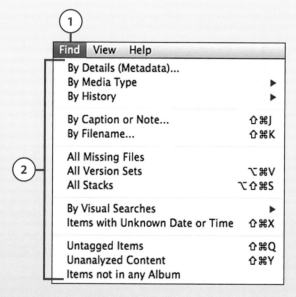

1. Choose Find from the menu bar.

2. Choose one of the search commands in the menu.

 • **By Details (Metadata)**—Create multiple criteria searches.

Metadata Search Categories

The By Details search command in the Find menu of the menu bar is a very detailed search. You can create multiple criteria for your search based on people, places, events, filename, file type, tags, albums, notes, author, capture date, camera model, shutter speed, and F-stop.

 • **By Media Type**—Search by media type of photos, video, audio, projects, PDFs, or items with audio captions.

- **By History**—Search based on a history of actions you have applied to your media. You can search based on actions for importing, exporting, emailing, ordering, or sharing.

- **By Caption or Note**—Search by caption or note. You can use partial words or phrases or one specific word.

- **By Filename**—Search by Filename. Search by one word or partial words.

- **All Missing Files**—Find media that has a missing link or a broken link to the file on your disk drive.

- **All Version Sets**—Find media that you have edited or modified in the Photo Editor or another external photo editor.

- **All Stacks**—Search based on photo stacks that you created.

- **By Visual Searches**—Search your media based on visually similar photos or videos, objects in a photo, or find duplicate photos.

- **Items with Unknown Date or Time**—Find media with unknown dates or times in the metadata info.

- **Untagged Items**—Find all media that have not been tagged with any metadata.

- **Unanalyzed Content**—Find media that have not been analyzed by Auto-analyzer.

- **Items Not in Any Album**—Find media not associated with an album.

Cropping in
progress

Instant Fix option

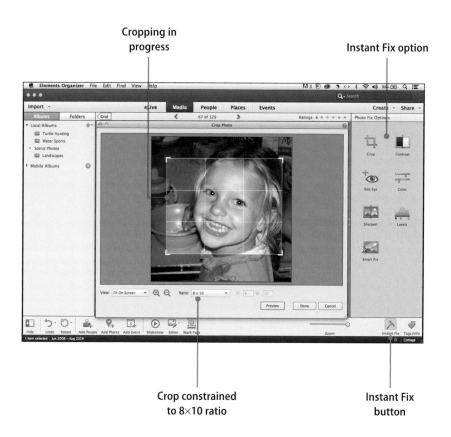

Crop constrained
to 8×10 ratio

Instant Fix
button

This chapter covers how to fix common photography problems, such as blurry photos, color issues, and red eye using the Instant Fix options of Elements Organizer. You also learn how to crop and resize your photos. Topics include the following:

→ Applying the Smart Fix photo fix option to fix multiple problems in a photo
→ Applying the Contrast photo fix option to increase contrast in your photo
→ Fixing red eye in a photo using the Red Eye photo fix option
→ Adjusting color in your photo using the Color photo fix option
→ Sharpening an image using the Sharpen photo fix option
→ Applying levels to your photo to adjust the luminance in your photo

Editing Photos with Organizer

Adobe Photoshop Elements 13 has photo-editing capabilities. Both components, Organizer and Photo Editor, have options for modifying and fixing blemishes and camera problems that can occur in a photo. This chapter covers the photo-editing features of Organizer. You can quickly crop and resize a photo, as well as rotate any photo in your Catalog. You can fix red eye, change the contrast, sharpen a photo, and correct image levels and color. Organizer has an Instant Fix pane that contains all the photo fix options.

Applying Instant Fixes

You can access the Instant Fix options in the Instant Fix pane of Organizer. Similar to how you access the Tags and Information panel through the Tags/Info button in the taskbar, you access the Instant Fix pane through the Instant Fix button. There are seven photo fix options for applying instant fixes to your photos in Organizer. Each option is used to fix a specific problem that can occur in your photos. You can apply Instant Fixes to the photo through the thumbnail in the Viewer, as well as in Preview mode.

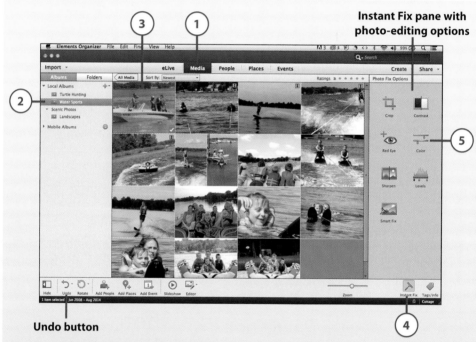

Instant Fix pane with photo-editing options

Undo button

1. In Organizer, click the Media view.

2. If necessary, click an album or folder to locate your photo for editing.

3. In the Viewer, click to select the photo you want to edit. You can use Shift-click or Command-click (Mac)/Control+click (PC) to select a group of photos.

4. Open the Instant Fix panel by clicking Instant Fix in the taskbar.

5. In the Instant Fix pane click a photo fix option.

Close the Instant Fix Pane

You can close the Instant Fix pane by clicking the Instant Fix button again in the taskbar. It is a toggle button; click once to open, click again to close.

6. Organizer analyzes the photo, and the fix is applied instantly to the photo. The photo thumbnail now displays an icon in the upper-right corner indicating that the photo has been edited with an Instant Fix option.

Undoing Instant Fixes

Instant Fix options are programmed to fix common problems in photos. Each option is programmed to apply a set of corrections to the photo based on the analysis that Organizer performs on the photo. Typically, this fix improves the photo, but at times you might like the original photo better. To undo an Instant Fix, click the Undo button in the taskbar or choose Edit, Undo from the menu bar.

If you click the triangle to the right of the Undo button, you can access the Redo button. The Redo button undoes the most recent Undo action you initiate. In others words, it is an undo for the Undo button.

Applying Instant Fixes to a Photo in Preview

Applying Instant Fixes to the photos in thumbnail view in the Viewer is great for quickly correcting one or multiple photos at once. But sometimes, you need a better view of a photo for determining what photo fix options work the best on the photo. Viewing the photo in Preview can help you see how the fix has changed your photo.

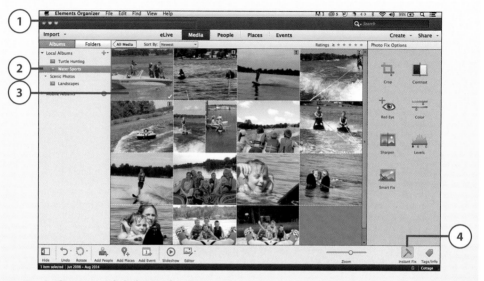

1. In Organizer, click the Media view.

2. If necessary, click an album or folder to locate your photo for editing.

3. In the Viewer, double-click a photo to open it in Preview.

4. If necessary, open the Instant Fix panel by clicking Instant Fix in the taskbar.

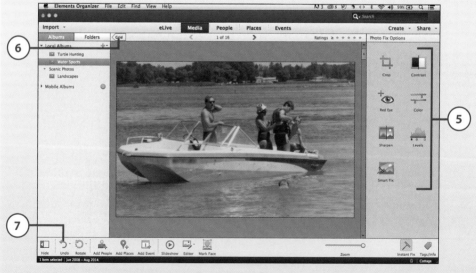

5. The photo displays in Preview. In the Instant Fix pane, click a photo fix option.

6. Examine the fix applied to the photo; if it is what you want, click the Grid button to return to the Viewer display of thumbnails.

7. If you want to undo the fix, click the Undo button.

Applying Multiple Instant Fixes

You can apply multiple Instant Fixes to a photo. To do this, click the Photo Fix option that you need and then click another from the Instant Fix pane. You can also apply the same photo fix option multiple times to a photo to further edit your photo.

Creating Version Sets

When you apply the Instant Fix option, Organizer creates a version set. A version set is a special photo stack composed of two photos that are linked based on an Instant Fix option. The modified photo is first and then the original photo is second in the version set photo stack. The optimized photo is the profile image for the stack.

If you apply another Instant Fix option to the photo, the version set still consists of two photos; the modified photo is updated a second time.

Using Smart Fix

The Smart Fix option applies all the Instant Fix options to the photo. This is perhaps the best Instant Fix option to apply first, because it should fix any problems based on color, contrast, balance, poor exposure, and color saturation. Organizer analyzes the photo for these problems and then applies a Smart Fix to correct the problem areas it identifies. It creates a copy of the original photo and saves this in the version set with the modified photo.

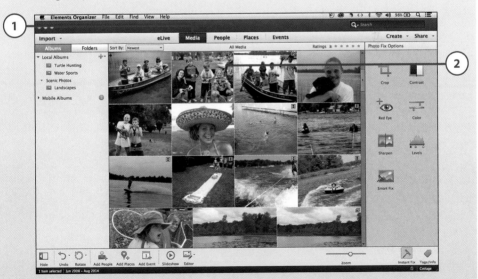

1. Click the Media view.

2. Locate the photo to edit and either click to select a thumbnail in the Viewer or double-click a thumbnail to open it in the Preview mode.

3. If necessary, click Instant Fix in the taskbar to open the Instant Fix pane.

4. Click the Smart Fix option.

5. Organizer displays a message window. If necessary, click Abort to cancel the Smart Fix.

6. Review your photo with the new fix applied. If you do not like it, click Undo to return to the original photo.

Apply an Instant Fix Multiple Times

Sometimes you might want to apply an Instant Fix option again to see whether a second enhancement might clear up an issue that still exists. Each time you click, the photo is analyzed and the fix applied again. This can result in the issue being fixed, and it can also start to degrade the quality of the image. Always review the results of the Instant Fix carefully to make sure the fix doesn't lower the visual quality of the image.

>>>*Go Further*

WORKING WITH VERSION SETS

The Organizer has menu commands just for working with version sets that are created as you apply Instant Fix options. You cannot be in the Adaptive Grid view in the Viewer to work with version sets. To turn this off and return to the legacy Viewer display, choose View from the menu bar, and then click Details. Select a version set photo stack and from the menu bar choose Edit, and then click Version Set. Choose a version set submenu command. You can also access these version set menu commands by right-clicking a version set and choosing Version Set from the contextual menu. You use the Version Set commands in either the Viewer or in the Preview mode. Here is an overview of each version set command.

Submenu

- **Expand Items/Collapse Items in Version Set**—Expand Items command expands the two photos in the version set. They display as thumbnails in the Viewer. If you open the Version Set in the Preview mode, click the Forward or Backward buttons to see both photos in the version set; the modified one is first and the original is second in the stack order. Collapse the expanded version set with the Collapse Items in Version Set command.

- **Flatten Version Set**—This command flattens the version set into just the modified photo.

- **Convert Version Set to Individual Items**—Choose this command to make individual photos of the two photos in the version set, adding them to your Catalog.

- **Revert to Original**—Use this command to revert an optimized photo back to its original version, disregarding the modified photo.

- **Remove Item(s) from Version Set**—Use this command to remove one of the two photos from a version set. This keeps the version set, but it is only composed of one photo.

- **Set Has Top Item**—When you have expanded a version set, choose one of the two photos to make it the profile picture of the special photo stack. Then choose the Set as Top Item command.

Tagging Photos in Version Sets

You can apply tags to photos in a version set or to the version set itself. To attach a tag to the version set, select the thumbnail in the Viewer and attach a tag. The tag is attached to both photos in the version set. To attach the tag to the photos in the version set, expand the version set by selecting it in the Viewer; from the menu bar choose Edit, Version Set, Expand Items in Version Set. Then tag each photo as you like. This lets you attach a different tag to each photo in the version set.

Cropping Photos

The most popular technique used in photo editing is cropping. Cropping is a way to zoom in on the part of the photo image you want to keep, and then cut away or crop out the unwanted areas of the photo. Organizer lets you crop a photo to whatever size you want. It creates a copy of the original photo and saves this in the version set.

1. Click the Media view.

2. If necessary click Instant Fix in the taskbar to open the Instant Fix pane.

3. Locate the photo to edit and double-click a thumbnail to open it in the Preview mode. You cannot crop a photo thumbnail image.

4. Click the Crop option.

5. The Crop Photo window displays with crop marks. Click the View menu and zoom in or out of the image.

6. You can also use the Zoom In/Zoom Out tools to adjust the zoom on the photo. Click either tool and then click in the photo to zoom in or out based on which tool you selected.

7. To constrain the crop marks to a set ratio, such as 4×6, click the Ratio menu to select a ratio menu option.

8. Click in the crop area and drag to position it to focus on the image in the photo. Grid lines display to help you position the crop area where you need for your photo.

9. Click anywhere on the border of the crop area and drag to adjust the size of the cropping area. If you click a corner border, you can adjust both the width and the height of the crop area.

10. Click Preview to see a preview of your crop.

11. Click Done to crop the photo and close the Crop Photo window. You can also double-click in the crop area to apply the crop.

12. Click Cancel if you need to cancel out of the crop.

Setting Your Dimension for a Cropping Area

If you need to set a custom area as your cropping area, you can do this through the Ratio menu and the Width and Height fields. Click the Ratio menu and choose Custom Ratio from the pop-out menu. Then type a custom ratio in the W (Width) and H (Height) fields, such as 10×12.

Rotating Photos

You can also rotate the orientation of your photos by 45 degrees, either clockwise or counterclockwise. You can do this either in the Viewer to a thumbnail or in the Preview mode.

1. Click the Media view.

2. Locate the photo to rotate and either click to select a thumbnail in the Viewer or double-click a thumbnail to open it in the Preview mode.

3. Click Rotate in the taskbar. The photo rotates 45 degrees to the left, or counterclockwise.

4. To rotate a photo to the right, or clockwise, click the triangle to the right of the Rotate button to display the Right Rotate button.

5. Click the Right Rotate button.

6. Click either the Left or Right Rotate button to rotate another 45 degrees.

Adjusting Contrast

You can also adjust the contrast in a photo. Contrast is the difference between light and dark areas in your photo. You can increase or decrease the contrast to enhance your image. Organizer analyzes the photo and fixes the contrast. It creates a copy of the original photo and saves this in the version set with the modified photo.

1. Click the Media view.

2. If necessary, click Instant Fix in the taskbar to open the Instant Fix pane.

3. Locate the photo to edit, and either click the thumbnail in the Viewer to select it or double-click a thumbnail to open it in the Preview mode.

4. Click the Contrast option.

5. Review your photo with the new fix applied. If you do not like it, click Undo to return to the original photo.

Fixing Red Eye

Another common problem that can occur in a photo is the red eye effect, which can occur when people have a photo taken and their eyes have a red glow. This happens often to blue-eyed people. You can fix this problem with the Red Eye option. This option analyzes the photo for any images with red eye and then corrects the problem. It creates a copy of the original photo and saves this in the version set with the modified photo.

1. Click the Media view.

2. If necessary, click Instant Fix in the taskbar to open the Instant Fix pane.

3. Locate the photo to edit and either click the thumbnail in the Viewer to select it or double-click a thumbnail to open it in the Preview mode.

4. Click the Red Eye option.

5. Organizer applies the Red Eye fix to the photo and a window opens. Click OK to close the window.

6. If you do not want this window to show again when you apply a Red Eye fix, click the Don't Show Again check box, and then click OK.

7. Review your photo with the new fix applied. If you do not like it, click Undo to return to the original photo.

Adjusting Color

You can also adjust the color in a photo; for example, a photo might have a yellow tint or a washed-out look. Organizer uses an RGB (Red, Green, Blue) color mode for photos. The Color option analyzes the photo and adjusts each of these three colors to make your photo brighter or more even in color. It creates a copy of the original photo and saves it in the version set with the modified photo.

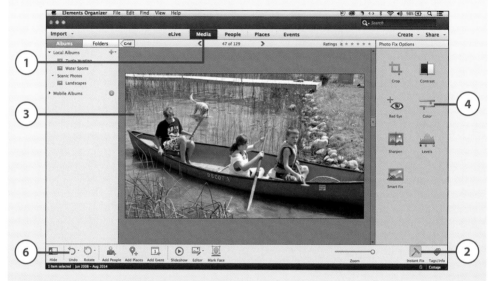

1. Click the Media view.

2. If necessary, click Instant Fix in the taskbar to open the Instant Fix pane.

3. Locate the photo to edit and either click the thumbnail in the Viewer to select it or double-click a thumbnail to open it in the Preview mode.

4. Click the Color option.

5. The Auto Color window opens. Organizer analyzes the photo and then applies the Color fix to the photo. If necessary, click Abort to cancel this fix.

6. Review your photo with the new fix applied. If you do not like it, click Undo to return to the original photo.

Using Sharpen

Another common problem with photography is photos that are blurry. You can sharpen a blurry photo with the Sharpen option. The Sharpen option analyzes your photo and then sharpens it. It creates a copy of the original photo and saves it in the version set with the modified photo.

1. Click the Media view.

2. If necessary, click Instant Fix in the taskbar to open the Instant Fix pane.

3. Locate the photo to edit and either click the thumbnail in the Viewer to select it or double-click a thumbnail to open it in the Preview mode.

4. Click the Sharpen option.

5. Organizer applies the Sharpen fix to the photo and a window opens. If necessary, click Abort to cancel this fix.

6. Review your photo with the new fix applied. If you do not like it, click Undo to return to the original photo.

Adjust Image Levels

You can also adjust the image color levels with the Levels option. The Levels option analyzes your photo for problems with luminance and then adjusts the image levels. This option is good for correcting overexposed or underexposed photos. The Levels option also creates a copy of the original photo and saves this in the version set with the modified photo.

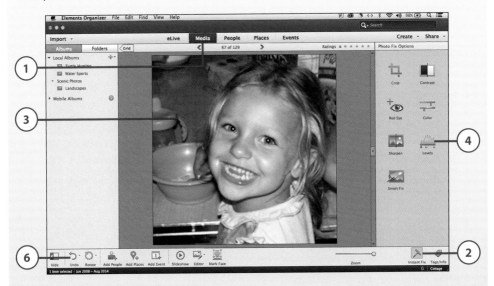

1. Click the Media view.

2. If necessary, click Instant Fix in the taskbar to open the Instant Fix pane.

3. Locate the photo to edit and either click the thumbnail in the Viewer to select it or double-click a thumbnail to open it in the Preview mode.

4. Click the Levels option.

5. Organizer applies the Levels fix to the photo and a window opens. If necessary, click Abort to cancel this fix.

6. Review your photo with the new fix applied. If you do not like it, click Undo to return to the original photo.

Views Quick mode Adjustments pane

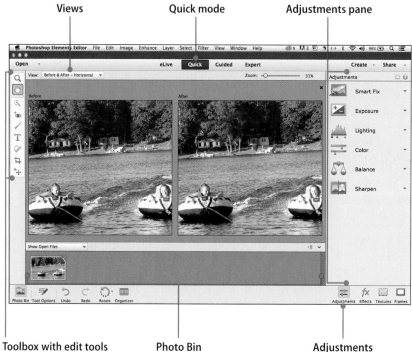

Toolbox with edit tools Photo Bin Adjustments

In this chapter, you learn how to apply quick fixes to a photo in the Quick mode of the Photo Editor. The tools and adjustments are covered. You also learn how to save a photo that you edited in the Photo Editor. The Preference options for tools and saving a file are also covered.

6

→ Applying Quick mode fixes and edits to a photo
→ Opening and saving a photo in the Photo Editor
→ Applying adjustments to a photo in the Quick mode of the Photo Editor
→ Customizing Preferences that control tools, saving functionality and type.

Applying Quick Fixes with the Photo Editor

This chapter covers how to edit a photo in the Quick mode of the Photo Editor. Many of the tools, functions, and features are similar to the Instant Fix tools of the Organizer, but the Photo Editor has even more tools, functions and features for editing and enhancing your photos. This chapter looks at how to use the Quick mode and its tools that can quickly fix blemishes or problems in a photo. Also covered is how to apply Adjustments to fix common problems that occur in photography and to enhance the photo image.

Editing Modes of the Photo Editor

The Photo Editor of Photoshop Elements 13 is very powerful and offers many options for getting just the right look for all your photos. It allows you to edit the entire photo, or just a selection in the photo, and quickly apply enhancements, modifications, and edits. There are three modes: Quick, Guided, and Expert. Each mode offers tools, features, and functions for editing and enhancing your photos. This chapter covers the Quick mode and how to apply quick fixes.

1. Open the Photo Editor. (See Chapter 1, "Getting Comfortable with the Photoshop Elements 13 Workspace, Preferences, and Settings," to learn how to open the Photo Editor.)

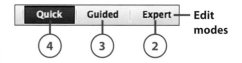

2. To access the Expert mode, click the Expert mode.

3. To access the Guided mode, click the Guided mode.

4. To access the Quick mode, click the Quick mode.

Which Mode Should I Use?

If you are new to Photoshop Elements and the Photo Editor, the Quick or Guided modes are a good place to start for your photo edits and enhancements.

Opening a Photo in Photo Editor

1. Open the Photo Editor.

2. Click the Quick mode.

3. To open a photo in the Photo Editor, click the File menu and choose one of the following menu commands:

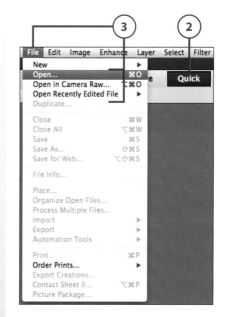

 - **Open**—Open a file from your disk drive, camera, external drives, or flash drive.

 - **Open in Camera Raw**—Open a camera raw photo from your disk drive, camera, external drives, or flash drive. (See Chapter 11, "Processing Photos in Camera Raw.")

 - **Open Recently Edited File**—Open a file that you have recently worked on in Photo Editor.

Open a Photo from Organizer

If you are working in Organizer, you can select a photo or group of photos and then open them in the Photo Editor. Select the photo(s) that you want to edit in the Organizer Viewer and click the Editor button in the taskbar.

You can also click the triangle to the right of the Editor button and choose Photo Editor from the pop-out menu.

4. If you choose the Open or Open in Camera Raw command, the Open window displays. Navigate to the file you want to open, and click it.

5. Click Open to open the photo.

How Organizer Handles Editing of Photos

When you open a photo in the Photo Editor that is in your Organizer Catalog, that photo is no longer accessible in Organizer. It displays with a red strip and a lock icon indicating that that photo is being edited in the Photo Editor. This photo cannot be modified or accessed in Organizer until it is closed from the Photo Editor.

Workspace of the Photo Editor

In Chapter 5, "Editing Photos with Organizer" you learned how to make quick edits to your photos in Elements Organizer. Now let's look at how to use the Photo Editor to make quick edits. The Quick mode of the Photo Editor is designed just for this—quick fixes. It has a workspace composed of tools, a Photo Bin, the Adjustments pane, Effects, Textures, Frames, different Views for the Viewer, and various Tool Options easily accessible for quickly applying precise enhancements, edits, and modifications to your photos. Open a photo in the Photo Editor to work through the following instructions.

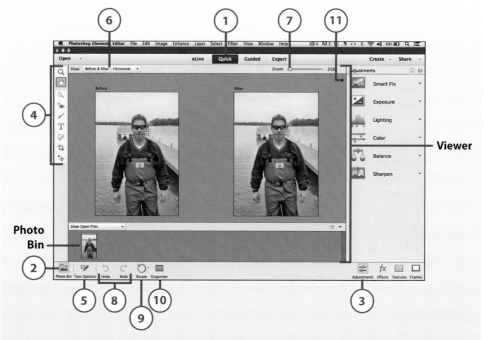

1. When you first open the Photo Editor, the eLive view is the default display mode. Click Quick mode to access the Quick mode.

2. To display the Photo Bin, click Photo Bin in the taskbar.

3. To display the Adjustments pane, click Adjustments in the taskbar.

4. To choose a tool, click it from the Toolbox.

5. When you choose a tool, the Tool Options bar for the selected tool displays. If you want to close the Tool Options bar, click Tool Options from the taskbar.

Tools Display Last Tool Selected

When you start using the tools in the Toolbox, you might find that the icons for the tools change. This is due to the sticky interface of Photoshop Elements. Many tools in the Toolbox have a few different Tool Options that you can select. For example, the Quick Selection tool has the Quick Selection tool, the Selection Brush, and the Refine Selection Brush as Tool Options. If you last used the Refine Selection Brush, the icon for the Quick Selection tool in the Toolbox will be the icon for the Refine Selection Brush. This can be confusing at first, but the more you use the Photo Editor, the more familiar you'll become with the tools in the Toolbox and their Tool Options.

6. Click the View menu to display a different view of the photo in the Viewer.

7. To view the opened photo in a smaller or larger size in the Viewer, click and drag the Zoom slider.

8. To Undo or Redo a change, click Undo or Redo in the taskbar.

9. To rotate a photo in the Viewer, click Rotate in the taskbar.

10. To launch or return to Organizer, click Organizer in the taskbar.

11. To close the photo you are editing in the Photo Editor, click the Close button.

Working with the Quick Mode Tools

The Quick mode tools in the Toolbox let you edit and modify your photos. The difference between these tools and the Instant Fix options in the Organizer is that the Photo Editor's tools are more powerful in what and how they fix your photos, and you have more tools and Tool Options as well. You also can select an area in the photo and apply the tools to just that area, leaving the rest of the photo untouched. This section covers each of these tools.

ToolTips

Hover your mouse over a tool in the Toolbox and you'll see a ToolTip identifying the tool and the keyboard shortcut that you can use to access the tool. You can turn the ToolTip on or off in the Photo Editor General preferences, as well as require that the Shift key be used for the keyboard shortcuts. This is covered later in this chapter.

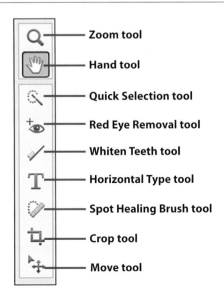

Zoom tool

Hand tool

Quick Selection tool

Red Eye Removal tool

Whiten Teeth tool

Horizontal Type tool

Spot Healing Brush tool

Crop tool

Move tool

Sticky Interface

The Photo Editor remembers the workspace layout and the last tool that you accessed each time it is opened. For instance, if you were using the Horizontal Text tool with the Tool Options bar displayed and then closed out of the Photo Editor, the next time you open the Photo Editor, the Horizontal Text tool is selected and the Tool Options bar is displayed.

Using the Zoom Tool

The Zoom tool lets you zoom in and out of your photo. Zooming in lets you see the photo details at a larger size to help you apply a precise edit. Zooming out lets you see the entire photo image to make an overall adjustment or modification to the photo. There are a few techniques you can use to Zoom in or out of your photo in the Viewer.

1. Click Quick mode.

2. Click the Zoom tool.

3. The Tool Options bar displays, with the Zoom In option selected.

4. Click anywhere in the photo to zoom in. Click multiple times to zoom in more.

5. Click the Zoom Out option.

6. Click anywhere in the photo to zoom out. Click multiple times to zoom out more.

7. Click and drag the Zoom slider to manually zoom in and out of the photo.

8. Click the Zoom Percentage box and type in a set percentage.

9. Click one of the Size buttons to resize the photo display to the indicated size.

Use Keyboard Keys for Zooming In or Out of a Photo

When you have the Zoom tool selected, you can switch between the Zoom In and the Zoom Out options by pressing the Command (Mac)/Control (PC) key on your keyboard to Zoom In and the Option (Mac)/Alt (PC) key to Zoom Out. Move your cursor into the photo while holding down either key and then click to initiate the zoom.

Designate an Area for the Zoom

The Zoom tool lets you select an area that you immediately zoom in on through clicking and dragging. With the Zoom tool, click and drag out a rectangle that encompasses an area in the photo. When you release the drag, this selected area fills the Viewer, letting you focus on that area of the photo to make your edits and modifications.

Use the Hand Tool

The Hand tool lets you move around in the photo. It is a great tool to use with a photo that you have zoomed in on. You can use it to move the photo so you can see other areas of the photo that are outside of the zoom area of the photo.

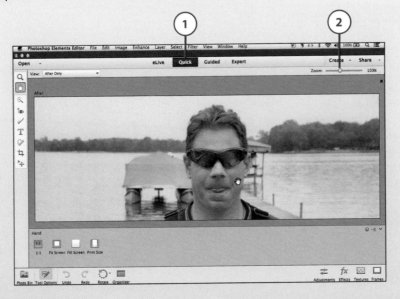

1. Click Quick mode.

2. Click the Zoom slider and zoom in on the photo by dragging to the right.

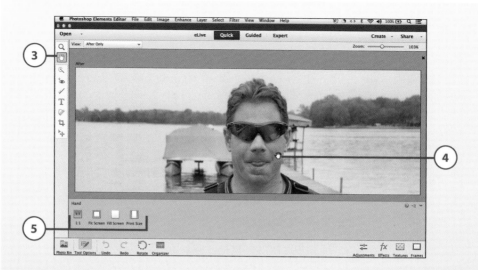

3. Click the Hand tool.

Access the Hand Tool Anytime with a Keyboard Shortcut

You can activate the Hand tool anytime, no matter what tool you have active, by pressing and holding the spacebar on your keyboard. Then click and drag in the photo to move it around.

4. Click anywhere in the photo and drag left, right, up, or down to move the photo so that a new area of the photo displays.

5. Click any of the Hand options in the Tool Options bar to immediately go to that display size.

Quickly Return to Full-Size Photo Display in Viewer

You can quickly return to the full photo display by double-clicking the Hand tool. You also can click the Fit to Screen button in the Tool Options bar or choose View, and then Fit On Screen from the menu bar.

Use the Quick Selection Tool

The Quick Selection tool lets you select an area or multiple areas in a photo. You can choose from three Quick Selection tools when you select the Quick Selection tool from the Toolbox. These three tools are found in the Tool Options bar: the Quick Selection tool, the Selection Brush tool, and the Refine Selection Brush tool. These selection tools are to be used together and in a sequence for precisely defining a selection. The Quick Selection tool is to be used first to quickly define the selection area. Then the Selection Brush tool is used to refine and tighten the selection area. The third tool, the Refine Selection Brush tool is used to finalize the selection by refining the edges of the selection even more so that your area is precisely defined. Each of these Quick Selection tools has its own Tool Options and settings.

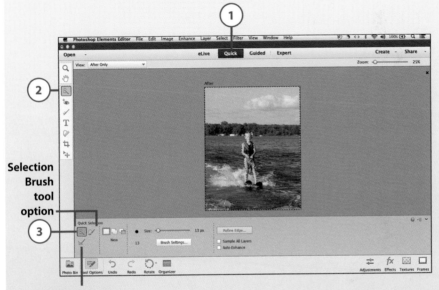

Selection Brush tool option

Refine Selection Brush tool option

1. In the Photo Editor, click Quick mode.

2. Click the Quick Selection tool.

3. The Tool Options bar displays. If the Quick Selection Tool Option is not selected, click it.

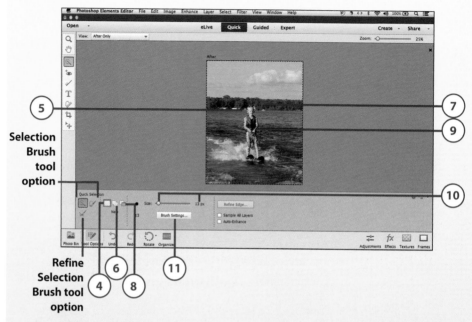

Selection
Brush
tool
option

Refine
Selection
Brush tool
option

4. In the Tool Options bar, click the type of selection you want to use. By default, the New Selection option is selected. After you make a selection in the photo, the Add to Selection option automatically becomes selected.

Use Keyboard Keys for Adding or Subtracting from a Selection

To save time, if the Add to Selection option is active, you can toggle to the Subtract from Selection option by pressing the Option (Mac)/Alt (PC) key on your keyboard. When you release the key, the Photo Editor switches back to the Add to Selection option.

5. Click and drag across an area in your photo. It is outlined with a Marquee that is commonly referred to as the "marching ants." You can also just click in an area to select a smaller area.

6. To add to the selection, click the Add to Selection option.

7. Click and drag an area in the photo that is not included in the selection to add it to the selection.

8. To subtract an area from an existing selection, click the Subtract from Selection option.

9. Click and drag through an area of the photo that is already selected to subtract that area from the selection area.

10. Click the Size slider and drag left or right to decrease or increase the size of the brush tip for the Quick Selection tool. You can also click in the size field and type a set size.

11. Click the Brush Settings button to adjust the brush settings.

12. This displays the Brush Settings window. Click the Hardness slider to adjust the hardness of the selection tool. You can also click the Hardness field and type a set percentage. Hardness is basically how tight the selection is to the edge of an area based on the color tones in the image. The larger the number the sharper the edge.

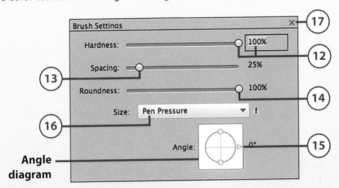

13. Click and drag the Spacing slider left or right to decrease or increase the amount of spacing between similar colors the selection tool recognizes for the selection.

14. Click and drag the Roundness slider left or right to decrease or increase how round the brush tip is of the Quick Selection tool. You'll see the Angle diagram adjust to display the changes you make to the tool.

15. Click the triangle in the Angle diagram and drag it up, down, left and right to reposition the angle of the brush tip.

16. Click the Size menu to set whether you are using a drawing tablet, a stylus pen with a thumb wheel, or a mouse. Choose one of the following three menu options:

 - **Pen Pressure**—Click this option if you are using a pressure-sensitive drawing tablet to control the pressure you use for your selection. The more pressure, the larger the selection brush tip and the larger the area selected. The lighter the pressure, the smaller the Quick Select brush tip and the smaller the selection.

 - **Stylus Wheel**—Click this option to control the pressure if you are using a stylus pen that has a thumb wheel.

 - **Off**—Click this option if you are using a regular mouse for your input method.

17. Click the Close button to close the window and apply the settings to your selection.

Use the Select Menu Commands

The menu bar of the Photo Editor has a Select menu that lets you further manipulate your selections. The Select menu commands can be used with the Quick Selection tool. Choose Select from the menu bar, and then choose a Select menu command. Visit this chapter's online content, found at www.quepublishing.com/title/9780789753809, for more instruction on how to use the Select menu commands.

Using the Selection Brush Tool

After you have a selection area defined with the Quick Selection tool, you can refine that selection using the Selection Brush so that it more precisely outlines your selection area.

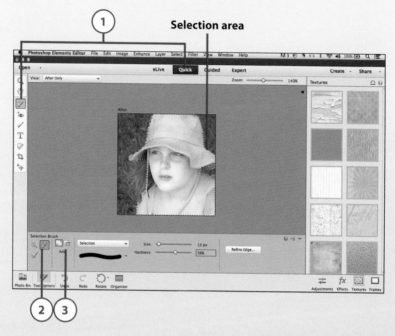

1. In the Photo Editor in Quick mode, make a selection using the Quick Selection tool. See previous topic.

2. With the Quick Selection tool still selected, click the Selection Brush from the Tool Options bar.

3. By default the Add to Selection option is selected. Click this option to select it if it is not.

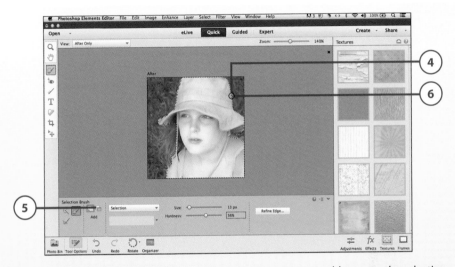

4. Click and drag along the selection edge where you want to add more to the selection to better define the edge.

5. Click the Subtract from Selection option.

6. Click and drag along the selection edge where you want to subtract from the existing selection to better define the selection edge.

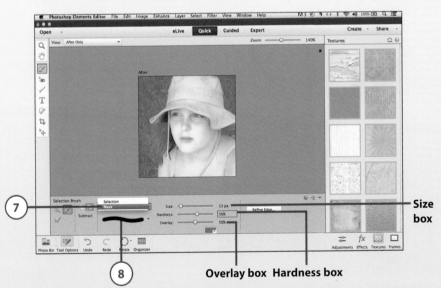

Size box

Overlay box Hardness box

7. Click the Selection menu and choose Mask to view a masking of the selection area in the photo. A red overlay displays over the area not selected, allowing you to focus on your selection.

8. Click the Brush Preset Picker and choose a brush.

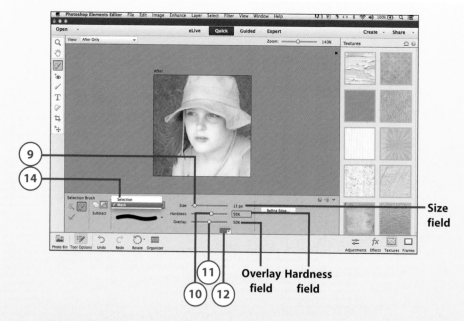

9. Click the Size slider and drag left or right to adjust the size of the Selection Brush tip. You can also click in the Size field and type a pixel size.

10. Click the Hardness slider to adjust the hardness of the Selection Brush tip. You can also click in the Hardness field and type a number.

11. Click the Overlay slider to adjust the opacity of the red overlay mask display. You can also click the Overlay field and type a number.

12. Click the Mask Color palette to choose a new color for the mask.

13. Repeat steps 3–6 to adjust the selection area more precisely.

14. Click the Selection menu and choose Selection to return to the "marching ants" selection display.

Benefit of Color Overlay Mask for Selections

Sometimes it is easier to see what you are selecting and your object's edges for defining the selection if you display the Color Overlay Mask from the Selection menu. When this feature is displayed you see the edge of your selection very clearly.

Using the Refine Selection Brush

The third and final brush that you can use to precisely define and finalize your selection is the Refine Selection Brush. This brush focuses on an already defined selection and lets you push and pull the selection based on the selected object's edges. You can manually guide the tool to snap the selection tighter or looser to the object's edge. It has a special cursor that visually guides you through the process of pushing the selection out or pulling the selection tighter to the selected object's edges.

This tool is new to Photoshop Elements 13.

1. In the Photo Editor in Quick mode, make a selection using the Selection tool. See the previous topic.

2. With the Quick Selection tool still selected, click the Refine Selection Brush option from the Tool Options bar.

3. Set the brush size by dragging the Size slider left or right to adjust the brush tip size. You can also click in the Size field and type a pixel size.

4. Drag the Snap Strength slider left or right to adjust the snap strength of the tool to the object's edge being selected. You can also click in the Snap Strength field and type a percentage number between 1 and 100%.

5. Click the Add to Selection option or the Subtract from Selection option to refine your selection.

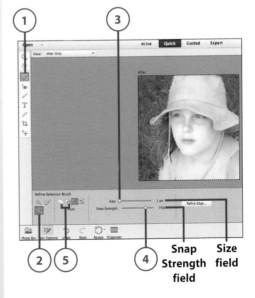

Snap Strength field Size field

6. Click and drag along the edges of your selection to include or de-select fine areas of the selection.

7. To refine your selection, click the Push Selection option.

8. Your cursor displays as an outer gray circle with an inner white circle. Hover your cursor outside the selection, and it displays a minus sign in the middle of the white circle, indicating that it will push the overdefined selection tighter to the object's edge.

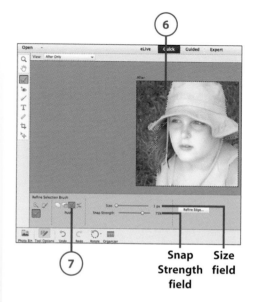

Snap Strength field

Size field

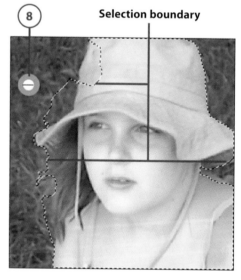

Selection boundary

9. Position your cursor inside the selection, and it displays a plus sign indicating that it will push to expand the underdefined selection to the object's edge.

10. Before you can apply the Push, you need to adjust your brush size so that the outer circle defines the area that needs to be adjusted as the selection boundary to the object's edge.

11. To manually refine an under-defined selection that does not include the entire object, position your cursor inside the selection with the outer circle radius set to the distance of the selection boundary to the object's edge.

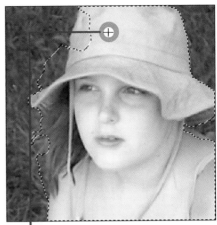

⑨ ⑩ **Outer circle sized from selection edge to object edge**

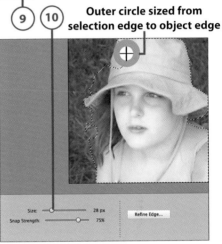

Size: — 28 px
Snap Strength: — 75%
Refine Edge...

⑪

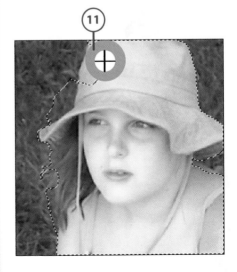

12. Click and drag along the object's edges to apply the Push option. The Push option expands the selection based on the size of the outer circle.

13. To manually refine a selection that extends out too far from the object's edge, position your cursor outside the selection. The inner circle displays a minus sign, indicating that it will push to tighten the overdefined selection to the object's edge.

14. Adjust your brush size so that the outer circle is about the distance of the selection boundary from the object's edge.

15. Click and drag to push the selection to the object's edge.

Let the Photo Editor Refine the Selection

To let the Photo Editor automatically refine the edge using the Refine Selection Brush and the Push option, position the cursor either inside or outside the selection with the outer circle sized to the distance from the selection to the objects edge, and click to push the selection to the object's edge.

Repeat the clicking process, moving your cursor either inside or outside of the selection and clicking until you have the selection boundary redefined. You'll need to adjust the brush size as it controls the size of the outer circle of the Push option cursor. The size of the outer circle is the key to how this tool works. It defines the area that the Photo Editor needs to fine-tune the object's edge. The Photo Editor expands or contracts the selection boundary to the nearest edge.

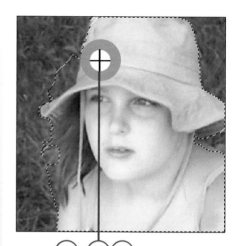

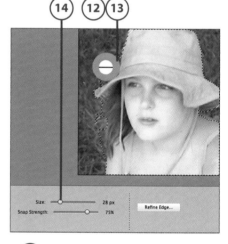

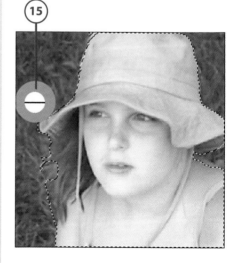

16. Click the Smooth Selection option to smooth out the jagged edges in the selection.

17. Again, click and drag along the edges of your selection to smooth out the edges.

18. Work between all these Refine Selection Brush options to refine your selection to precisely define the object.

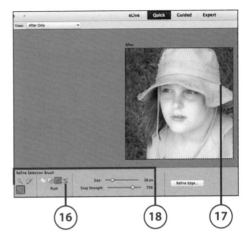

Remove Red Eye

The Remove Red Eye tool in the Photo Editor is similar to the Red Eye Instant Fix option in Organizer in that it instantly removes the red eye effect that sometimes happens in photos. Unlike the Organizer and its Red Eye Instant Fix option, the Remove Red Eye tool can be precisely adjusted to fix a specific area of the affected eye. You can also turn on the Pet Eye option to handle the flare effect that sometimes occurs when taking a pet photo with a flash.

1. Open a photo either from Organizer or from your hard disk in the Photo Editor. See "Opening a Photo in Photo Editor" in this chapter for how to open a photo in the Photo Editor.

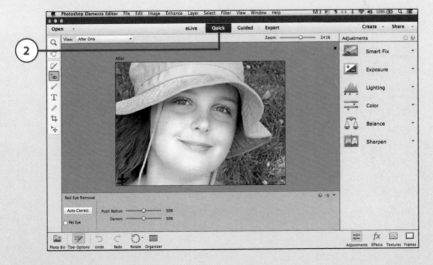

2. Click the Quick mode.

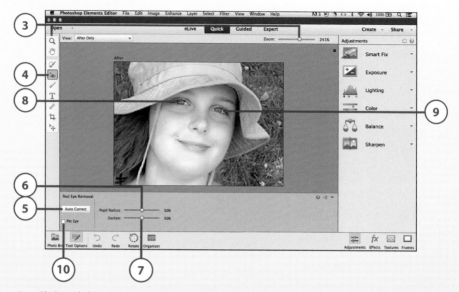

3. Click and drag the Zoom slider right to zoom in on the photo so you can see the eyes clearly. You might need to use the Hand tool to move the photo so that the eyes are shown in the zoomed-in display.

4. Click the Remove Red Eye tool from the Toolbox.

5. To automatically correct the red eye effect, in the Tool Options bar, click Auto Correct.

6. To manually correct the red eye effect, first adjust the Remove Red Eye settings by clicking and dragging the Pupil Radius slider left or right to decrease or increase the size of the brush tip so it is about the same size as the iris of an eye.

7. Click the Darken slider and drag left or right to darken or lighten the red eye fix color.

8. Then do one of the following to fix the red eye effect:

 • Position your cursor over an iris of the person and click.

 • Click and drag a rectangle around the entire eye. If you do not enclose the entire eye in the rectangle, this technique does not work.

9. Repeat step 8 with the other eye.

10. If you are fixing a pet photo, click the Pet Eye option and repeat steps 3–9.

Photoshop Elements 13 Pet Eye Fix

Photoshop Elements is one of the few photo-editing applications that can fix the light flare that sometimes occurs when you photograph your pets. This flare can be red, as well as white, yellow, or green. Other red eye removal tools do not fix this effect in pets. When you have the Remove Red Eye tool selected, click the Pet Eye check box in the Tool Options bar. This disables the Auto Correct button, letting you manually fix the light flares in your pet photos.

Whiten Teeth

The Photo Editor also lets you whiten teeth in a photo. It works similarly to the Remove Red Eye tool. Using the Whiten Teeth tool, select the area of the teeth and the Photo Editor automatically applies a whitening effect to the selected area.

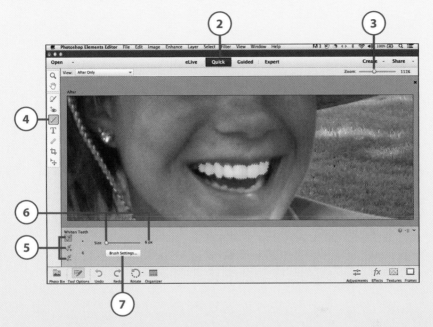

1. Open a photo either from Organizer or from your hard disk in the Photo Editor. See "Opening a Photo in Photo Editor" in this chapter for how to open a photo in the Photo Editor.

2 Click the Quick mode.

3. Click the Zoom slider to zoom in on the photo so you can see the teeth clearly.

4. Click the Whiten Teeth tool from the Toolbox.

5. By default, the New Selection tool is selected. You can click to choose any of the three Selection options.

6. If you need to adjust your Brush size prior to selecting the teeth, click the Size slider and drag it left or right to decrease or increase the brush tip size. You can also click in the Size field and type a pixel size.

7. Click the Brush Settings button to adjust the brush settings.

8. In the Brush Settings window, click the Hardness slider to adjust the hardness of the selection tool. You can also click the Hardness field and type a set percentage size. Hardness is basically how tight the selection is to the edge of an area based on the color tones in the image.

Angle Diagram

9. Click and drag the Spacing slider left or right to decrease or increase the amount of spacing between similar colors the selection tool recognizes for the selection.

10. Click and drag the Roundness slider left or right to decrease or increase how round the brush tip is of the Quick Selection tool. You'll see the Angle diagram adjust to display the changes you make to the tool.

11. Click the triangle in the Angle diagram and drag it up, down, left, and right to reposition the angle of the brush tip.

12. Click the Size menu to set whether you are using a drawing tablet, a stylus pen with a thumb wheel, or a mouse. Choose one of the following three menu options:

 • **Pen Pressure**—Click this option if you are using a pressure-sensitive drawing tablet to control the pressure you use for your selection. The more pressure, the larger the selection brush tip and the larger the area selected. The lighter the pressure, the smaller the Quick Select brush tip and the smaller the selection.

 • **Stylus Wheel**—Click this option to control the pressure if you are using a stylus pen that has a thumb wheel.

 • **Off**—Click this option if you are using a regular mouse for your input method.

13. Click the Close button to close the window and apply the settings.

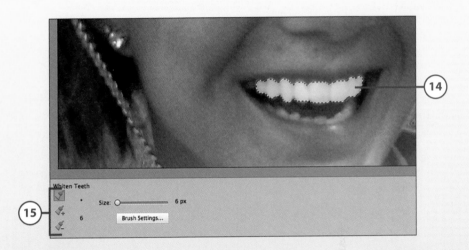

14. Click and drag in the teeth area to define the selection.

15. Click the New Selection or Add to Selection or the Subtract from Selection option(s), and then drag again in the teeth area to refine your selection. As you add new areas, the whitening effect is applied to that area. If you take away areas, the effect is voided.

16. If you think you need to reapply the effect to whiten the teeth more, choose Select, Deselect from the menu bar to end the first whitening effect, and then repeat steps 4–15.

Don't Overdo the Whitening

The Teeth Whitening tool should not be reapplied too many times because it creates an unnatural white to the teeth in the photo. You can always undo this tool by clicking the Undo button in the taskbar.

Adding Labels and Text to a Photo

The next tool in the toolbox is the Horizontal Type tool, and it is covered in Chapter 10, "Enhancing Photos."

Use the Spot Healing Brush Tool

The Spot Healing Brush tool of the Photo Editor is a neat tool that corrects blemishes in a photo. This could be smudges, light flares, blurs—any problem that might exist in the photo. This tool works by sampling an area close to the blemish and then pasting that sample over the blemish. It has two Brush modes, an automatic mode represented by the Spot Healing Brush and a manual mode represented by the Healing Brush. The Spot Healing Brush mode is covered in this chapter. The Healing Brush mode is covered Chapter 9, "Advanced Photo Corrections."

1. Open a photo either from Organizer or from your hard disk in the Photo Editor. See "Opening a Photo in Photo Editor" in this chapter for how to open a photo in the Photo Editor.

2. Click the Quick mode tab.

3. Click the Healing Brush tool from the Toolbox.

4. By default, the Spot Healing Brush tool option is selected. If not, click to select it.

5. Click the Type option to set the Brush Type:

 - **Proximity Match**—This Brush Type fixes blemishes based on the pixels around the edges of the selection area. It samples these pixels and pastes them over the blemish.

 - **Create Texture**—This Brush Type samples all the pixels based on the selection area. It samples this area and pastes this sample over the blemish.

 - **Content Aware**—Content Aware Brush Type is new to Photoshop Elements 13. It is aware of the image surrounding the blemish and makes a best guess on how to cover the blemish with existing parts of the image.

6. Click the Brush Preset Picker and choose a preset brush.

7. Click the Size slider and drag it left or right to manually set a custom brush size. You can also double-click the Size field and type a number.

What Brush or Brush Size Works Best for the Spot Healing Brush

It is best to use a brush size that is slightly bigger than the area that you want to fix. This way, you can just position the brush over the area and click to fix the blemish. As for the Brush to choose, the Photo Editor offers many different brushes based on textures, soft edges or feathering, and size. Experiment with these brushes. Also try dragging through the blemish again to reapply the Spot Healing Brush.

8. Click the Sample All Layers option to sample all layers of a multiple layered composite. Layers are covered in Chapter 7, "Working with Layers."

9. Click the blemish. If necessary, drag over any areas that the brush does not cover. Photo Editor corrects the blemish based on the Brush Type you select.

10. If you do not like the modification, click Undo.

11. Then click a new Brush Type by repeating steps 5–10 until you have tried all Brush Types.

Cropping a Photo

Cropping is the most popular edit that people make when enhancing and modifying photos. Cropping a photo can change the mood and message of a photo. Cropping is cutting away unwanted images in your photo so that you can focus on an object or view in the photo. The Photo Editor offers different ways to crop your photos using the Crop tool.

1. Open a photo either from Organizer or from your hard disk in the Photo Editor. See "Opening a Photo in Photo Editor" in this chapter for how to open a photo in the Photo Editor.

2. Click the Quick mode tab.

3. Click the Crop tool from the Toolbox.

4. Click and choose a preset dimension from the Show Crop Presets Options menu in the Tool Option bar.

5. To set a custom crop area, click in the W/H boxes and type custom area settings for the Width and Height.

6. Photo Editor displays Crop Suggestions based on the crop area you chose in step 4. Hover your cursor over each suggestion and the Viewer reflects this new crop dimension applied to the photo.

7. Click to choose the Crop Suggestion you want.

8. If you want to change the photo resolution, click in the Resolution box and type a resolution.

9. Click the Set Resolution for Cropping Image menu and choose a unit of measurement.

10. Click a Grid Overlay to display a grid.

11. You can also resize the crop area by clicking and dragging the crop handles around the edge of the selection in the Viewer to focus on the area that you want.

12. To move the crop area, click in the middle of the area and drag to reposition it in the photo.

13. Click Confirm to apply the crop.

14. Click Reject to discard the crop.

Manually Setting the Crop Area

You can also set a custom crop area with the Crop tool by setting the Crop Presets Options menu to No Restrictions and then clicking and dragging a crop area in the photo. If you need to adjust the crop area, click and drag the handles displayed in the Viewer. Click Confirm to apply the crop.

Use the Move Tool

The Move tool is useful for positioning your photo elements such as text boxes, shapes, and other objects in a photo. You can also use the Move tool to resize your objects.

1. Open a photo in which you have added a shape or a text message.

2. Click the Quick mode.

3. Click the Move tool from the Toolbox.

4. Click a text box, shape, or object in the photo that you added to the photo.

5. Handles display around the selected item. Click and drag the handles to resize the item.

6. Click Confirm to apply the resize.

7. Click Reject to cancel the resize.

8. Click anywhere in the item and drag it to a new location in the photo.

Applying Adjustments

Just like Organizer, the Photo Editor has adjustments that can automatically fix problems in a photo. Photo Editor has nine preset options per adjustment, which gives you more control. You can apply Smart Fix, Exposure, Lighting, Color, Balance, and Sharpen adjustments to your photos. The process of applying these adjustments to a photo is basically the same.

1. Open a photo either from Organizer or from your hard disk in the Photo Editor. See "Opening a Photo in Photo Editor" in this chapter for how to open a photo in the Photo Editor.

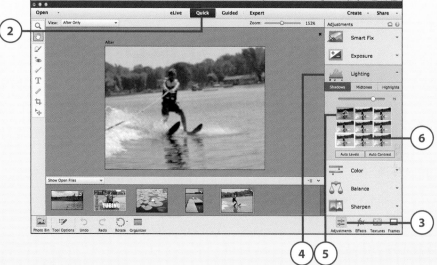

2. Click the Quick mode.

3. Click the Adjustment button in the taskbar. This button is a toggle button, so if you click this button again it closes the pane.

4. In the Adjustments pane, click the adjustment that you want to apply.

 * **Smart Fix**—Use this adjustment to automatically correct exposure, lightening, color, balance, and sharpen issues in the photo.

 * **Exposure**—Use this adjustment to correct exposure issues, such as underexposed or overexposed photos.

 * **Lighting**—Use this adjustment to correct lighting issues, such as photos that are too dark or too light, by adjusting the Shadows, Midtones, and Highlights.

 * **Color**—Use this adjustment to correct color issues, such as adjusting color saturation, hue, and vibrancy.

 * **Balance**—Balance the temperature and tint colors in a photo.

 * **Sharpen**—Increase or decrease the contrast in your photo to improve the sharpness of the image.

5. Each adjustment displays nine preset adjustments as well as a slider bar. Hover your mouse over any of the nine presets and the photo displays the fix.

6. If any of the presets fixes the problem, click it.

7. To manually apply the adjustment fix, click and drag the slider bar to set the amount of adjustment to the photo.

8. To automatically let Photo Editor apply the fix, click the Auto button(s).

9. To reset the photo, click the Reset button.

10. If you need help on the adjustment, click the Help button.

Quick Automatic Fix Recommendations

Adobe recommends that you limit the number of Adjustment fixes that you use on a photo in the Quick mode. The correct process for these fixes is to try one; if it does not fix the problem, click the Reset button and try another. Adobe also recommends that you always apply sharpening to a photo last.

Saving Edited Photos

When you are done making edits to your photos, you need to save them. You can save a photo in a new file format, such as TIF, PNG, or JPG. The default format is Photoshop or PSD. You can also save an edited photo as a Version Set for use in Organizer. You can choose to save the file outside of Organizer as an individual file or to be included in the Organizer Catalog.

1. Choose File, Save from the menu bar. If this is the first time you have saved the photo, you can also choose File, Save As. Both commands perform the same Save function when saving the file for the first time.

2. Click here and type a file name.

3. Click the More button (Mac) or Browse Folders button (Windows PC) to expand the Save As window to show full file access. This is a toggle button; click it again to collapse the full file access.

4. (Mac Only) Click the Tags box and type any tags you want for the photo.

Save window (Mac)

Save window (Windows PC)

5. In the full file access area, navigate to the folder where you want to save your photo.

6. If needed, click the New Folder button to create a new folder in your navigation.

7. Click this menu and choose a file format.

8. Click to select the Save options you want.

9. Click to select the Organize options you want.

10. Click to deselect the Embed Color Profile Color option.

11. (PC Only) Click the Thumbnail option to save a thumbnail preview with the file.

12. Click Save.

13. If you want to cancel the Save function, click Cancel.

14. Many of the file formats have an additional window that lets you further customize the file format. Each file format has its own customizing options. Click the options you need for that file format.

15. Click OK.

How Can I Learn More About Graphic File Formats?

You can learn more about graphic file formats by visiting Wikipedia at this URL: http://en.wikipedia.org/wiki/Image_file_formats.

Set Preferences for the Photo Editor

The topics covered in this chapter can have certain preferences set for their use. Visit the online bonus contents page for this chapter (www.quepublishing.com/title/9780789753809) for more instruction on how to set the General, Saving, and Display & Cursors preferences.

Design composite
created through layers

Type layer

Adjustment
layers

Layer mask Fill layer

In this chapter, you learn how to work with layers in Photoshop Elements 13. A mask was introduced in the previous chapter in the section, "Using the Selection Brush Tool," and this mask is really a Mask layer. Now it's time to learn about layers and Mask layers, as well as how to use them to work with your photos to create a design composite. Topics include the following:

7

→ Creating a new layer
→ Reordering layer stacking order
→ Showing and hiding layers
→ Deleting a layer
→ Linking and locking layers
→ Creating layer mask, Clipping Mask layers, and Adjustment layers
→ Creating and using Shape layers
→ Applying enhancements and styles to layers

Working with Layers

This chapter is all about layers and their use in Photoshop Elements 13. A layer can be compared to a clear sheet of plastic. You can put images, shapes, borders, frames, and messages on individual layers to create a composite image. You can also change the opacity and Blending mode as well as add special effects and filters to each layer. Because the image is on a layer, you can work on that image without changing anything else in your photo. This is very useful to create a design composite with many layers each containing images, shapes, text, borders, or frames. Based on the layer content, Photoshop Elements 13 has different types of layers—Image, Background, Shape, Mask, Adjustments, Type, and Fill layers. Each is designed for a special use in Photoshop Elements 13.

Creating a New Layer

Layers are used in all modes of the Photo Editor. For instance, in the previous chapter when you created a selection of an object in a photo, you used a mask to select the object. Photoshop Elements actually used a Mask layer to create this mask functionality. You did not have access to the actual Mask layer, just the functionality. The layers in the Quick and Guided modes are automatic and allow little modification. The Expert mode has a Layers panel for working with layers, and it gives you lots of control for customizing and modifying layers. When you open a photo in the Photo Editor, it automatically creates and displays the photo image on a Background layer. It is a good idea to leave the Layers panel displayed while you work in the Expert mode.

Photo on Background layer **Background layer**

Layers button

When you create a new layer, it is stacked on top of the layer below. You can create and delete layers, show or hide layers, and reorganize layer stacking order. You can also apply enhancements and effects to a layer, as well as change the opacity of the layer. You can set a Blending mode for layer so that the image on the layer is transformed by blending with the layers below it.

1. In the Photo Editor, open a photo or a new document. See Chapter 2, "Importing Photos and Videos."

2. Click the Expert mode.

3. Click Layers in the taskbar.

4. The Layers panel displays with a background layer.

Understanding Background Layers

A Background layer is automatically created when you open a photo or blank document in the Photo Editor. It is a special layer in that it is composed of pixels only and is always at the bottom of the stacking order in the Layers panel. By default it is partially locked, and in this state its image cannot be edited or modified.

To modify a Background layer you must convert it to a regular Image layer by double-clicking it in the Layers panel. Click and type a name for the layer in the Name box of the New Layer window. Set the Blending mode and Opacity settings, and then click OK. The layer is converted to an image layer. You can also convert a Background layer to an Image layer by clicking the Partially Locked icon.

5. To create a new layer, click the Create New Layer button in the Layers panel.

6. A new Image layer is added above the Background layer. Type a name into the Name box. It is a good idea to rename layers to something that makes sense for the image that will reside on the layer.

Layers and Transparent Backgrounds

When you create a new Image layer, it displays with a transparent background. A checkerboard pattern is displayed in the Viewer for the layer indicating that this is transparent. This allows the layers underneath a layer to also be visible. As you develop the layer by adding images and other shapes and objects, you can place your new layer content where it needs to be in the overall image.

7. Use any of the tools in Expert mode of the Photo Editor to add images and shapes to your layer. See Chapter 9, "Advanced Photo Corrections," for more information on these tools.

8. To set the opacity of a layer, click in the Opacity box and type a number between 0–100. You can also click the Triangle to the right of the Set the Layer Opacity box and drag the Opacity slider to adjust the opacity.

9. Click the Set the Blending Mode menu.

10. Choose a Blending mode from the Blending Mode menu. The default is Normal.

Understanding Blending Modes

To learn more about Blending modes, please see the online content for Blending modes at www.quepublishing.com/title/9780789753809.

Show and Hide Layers

Layers can be hidden in your composite image. You hide certain layers so that you can focus on the layer that you are working on. You also can show any hidden layers.

1. Open a photo with multiple layers in the Photo Editor.

2. Click the Expert mode.

3. In a photo that has multiple layers, click the eye icon on the layer that you want to hide. The layer and its contents are hidden in the photo.

4. To show the layer again, click the eye icon a second time. The layer and its contents are displayed again.

Understanding Hidden Layers

When you hide a layer, you cannot apply any changes to that layer. For instance, you cannot draw, paint, or enhance the layer. You cannot even delete the layer. You must show the layer to work or modify it in any way.

Reorder Layers

When you create layers, they are stacked on top of each other. The background of each layer is transparent by default. This lets the images on other layers below a layer to still display, but any overlapping images will appear below or above each other based on layer stacking order. You can create layers that have a solid or pattern background, and we cover this later in this chapter. If you need to have an image display above or below another image, you can modify the layer stacking order, reordering the layers to get the effect that you want.

1. Open a photo that has multiple layers in the Photo Editor.

2. Click the Expert mode.

3. Click to select the layer that you want to move up or down in the layer stacking order.

4. Drag the layer to a new location in the layer stacking order. You'll see a darker horizontal bar display between the two layers you are moving to indicate that the layer will be placed between the two layers.

Deleting a Layer

You can delete a layer, which deletes that layer contents from the photo. There are a couple of different techniques you can use to delete a layer.

1. Open a photo that has multiple layers in the Photo Editor.

2. Click the Expert mode.

3. Click to select the layer that you want to delete. Using the Move tool, you can also click the image in the photo that resides on the layer to select the layer.

4. Press the Delete key on your keyboard to delete the layer, or click the Trash icon in the Layers panel.

5. You can also right-click the layer and choose Delete Layer from the context menu.

6. A window displays; click Yes to delete the layer.

Don't Ask Again

If you are confident in your deletion choices, you can select the Don't Show Again checkbox to avoid being asked to confirm a deletion. It is a good safety feature to prevent you from accidentally deleting a layer, so it's recommended you leave that box unchecked.

Merging Layers

As you create your layers for your design composite, you might notice that that file size is increasing for the composite. Adding layers increases the file size of the document. You can merge layers into each other to decrease the file size. You can also flatten the entire composite into one layer. After you merge or flatten your composite, the images, shapes, type, frames, and backgrounds become one layer and cannot be accessed individually as they could when they were on their own layer. A flattened image requires selection techniques to access an individual component of your photo.

1. Open a photo that has multiple layers in the Photo Editor.

2. Click the Expert mode.

3. Click to select the layer that you want to merge down a layer.

4. Choose Layer, Merge Down from the menu bar.

5. If you want to Merge only the visible layers, not the ones that you have hidden, choose Layer, Merge Visible.

6. If you want to flatten all layers into one, choose Layer, Flatten Image.

Creating Fill Layers

Fill layers are special layers for solid colors, gradients, and patterns. The opacity and Blending modes can be applied to a Fill layer, but this type of a layer does not affect images on any of the layers below them in the stacking order. When you create Fill layers, they are automatically named based on their type. For example, if you create a solid color Fill layer, it is named Fill Color 1. If you create a second Fill layer, it will be called Fill Color 2. Fill layers are often used as background layers.

1. Open a photo or new document in the Photo Editor.

2. Click the Expert mode.

3. Click the layer that you want the new Fill layer to be above.

4. Click the Create New Fill or Adjustment Layer button.

5. From the menu choose Solid Color. The first three menus create Fill layers.

 - **Solid**—Creates a Fill layer with a solid color fill.

 - **Gradient**—Creates a Fill layer with a gradient color fill.

 - **Pattern**—Creates a Fill layer with a pattern fill.

6. In the Color Picker, choose a color and click OK. The Fill Layer is created above the active layer.

Use the Color Picker to Sample Colors

The Color Picker can be used to sample colors from the image, no matter what layer the color resides on. Click the Foreground color to open the Color Picker at any time, and then click in the Viewer on the image where the color you want to sample is used. Your cursor becomes the eye-dropper icon when sampling colors. The sampled color is displayed as the new color.

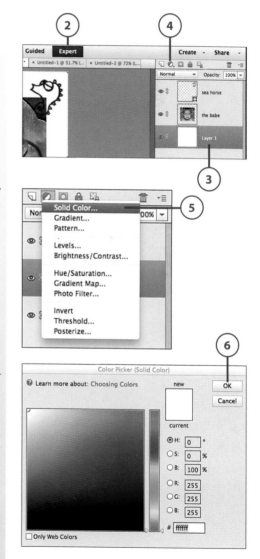

Creating a Gradient Fill Layer

Anther type of Fill layer that can be created is a Gradient Fill layer. This layer uses a gradient color as the fill.

1. Open a photo or new document in the Photo Editor.

2. Click the Expert mode.

3. Click the layer that you want the new Fill layer to be above.

4. Click the Create New Fill or Adjustment Layer button.

5. From the menu choose Gradient color.

6. In the Gradient Fill window, click the triangle to the right of the Gradient menu.

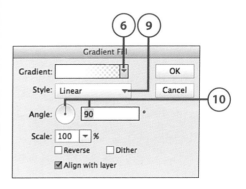

Using the Gradient Editor

If you click the Gradient menu and not the triangle, you open the Gradient Editor. This feature is covered in Chapter 10, "Enhancing Photos."

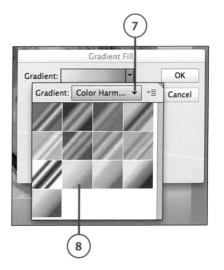

7. Click to choose a Preset Gradient type from the Gradient pop-out menu.

8. Click to choose a gradient swatch.

9. Click the Style menu and choose a gradient style.

10. Click and drag the Angle Indicator line to adjust the gradient flow angle. You can also click in the Angle field and type a number between 1–360.

11. Click in the Scale box and type a number between 1–100. You can also click the triangle and choose a preset number from the menu.

12. Click the Reverse option to reverse the gradient flow of colors.

13. Click the Dither option to add dithering to the gradient.

14. Click the Align with Layer option to deselect this option. This option is selected by default and aligns the gradient to the layer's bounding box.

15. Click OK to close the window and create the Gradient Fill layer.

Creating a Pattern Fill Layer

You can also create a Pattern Fill layer. The Photo Editor has many patterns that you can choose from.

1. Open a photo or new document in the Photo Editor.

2. Click the Expert mode.

3. Click the layer that you want the new Fill layer to be above.

4. Click the Create New Fill or Adjustment Layer button.

5. From the menu choose Pattern color.

6. In the Pattern Fill window, click the Pattern menu.

7. Click the Preset Patterns menu and choose a Preset Pattern type.

8. Click a pattern swatch.

9. Click the Scale box and type a number between 1–1000. You can also click the triangle to choose a preset scale percentage.

10. If you want the pattern to not be linked with the layer, click the Link with Layer option to deselect it. This option is on by default and forces the pattern to move with the layer.

11. Click the Create a New Preset from this Pattern option to include your choices for the pattern in the Custom Preset menu.

12. Click the Snap to Origin button to reset the pattern position.

13. Click OK to create the Pattern Fill layer and close the window.

Creating Layer Masks

A Layer Mask is a way to mask areas of a layer so that only certain areas of the layer's image display. This layer works only with bitmap images, so vector images cannot be used to create a masking area. You learn about vector image shapes in Chapter 10. You use the Brush and the Eraser tools to define your mask areas. You do this based on colors:

- Paint white on all areas you want to be visible.

- Paint black on all areas you want to be hidden.

- Use shades of gray for areas to apply a transparency.

A quick way to choose white is to use the Web hexadecimal equivalent of #FFFFFF or the black hexadecimal equivalent of #000000.

1. Open a photo that has multiple layers in the Photo Editor.

2. Click the Expert mode.

3. Click to select the layer that you want to attach a mask.

4. Click the Add a Mask button.

5. A layer mask is created for the selected layer. To define the mask area, make sure the Mask thumbnail is selected.

Delete a Layer Mask

You can delete a layer mask by right-clicking the Mask thumbnail in the Layers panel and choosing Delete Layer Mask from the context menu.

6. Click the Color Picker foreground color.

7. Click a color of black, white, or a shade of gray. You can click in the Hexadecimal box and type a hexadecimal equivalent.

8. Click OK to close the Color Picker.

9. Click the Brush tool from the toolbox.

10. Set your Brush settings. (This topic is covered in Chapter 10.)

11. Click and drag to paint your mask area.

12. Repeat steps 5–11 to continue to develop your mask.

>>>*Go Further*

MODIFYING A LAYER MASK

After you have a layer mask created, you can adjust its scale, position, orientation, and add other bitmap images or shapes to it. A layer mask is made up of two thumbnails that represent the image on the layer and the masking area. By default, these two thumbnails are linked. You can work between the two thumbnails to adjust and modify your mask. Click the Mask thumbnail and modify the mask using the Brush and/or Eraser tools. Use the Color Picker to establish the mask area—black, white, and gray. If you click the link between them, this unlinks the two thumbnails, and any edits you make apply to just that thumbnail's content, the mask or the image. Click the link again to link the layer image with the mask.

Link

Layer content thumbnail

Mask thumbnail

You can also use the Selection tools to transform, scale, and reposition the mask or the layer content in the layer. The Selection tools are covered in Chapter 9. The Brush and Eraser tools are covered in Chapter 10.

Creating and Using Clipping Layer Masks

You can also create a Clipping Layer Mask, which is a mask that applies to multiple layers. This enables you to mask the images in multiple layers with one mask. This is covered in the online content available for this book. Please see the "Using Clipping Layer Masks" topic in this chapter's online content at www.quepublishing.com/title/9780789753809.

Creating Adjustment Layers

Another nice feature in Photoshop Elements 13 is Adjustment layers. An Adjustment layer is a layer that lets you apply color and tonal adjustments to all layers below it without affecting the actual pixels in those layers. Adjustment layers have the same Opacity and Blending mode settings as an Image layer, but unlike an Image layer, the changes you make apply to all the layers below it.

1. Open a photo that has multiple layers in the Photo Editor.

2. Click the Expert mode.

3. Click the layer you want the Adjustment layer to be above.

4. If you want to focus on just an object in the image, select it. Selection techniques are covered in Chapter 9.

5. Click the Create New Fill or Adjustment Layer button.

6. Choose one of the eight layer enhancement commands for an Adjustments layer.

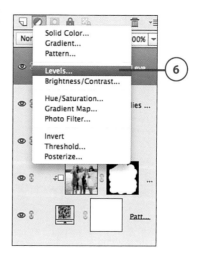

- **Levels**—The Levels window lets you adjust the shadows and highlights in an image or selection. Click the Channel menu to set the channel. Click and drag the three sliders to adjust the shadows, middle tones, and highlights. Adjust the Output levels of black and white by dragging either of the two sliders. Click the Close button to apply the enhancement and close the window.

- **Brightness/Contrast**—This window lets you adjust brightness and contrast. It is best used on just a selection in the image. Click and drag the Brightness and the Contrast sliders to enhance the image. You can also click in the number value box for each setting and type a number between 1 and 100. Click the Close button to apply the enhancement and close the window.

Shadows **Channel menu**

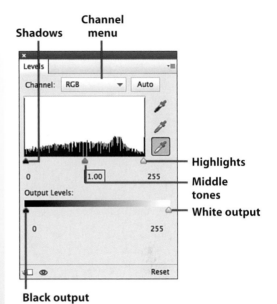

Highlights

Middle tones

White output

Black output

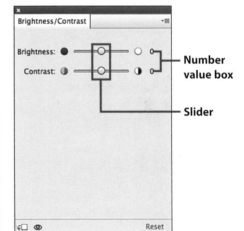

Number value box

Slider

- **Hue/Saturation**—This window lets you adjust the Hue/Saturation in an image. Click and drag the sliders for Hue, Saturation, and Lightness to adjust these settings, or click in the number value box and type a number between 1 and 100. Click the Colorize option to deselect this. Click the Close button to apply the enhancement and close the window.

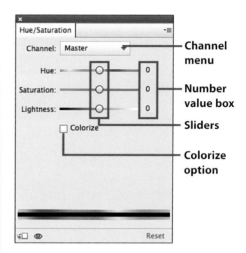

Channel menu

Number value box

Sliders

Colorize option

- **Gradient map**—Adjust a Gradient map with this window. See the topic "Creating a Gradient Fill Layer" in this chapter for instructions on how to use this enhancement. Click the Close button to apply the enhancement and close the window.

- **Photo Filter**—Adjust a Photo Filter enhancement. Click the Filter menu and choose a filter. Click the Color option and choose a color for the filter. Click the Density slider and adjust the density of the color filter by dragging left and right. Click Preserve Luminosity to deselect this option.

Filter menu

Color option and Color Picker

Density slider

Preserve Luminosity option

- **Invert**—this enhancement does not have any settings and is immediately applied to the image.

- **Threshold**—Adjust the color threshold by clicking and dragging the Threshold slider. You can also click in the number value box and type a number between 1 and 255.

- **Posterize**—Use this window to set the posterization in the image. Click the Levels slider to adjust this enhancement. You can also click in the number value box and type a number between 1 and 255.

Number Value box

Threshold slider

Number Value box

Posterize slider

7. All the Enhancement windows have common buttons. Click this to apply to all layers below.

8. Click this to turn on or off the layer visibility.

9. Click Reset to reset the enhancement settings to the default settings.

10. Click this to access a menu of commands specific to the selected Enhancement panel.

11. Click the Close button in the Enhancement window to close the window and apply the enhancement.

12. You can access any Adjustment layer enhancement settings again by double-clicking the Enhancement thumbnail in the layer.

The Beauty of Adjustment Layers

You can apply as many Adjustment layers that you need in your photo. You can experiment and test different enhancements to the entire image or just a selection in the image. These enhancements don't change the photo pixels and can be turned off by hiding the Adjustment layer or by deleting the layer. You can reorder Adjustment layers, and the enhancements of the layer affect all layers below them in the new stacking order. You can merge an Adjustment layer with the layer below or a group of layers. This simplifies the Adjustment layer and permanently applies the enhancement.

Locking and Linking Layers

Other nice features of layers are to lock and/or link them. When you lock a layer, the layer contents cannot be modified. You can also lock only the transparent pixels in the layers image. You can choose multiple layers by Shift+clicking them, and then linking them. When you link layers, the content of all the layers are linked and any modification you apply is applied to all the linked layers together.

1. Open a photo that has multiple layers in the Photo Editor.

2. Click the Expert mode.

3. Click to select a layer you want to lock.

4. Click the Lock button.

5. Click the Lock Transparent Pixels button to lock the layer's transparent pixels.

6. A lock icon displays to the right of the layer name indicating that the layer is now locked.

7. To select multiple layers to link, Command-click (Mac)/ Control+click (PC) the individual layers.

8. Click any of the selected layer Link icons. An orange Link icon displays for all selected Link icons, indicating that these layers are now linked.

9. To unlink a layer, click the orange Link icon.

Adding Layer Styles

Photoshop Elements 13 has many layer styles that you can apply to an image to change the look and style of the image. You need to work between the Layers panel and the Effects panel to apply layer styles. All styles are applied to the entire layer. You can apply as many styles as you need for your image.

1. Open a photo that has multiple layers in the Photo Editor.

2. Click the Expert mode.

3. If necessary open the Layers panel by clicking Layers in the taskbar.

4. Click to select a layer.

5. Click Effects in the taskbar to open the Effects panel.

6. Click the Styles tab.

7. Click the Select a Type menu and choose a style type.

8. Double-click a variation of the style type or drag the variation to the preview of the layer image.

Graphics and Favorites

You might have noticed that some of the images and masks that have been created for the figures in this chapter have pre-created clip art on them. Photoshop Elements has quite a few clip art images available for use in your images and layers. Click the Graphics button in the taskbar to access them. When you add clip art, it is created on a special layer type, the Shape layer. The Shape layer is a vector layer, which means that the images on this layer are in vector format, in contrast to bitmap or raster images.

You can also add your favorite clip art to a specific panel so that they are easily accessible. The Favorites panel lets you store your favorite enhancements, features, and shapes—such as styles, textures, frames, clip art, backgrounds, shapes, and graphics.

1. Open a photo that has multiple layers in the Photo Editor.

2. Click the Expert mode.

3. If necessary, open the Layers panel by clicking Layers in the taskbar.

4. Click to select a layer.

5. Click Graphics in the taskbar.

6. The Graphics panel displays. Click the Graphics Category menu and choose a graphics category.

7. Click the Graphics Type menu and choose a graphics type. This menu is contextually sensitive to the category that you choose in step 6.

8. Double-click a variation to apply it to the photo. You can also click a variation, and then click and drag it on the photo to apply it.

Vector Versus Bitmap

Photoshop Elements can use both vector and bitmap images. When you add clip art to your photo, these are vector images. Vector images are created through a mathematical algorithm that creates shapes through end points, lines, and curves. Photos are bitmap images, and they are created through pixels. When you draw or paint, you create shapes that are bitmap based. A special layer, the Shape layer, is created for any vector shape images.

9. Return to the Layers panel by clicking Layers in the taskbar.

10. The Shape layer is created above the selected layer and the shape is accessible in the Viewer.

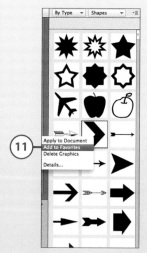

11. To add the clip art graphic to the Favorites panel, right-click the clip art and choose Add to Favorites from the pop-out menu.

12. Use the toolbox tools to scale, position, resize, rotate, or change the color of the shape. See Chapter 6 and Chapter 9 for more information on how to modify the shape.

13. Click Favorites in the taskbar to access your favorite graphics and enhancements.

Simplifying Vector-Based Layers

The Shape and Type layers are vector-based layers, meaning that they contain vector shapes. You cannot draw or paint on vector layers. Shape and Type layers need to be simplified before you can add bitmap images to them. To simplify a Shape or Type layer, select it and then choose Layer, Simplify from the menu bar. The layer is converted to an image layer, and the vector image is converted to a bitmap image. Now you can draw and paint on the layer as well as copy and paste selections from your photo to this layer.

Using the History Panel

A very helpful tool when you start developing design composites in the Photo Editor is the History panel. This panel keeps track of your actions as you work. At any time you can backtrack your steps to return to an earlier version of your photo as you developed it.

1. In a document that you have been working on, open the History panel by clicking the More button. You can also click the triangle to the right of the More button and choose History from the pop-out menu.

2. Click the History tab.

3. Click an action.

4. The Viewer displays the image at that step in development.

5. If this is not where you want to be, click another action.

6. Continue with your development from that point in the History list of actions.

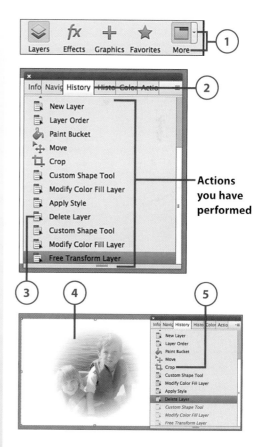

Actions you have performed

>>>Go Further

USING PANEL GROUPS

The History panel is part of a panel group of other useful tools. There are six other panels grouped in this panel group. Click the associated tab to access that panel. You can access the follow panels in this group:

- **Info panel**—Use this panel to see information about a selection, such as Color Mode, Color Swatches, and image and canvas dimensions.

- **Navigator**—Use the Navigator to zoom in and out in the Viewer.

- **History**—See a history of your actions in all open documents.

- **Histogram**—See and adjust colors through the Histogram of the image or selection.

- **Color Swatches**—Set color palettes to be used for the Color Picker. Add and delete color swatches from the color palettes.

- **Actions**—See actions that you have performed to an image. Select and replay these actions on other elements in your design composite.

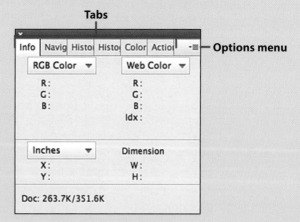

Click the Options menu to see more commands that you can use with this panel group.

Guided Edit panel

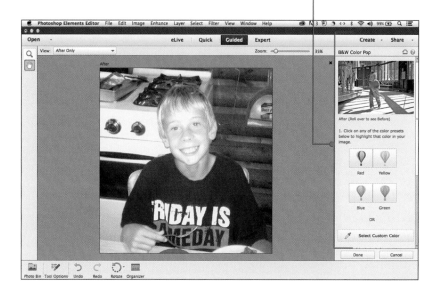

In this chapter, you learn how to use the Guided mode of the Photo Editor and how to apply the effects in the Guided Edits. Create the perfect portrait or quickly fix blemishes and other photographic problems such as colors, brightness and contrast, and blurry photos. You can also apply interesting Camera and Photo Effects. Have some fun with your photos by transforming them with the Photo Play effects. Topics include the following:

→ Using and working in the Guided mode
→ Applying Touchups Guided Edits to improve and enhance your photos
→ Applying Photo and Camera Effects Guided Edits to enhance your photos
→ Applying Photo Play Guided Effects to transform your photos

Correcting and Retouching Photos Using the Guided Mode

The Guided mode of the Photo Editor walks you through step-by-step instruction on how to apply Guided Edits. Photoshop Elements 13 really beefs up the Guided Edits that are available in this release by including many new Guided Edits. These edits are displayed in the Guided Edit panel and divided into four categories. All commands and functionality for performing these Guided Edits are presented in this panel. Guided Edits work hand in hand with the Viewer and Tool Options bar for getting more control and customization over the edit. The Guided mode is a great place to start learning the tools and functionality of the Photo Editor.

Making Guided Edits

The Guided mode lets you enhance, modify, and transform your photos using wizards that guide you through the process of fixing, enhancing, and modifying your photos. There are four Guided Edit categories: Touchups, Photo Effects, Camera Effects, and Photo Play. Each Guided Edit category contains multiple types of Guided Edits. Each Guided Edit works basically the same as far as how you use the tools and options to apply that edit. Start at the top of the panel and work your way down through the step-by-step wizard instruction. You can reset the photo at any time, as well as apply the Guided Edit multiple times to a photo. Work through the step-by-step instructions for each effect.

Following is an overview on how to access the various Guided Edits in each category.

1. In the Photo Editor, open a photo. See Chapter 1, "Getting Comfortable with the Photoshop Elements 13 Workspace, Preferences, and Settings," for more information on the Photo Editor.

2. Click the Guided mode.
3. To expand a Guided Edit category, click the category. If you click it again it collapses.

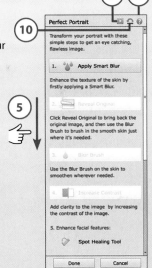

4. Click a Guided Edit.

5. A wizard displays with the step-by-step instruction on how to apply the edit. Start at the top of the panel and work your way down through each successive tool or enhancement.

6. If needed, Zoom in on the photo by doing one of the following:

- Click the Zoom slider and drag left or right.

- Click the Zoom tool in the toolbox. Click in the photo to Zoom in, hold the Option (Mac)/Alt (PC) key down to toggle the Zoom tool between Zoom In and Zoom Out.

7. Use the Hand tool to move the picture around.

8. Set your View by clicking the View menu and choosing a View.

9. To see a video on using the Guided Edit, click this.

10. To reset the image to the original image, click this. Many times the Undo button does not work with the guided steps of the wizards.

11. To get help on the Guided Edit click this.

12. Some of the Guided Edits have Tool Options that you can set; click the Tool Options in the taskbar to open the Tool Options bar.

Not All Guided Edits Have a Video

Most of the Guided Edits have a video that you can access by clicking the Video button at the top of the Guided Edit panel. At the time of the writing of this book, the new Guided Edits did not link to video instruction. Adobe put a lot of effort into the Guided mode of the Photo Editor and added many new Guided Edits. These videos should be released shortly to provide visual instruction for each of the Guided Edits.

Apply Multiple Guided Edits

Multiple Guided Edits can be applied to a photo. Work between the categories and the Guided Edits to create the look that you want for your photo.

Overview of Touchups Category

The Touchups category contains the Guided Edits for making photo edits to fix blemishes, problems, and issues that can occur in your photos. Each Guided Edit is focused on correcting a certain problem you might have with your photos. Each has its own set of instructions, buttons, and tools to solve these problems. Follow the instructions carefully to work through each edit. Here is an overview of each Guided Edit in the Touchups category:

- **Brightness and Contrast**—Correct brightness and contrast issues in a photo. You can correct them automatically, manually, or use a combination of both techniques.

- **Correct Skin Tones**—This Guided Edit is new to Photoshop Elements 13. Use it to correct skin tone issues by removing a color cast from a person's skin or by giving them a tan.

- **Crop Photo**—This Guided Edit is new to the Guided mode in Photoshop Elements 13. Crop photos based on a ratio, preset size, or manually. This tool works similarly to the Crop tool in Chapter 6, "Applying Quick Fixes with the Photo Editor."

- **Enhance Colors**—This Guided Edit is new to the Guided mode in Photoshop Elements 13. Balance colors in a photo. You can correct them automatically, manually, or use a combination of both techniques.

- **Levels**—This Guided Edit is new to the Guided mode in Photoshop Elements 13. Correct color tonal issues in a photo to help fix issues with the photo being too light or too dark.

- **Lighten and Darken**—This Guided Edit is new to the Guided mode in Photoshop Elements 13. This edit is not quite as precise as the Levels Guided Edit. It applies a general fix to the photo's exposure.

- **Perfect Portrait**—This Guided Edit steps you through the process of many fixes that can transform a photo to a perfect portrait. We'll explore this Guided Edit next.

- **Remove a Color Cast**—This Guided Edit is new to the Guided mode in Photoshop Elements 13. Use this Guided Edit to pull colors out of an image and adjust the overall photo's color cast.

- **Restore Old Photo**—This Guided Edit helps you fix problems and blemishes that occur with older photos, such as scratches, blemishes, blurry images, folds, and creases.

- **Rotate and Straighten**—This Guided Edit is new to the Guided mode in Photoshop Elements 13. Rotate and sharpen a photo with this Guided Edit.

- **Scratches and Blemishes**—This Guided Edit is new to Photoshop Elements 13. Fix scratches and blemishes in a photo.

- **Sharpen**—Increase the sharpness of a photo to fix blurry photos.

Using the Perfect Portrait Guided Edit

In this section, we take a look at the Perfect Portrait Guided Edit from the Touchup category. It uses many of the tools, buttons, and options in the other Guided Edits in the Guided mode of the Photo Editor. To complete this Guided Edit, we will work between the Guided Edit, the Viewer, and the Tool Options bar.

1. Open a photo in the Photo Editor. See Chapter 1.

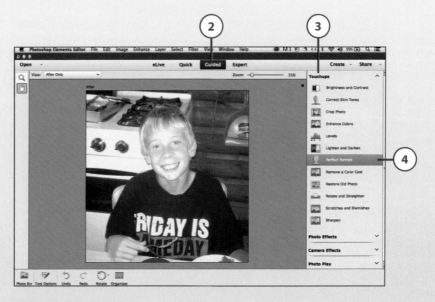

2. Click the Guided mode.

3. Click the Touchups category to expand it.

4. Click the Perfect Portrait Guided Edit.

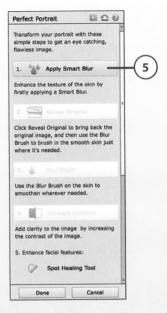

5. Click the Apply Smart Blur button.

6. In the Smart Blur window, click in the preview of the photo and drag the photo to show the area that needs the most Blur adjustment.

7. Set the Radius and Threshold settings for the blur by clicking and dragging the sliders to adjust the blur. You can also click in the associated field and type a number between 0–100.

8. Click the Quality menu and choose a quality setting.

9. Click the Mode menu and choose a mode.

10. Click OK to close the Smart Blur window.

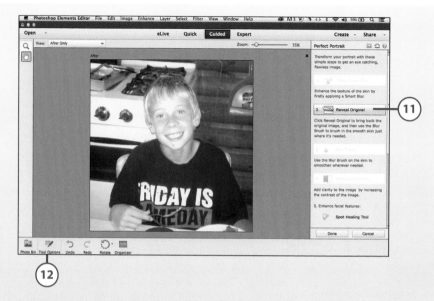

11. Click the Reveal Original button to bring back the original skin as an overlay on the blur created in the previous steps. This will let you manually smooth the skin a little more where needed with the Brush tool in the following steps.

Accessing the Hand Tool at Any Time

When you are working through the steps of the Guided Edits, you can activate the Hand tool so that you can move the preview photo image around by pressing and holding down the spacebar. Then click and drag in the photo to move the image around. You can also access the Move tool at any time by pressing and holding the Command (Mac)/Control (PC) key. Either technique can be used at any time in a Guided Edit.

12. Click Tool Options in the taskbar to open the Tool Options bar.

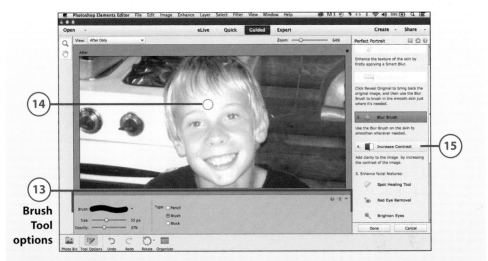

Brush Tool options

13. Set your Brush Tool Options. See Chapter 6 for how to set Brush tool options.

14. Click and drag to apply the blur to the photo.

15. Click the Increase Contrast button to clarify the image by increasing the image contrast.

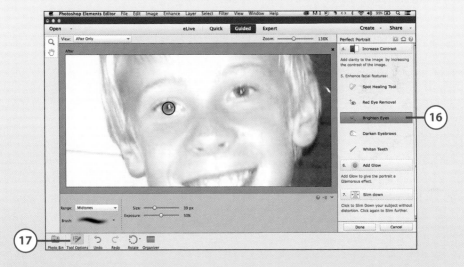

16. The Perfect Portrait Wizard displays step 5, Enhance Facial Features, with several fixes represented as buttons. The Spot Healing, Red Eye Removal, and Whiten Teeth buttons are covered in Chapter 6. We'll look at the Brighten Eyes button next. Click this button.

17. The Tool Options bar closes; reopen this bar by clicking Tool Options in the taskbar.

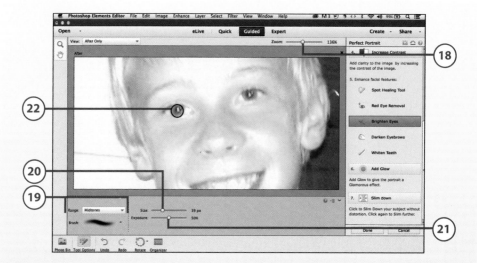

18. Zoom in on the photo so you can see the eyes better. Hold down the spacebar to activate the Hand tool and move the photo so you can see the eyes.

19. Set your Brush tool options settings for the Range and Brush by clicking the associated menu and choosing a menu option.

20. Set the Size slider to a brush size about the same size as the irises of the person's eyes.

21. Click the Exposure slider and set the exposure.

22. Click in the photo over the iris area of each eye.

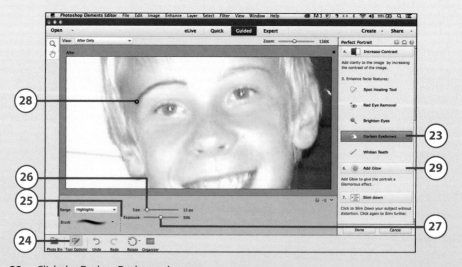

23. Click the Darken Eyebrows button.

24. The Tool Options bar closes; reopen this bar by clicking Tool Options in the taskbar.

25. Set your Brush tool options settings for the Range and Brush by clicking the associated menu and choosing a menu option.

26. Set the Size slider to a brush size about the same diameter in size as the person's eyebrows.

27. Click the Exposure slider and set the exposure.

28. Click in the photo over an eyebrow and drag to trace its shape. Do the same for the other eyebrow.

29. Click the Add Glow button.

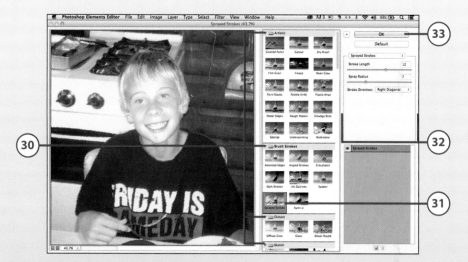

30. Click a Filter category to expand it.

31. Click a filter.

32. Click the options in the Filter pane of the Guided Edits panel and adjust the Filter settings. These vary based on the Guided Edit selected.

33. Click OK.

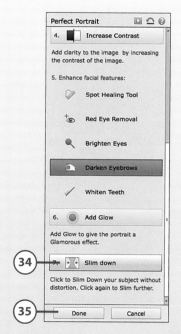

34. Click the Slim Down button to automatically slim the figure by 4%. Click it again to slim the person more by another 4%.

35. Click Done to finalize your Perfect Portrait Guided Edits.

36. If you don't like the results, click Undo.

Photo Effects

The Photo Effects Guided Edit category contains enhancements that you can apply to your photo to transform its display. These Guided Edits control how the photo looks in both its display and its presentation style. For instance, you can change a color photo quickly into a black-and-white photo and even have just one color that pops out. The B&W Color Pop, B&W Selection, and Black and White are new Guided Edits for Photoshop Elements 13.

Following is an overview of the Guided Edit Photo Effects:

- **B&W Color Pop**—Make one color pop out of a photo by changing the rest of the photo to Black and White.

- **B&W Selection**—Using the Brush tool accessible in this Guided Edit, designate the area of the photo to be black and white, and then designate the area of the photo that will have a color. This is similar to the B&W Color Pop but you have more control.

- **Black and White**—Change the photo to black and white.

- **High Key**—Create a High Key effect for your photo. This adds an ethereal or dreamy effect to the photo. Underexposed images work best with this effect. Photos that are overexposed appear bleached out when this effect is applied.

- **Line Drawing**—Convert your photo into a line drawing with this effect.

- **Low Key**—Bring out shadows and the edges of the highlights with this effect.

- **Old Fashioned Photo**—Convert your photo to look like an old-fashioned photo from days gone by.

- **Saturated Film Effect**—Make your photo appear like it was shot with saturated slide film. You might need to apply this effect multiple times to get the look that you want.

1. Open a photo in the Photo Editor. See Chapter 1.

2. Click the Guided mode.

3. To access the Photo Effects Guided Edits, click the Photo Effects category.

4. Click to choose a Photo Effect Guided Edit.

5. Work from the top to the bottom of the instructions in the Guided Edit panel.

6. Click Done to apply the effect.

Camera Effects

The Camera Effects category in the Guided mode of the Photo Editor lets you apply special effects to your photos that can usually be achieved only through special cameras and camera photography techniques. These Camera Effects are applied similarly to the Photo Effects.

Following is an overview of the Guided Edit Camera Effects.

- **Depth of Field**—This effect focuses on selected areas in a photo by creating a copy of the background and then blurring that background so only the selected areas are in focus. The blur can be customized.

- **Lomo Camera Effect**—This Guided Edit applies a Lomo Camera Effect to the photo. A Vignette Effect can be applied as well to really showcase the subject in the photo. This effect can be applied multiple times to intensify the effect.

What Is a Lomo Camera?
The Russians created the Lomo camera in the early 1990s. This camera is analog and uses 35mm film. It photographs images using high contrast with unusual saturation and color.

- **Orton Effect**—This effect was originally created by Michael Orton and creates a soft, dreamy display of your photo.

- **Tilt-Shift**—This effect focuses on an object or area of your photo by creating a blurring of everything else but the object of interest in the photo.

- **Vignette Effect**—This effect creates a vignette around an object or person in your photo.

- **Zoom Burst Effect**—This effect again focuses on an object in your photo and creates a burst around the object. The burst is blurred but in a way to create the illusion of motion.

1. Open a photo in the Photo Editor. See Chapter 1.

2. Click the Guided mode.

3. To access the Camera Effects Guided Edits, click the Camera Effects category.

4. Click to choose a Camera Effect Guided Edit.

5. Work from the top to the bottom of the instructions in the Guided Edit panel.

6. Click Done to apply the effect.

Photo Play

The Photo Play category of the Guided Edits panel lets you apply playful effects to your photos. These Guided Edits create fun effects for your photos, such as allowing part of a photo to extend over the photo border or overlaying a puzzle effect to the photo. Again, these Guided Edit effects are applied in a manner similar to the other effects we have covered already in this chapter.

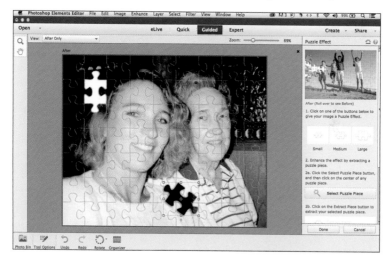

Following is an overview of the Guided Edit Photo Play effects.

- **Out of Bounds**—This fun effect guides you through adding a frame to the photo, followed by the process of selecting part of the image and displaying this out of the frame boundaries.

- **Picture Stack**—New to Photoshop Elements 13, this Guided Edit transforms your photo by dividing the display area into a set number of individual photos.

- **Pop Art**—This effect transforms your photo into a Pop Art style image.

- **Puzzle Effect**—This effect adds a puzzle piece overlay on your photo.

- **Recompose**—This effect lets you recompose your photo by identifying the objects you want to move, protect, and remove. The Brush tool lets you quickly identify these areas, and the Photo Editor does the rest.

- **Reflection**—Add a reflection to your photo with this effect.

1. Open a photo in the Photo Editor. See Chapter 1.

2. Click the Guided mode.

3. To access the Photo Play Guided Edits, click the Photo Play category.

4. Click to choose a Photo Play Guided Edit.

5. Work from the top to the bottom of the instructions in the Guided Edit panel.

6. Click Done to apply the effect.

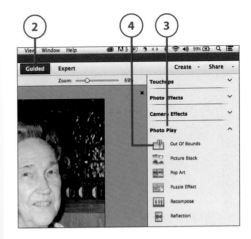

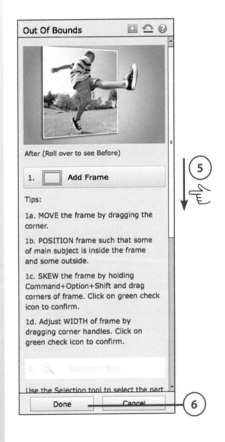

Move images from one Photomerge Compose
photo to another feature

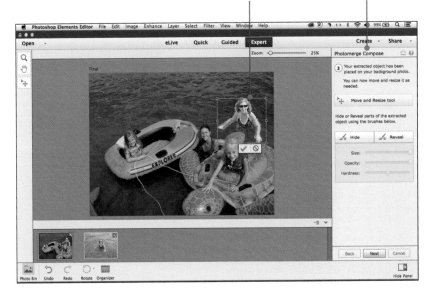

This chapter covers many of the tools and features of the Expert mode of the Photo Editor. First you learn how to create a new document with a set canvas size and how to resize your image on the canvas. Then you learn how to display rulers, grids, and guides for accurately positioning your photo images and shapes. Selection tools and techniques are discussed, and many of the tools for enhancing, recomposing, and transforming your photos are covered as well.

→ Customizing the Expert mode workspace
→ Making and modifying selections
→ Displaying and using guides, grids, and rulers
→ Modifying photo composition
→ Fixing imperfections and blemishes
→ Precisely adjusting color
→ Manipulate and transform a photo using Photomerge
→ Adding watermarks

Advanced Photo Corrections

The Expert mode of the Photo Editor works much like Adobe Photoshop CC in its workspace and its tools, features, and functionality, but with a focus on photo edits, modifications, enhancements, and transformations. The Expert mode and its many advanced photo correction tools and techniques are covered in this chapter.

Setting a Custom Workspace

The Expert mode in the Photo Editor lets you work in Photoshop Elements 13 with the freedom to create, develop, and customize any way you want. You have control over your workspace in this mode, unlike the Guided and the Quick modes that allow for no

customization of workspace elements. You can float the photos and images in their own windows. This lets you arrange your photos in your workspace in any order and location that you want. You can easily return to the default tabbed view too.

1. In the Photo Editor, open two or more photos or other image documents. See Chapter 1, "Getting Comfortable with the Photoshop Elements 13 Workspace, Preferences, and Settings," for more information on how to access images in Photo Editor.

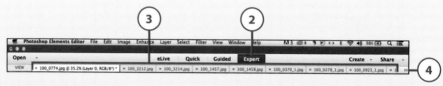

2. Click the Expert mode.

3. Click a document tab to quickly switch between open documents.

Use Photos in Photo Bin to Switch Between Documents

You can also double-click a Photo in the Photo Bin to switch documents in the Viewer or choose a document name from the Window menu.

4. If you have more documents open than can be displayed in the tabbed area of the Viewer, click the double arrow button and choose from the list.

5. To display documents in their own window, choose Photoshop Elements Editor, Preferences, General (Mac—shown) or Edit, Preferences, General (PC) from the menu bar.

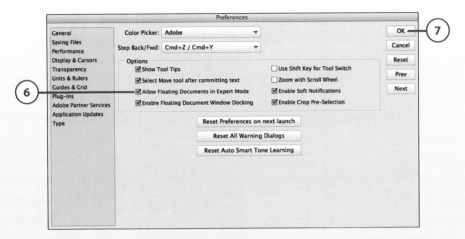

6. In the Preferences window, click the Allow Floating Documents in Expert Mode.

7. Click OK.

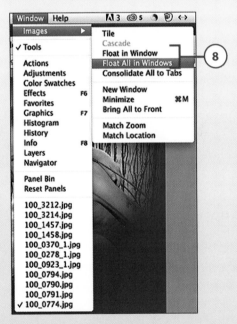

8. Nothing changes for the documents you have opened in the tabbed mode, but any new photos or images opened will be in a floating window. To see the already opened tabbed documents in a floating window do one of the following:

 - To display all opened documents in their own window, choose Window, Images, Float All in Windows.

 - To display just one document in a window, click a tabbed document and choose Window, Images, Float in Window from the menu bar.

9. You can also switch back to the tabbed view by choosing Window, Images, Consolidate All to Tabs.

10. Quickly create another copy of the active document by choosing Window, Images, New Window.

11. To tile the documents, choose Window, Images, Tile.

Opening a New Blank Document

When opening a blank document, you have the opportunity to configure everything from size to background contents.

1. In the Photo Editor, click the Expert mode.

2. To create a new blank document choose File, New, Blank File.

3. In the New window, click in the Name field and type a name for the new document.

4. Click the Preset menu.

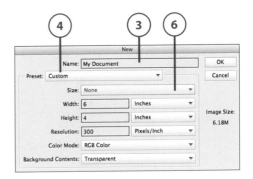

5. From the drop-down menu, choose one of the following:

 - **Clipboard**—This is the default setting and creates a document based on the size of the image on the Clipboard from your most recent Copy command.

 - **Default Photoshop Elements Size**—This creates a blank document based on the last document you created.

 - **Paper size**—There are four menu options for setting paper size. Choose one of the menu options.

 - **Media-based size**—There are three menu options for setting the new document based on media type.

 - **Opened document**—Choose an already opened document to create a new blank document based on the size and resolution of an opened document.

 - **Custom**—Choose this to create a custom blank document.

6. If you choose a preset based on paper size or media-based size, the Size menu is accessible. Click and choose a size from the pop-out menu.

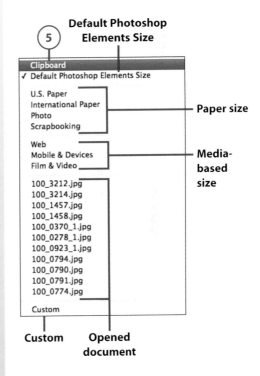

7. Click in the Width and Height fields and type a number; then click the Unit menu and choose a unit of measurement.

8. Click in the Resolution field and type a number; then click the Unit menu and choose a Resolution unit.

9. Click Color Mode and choose a color mode.

10. Click Background Contents and choose a color for the background of the new document.

11. Click OK.

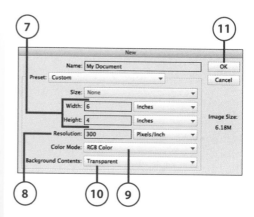

Setting Canvas and Image Size

After you have a photo opened or a new document created, you can set the canvas larger or smaller. This does not change the size of the image on the canvas. You can also change the image size as well as the resolution, which adjusts both the image and the canvas. You can resize both the canvas and the image in any of the editing modes of the Photo Editor.

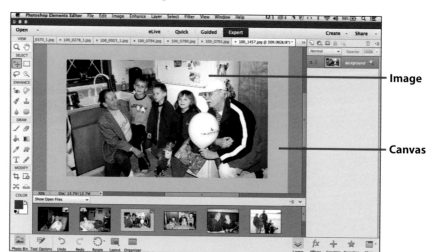

1. In the Photo Editor, open a photo. See Chapter 1.

2. To change the size of the canvas, choose Image, Resize, Canvas Size.

3. In the Canvas Size window, click the Relative option to keep the canvas size relative to the original dimensions. If you want to set your own height and width, do not click this option.

4. Click in the Width and Height fields and type a number; then click the Unit menu and choose a unit of measurement.

5. Click an arrow from the Anchor option to set where the image is positioned on the new canvas. The default is to center it.

6. Click the Canvas Extension Color menu to choose a preset color for the background of the canvas. You can also click the Color Picker to choose a custom color.

7. Click OK.

8. To resize the image, click Image, Resize, Image Size.

9. The Lock Aspect Ratio is active by default. This constricts the document dimensions based on the aspect ratio of the width, height, and resolution of the image. Change one dimension and they all adjust based on their aspect ratio to each other.

10. Click in the Width, Height, and Resolutions field and type a number, then click the Unit menu and choose a unit of measurement.

11. To change the number of pixels in the document, click Resample Image.

12. Select an interpolation method by clicking the pop-up menu and choosing a method.

- **Bicubic Smoother (Best for Enlargement)**—Use this when you are making an image larger.

- **Bicubic Sharper (Best for Reduction)**—Use this when you are making an image smaller.

- **Bicubic (Best for Smooth Gradients)**—Use this if you have a gradient in your photo. This method is slower but more precise for smoother tonal gradations. This is the default menu option.

- **Nearest Neighbor (Prevent Hard Edges)**—This method is recommended for illustrations with non–anti-aliased edges. It's the fastest method but less precise. You can get jagged edges with this method.

- **Bilinear**—Use this method to get medium quality.

13. Click the Scale Styles box if you used Styles in the image. See Chapter 7, "Working with Layers."

14. If you want to resize the image without constricting its aspect ratio, deselect Constrain Proportions.

15. Click in the Width, Height, and Resolution fields and type a number; then click the Unit menu and choose a unit of measurement.

16. Click OK.

Displaying and Using Guides, Grids, and Rulers

Other helpful tools of the Photo Editor are Guides, Grids, and Rulers. Each of these tools can be displayed or hidden. The guides can be locked so that they cannot be accidentally moved, and the Snap feature can be turned off so that guides can be positioned exactly where you need them. These features are also available in the Quick and Guided modes.

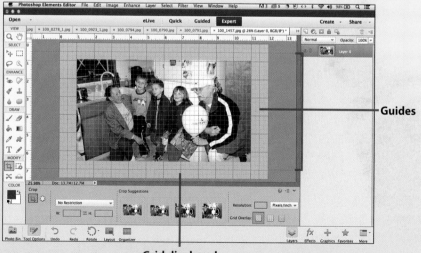

Guides

Grid displayed

1. To display the grid, choose View, Grid.

2. To display the Rulers, choose View, Rulers. Rulers must be displayed to add guides to your document.

3. To create a guide, first click the Move tool.

4. Then click in either the horizontal ruler or the vertical ruler and drag into the image. When you release the drag, the guide is positioned in the image.

5. You can also choose View, New Guide to add a guide.

6. To adjust a guide, position your cursor over it and the cursor becomes the double-headed arrow tool; click and drag to a new location.

7. To delete a Guide, click and drag it back to the ruler.

8. To hide the Guides, choose View, Guides. To display them again, choose View, Guides. This menu is a toggle switch.

9. To clear all Guides, choose View, Clear Guides.

10. To lock your Guides, choose View, Lock Guides. They cannot be moved when locked.

Use Keyboard Keys to Switch Between Add or Subtract Selection Tool Options

Use guides to help you align images, shapes, and objects in your photo. Click and drag your photo elements to a guide, and they snap to the guide. Also use layers for individual photo elements to make it easier to select and modify them.

11. By default, the Snap To feature is active. This feature snaps images and objects to the guides, grid lines, document boundary, and layers. To turn this Snap feature off, choose View, Snap To, and then choose from a submenu option of Guides, Grid, Layers, or Document Bounds.

12. To change the color for all Guides or Grid lines, double-click any displayed guide.

13. This opens the Photo Editor Preferences with the Guides and Grid category active. Set the colors and line style for the guides.

14. Set the Color and Line Style for the grid.

15. Click in the Gridline Every field and type a number. Then click the Unit menu and choose a unit of measurement.

16. Click in the Subdivisions field and type the number of Grid subdivisions.

17. Click OK.

Making Selections

The Expert mode in the Photo Editor has a few more Selection tools for making selections in an image or photo. After you make a selection, you can then copy/cut and paste it into a new layer and/or apply enhancements and styles to it. Making selections is key to enhancing, modifying, and transforming your photos because you can cut, copy, and paste areas and images from document to document or from layer to layer. We covered the Move and Quick Selection tools in Chapter 6, "Applying Quick Fixes with the Photo Editor." Now let's look at the other selection tools of the Expert mode.

Rectangular
Marquee tool

Move tool Magic Wand tool

2

Selection
tools

Lasso
tool

4

3

6

5

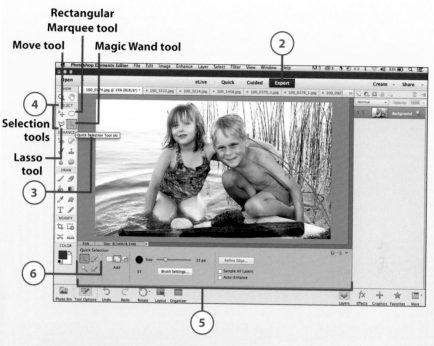

1. Open a photo or create a new document in the Photo Editor.

2. Click the Expert mode.

3. Hover your cursor over any of the selection tools to see an identifying tool ToolTip.

Tools in the Toolbox Reflect the Last Used Tool

Each tool has multiple tool options from which you can choose in the Tool Options bar. Based on the last tool option you used, the tool in the Toolbox and ToolTip reflect this tool option, so your tools might display a different tool. For example, if you click the Rectangular Marquee tool and then click the Elliptical Marquee tool option, the Toolbox reflects the Elliptical Marquee tool instead of the Rectangular Marquee tool. This is another example of the sticky interface of Photoshop Elements 13.

4. Click a selection tool.

5. Each tool has its own set of tool options. The Tool Options bar displays by default.

6. Each tool has multiple tool options. Hover your mouse over any tool option to see an identifying ToolTip.

7. Click to select a tool option.

8. Based on what you clicked, the Toolbox reflects the active tool option.

Using the Rectangular and Elliptical Marquee Tools

The Rectangular and Elliptical Marquee tools create rectangular or oval selections. Hold the Shift key when creating these shapes to constrain the marquee to a circle or square.

1. In the Photo Editor, open a photo and then click the Expert mode.

2. Click the Rectangular Marquee tool.

3. Choose either the Rectangular Marquee or the Elliptical Marquee Tool option.

4. If you want the edges of the selection with anti-aliasing, check that Anti-aliasing is selected. By default, this is active for selections. Click it if it is deselected.

5. Set the Feather and Aspect ratios as shown in Chapter 6.

6. Click and drag a selection in the image. Hold the Shift key while you drag to pull out a square or a circle.

7. Hover your cursor over each tool option to see an identifying ToolTip.

8. To adjust the selection, do one of the following:

 • To add another selection area to the image, click Add New Selection and then click and drag a new selection area.

 • To add to the selection, click Add to Selection, and then click and drag outside the current selection. The new area is added to the current selection.

 • To subtract from the selection, click Subtract from Selection and then click and drag inside the current selection to subtract that from the current selection.

 • Click Intersect with Selection, and then click and drag an intersecting shape through the current selection. The selection area is the intersected shape between the two selections.

Use Keyboard Keys to Switch Between Add or Subtract Selection Tool Options

Many of the Selection tools have the Add Selection or Subtract Selection options. You can initiate the Add Selection option at any time by pressing and holding the Shift key. You can initiate the Subtract Selection option by pressing Option (Mac)/Alt (PC). When pressing either of these keys, wait a moment for the cursor to change to the initiated option.

Using the Lasso Tool Option

The Lasso tool option creates freehand selections by letting you trace by dragging around the area that you want to select.

1. In the Photo Editor, open a photo and then click the Expert mode.

2. Click the Lasso tool.

3. Click the Lasso tool option.

4. Click and drag the slider for adjusting the Feather option, as shown in Chapter 6.

5. Click Anti-aliasing to select or click again to deselect.

6. Click where you want to begin your selection and drag along the object's edge.

7. When you are finished tracing the object, let up on the mouse button to stop the drag, and the ending point and the starting point of your selection are joined.

8. Adjust the selection using the New, Add, Delete, and Intersect selection options, which work the same as the Rectangular Marquee tool option previously covered in this chapter.

Deselect a Selection with a Keystroke

You can deselect a selection by pressing Command (Mac)/Control (PC)+D. This is the keyboard equivalent for the Select, Deselect menu command.

Using the Magnetic Lasso

This tool is similar to the Lasso Tool option, but it automatically detects the object's edge and lays down a selection marquee along the edge while you drag around the object.

1. In the Photo Editor, open a photo and then click the Expert mode.

2. Click the Lasso tool.

3. Choose the Magnetic Lasso tool option.

4. Click Anti-aliasing to select or click again to deselect.

5. Set the distance of the area of edge detection between the cursor and the object's edge by clicking the Width slider and adjusting this number of pixels. You can also click in the Width field and type a number between 1 and 256.

6. Click and drag the Contrast slider to set the sensitivity to edges in the image. You can also click in the Contrast field and type a number between 1 and 100%. The lower the number, the more edges detected. The higher the number, only strong edges are detected.

7. Click and drag the Frequency slider to set the frequency that you want the Magnetic Lasso tool option to create points. The higher the number, the more points. You can also click in the Frequency field and type a number between 0 and 100.

8. Click and drag the Feather slider to set the feathering distance from the edge. The higher the number, the more points. You can also click in the Feather field and type a number between 0 and 250.

9. Click once where you want your selection to begin and just hover (not drag) your cursor over the object's edge. The Selection Marquee automatically aligns with the edge.

10. Do one of the following to end the selection process:

 • Complete the trace by moving your mouse to the starting point and clicking on it.

 • Double-click to end the selection.

11. Adjust the selection using the New, Add, Delete, and Intersect selection options, which work the same as the Rectangular Marquee tool option previously covered in this chapter.

Polygonal Lasso Tool Option

The Polygonal Lasso tool option is also similar to the Lasso tool option, but it is more manual in the selection process.

1. Work through steps 1–8 from "Using the Lasso Tool Option" previously covered in this chapter.

2. To make your selection, click once where you want to begin your selection.

3. Click again a short distance from the first click.

4. Keep clicking along the edge of your object.

5. Do one of the following to end the selection process:

 • Set your final click on the starting point.

 • Double-click to end the selection.

6. Adjust the selection using the New, Add, Delete, and Intersect selection options, which work the same as the Rectangular Marquee tool option previously covered in this chapter.

Refining Edges of a Selection

After you have a selection created, you can refine the edges of your selection.

Selection

1. Create a selection in a photo with a selection tool.

2. If necessary open the Tool Options bar by clicking Tool Options in the taskbar.

3. Click either the Lasso or Polygonal tool options.

4. Click the Refine Edge button.

Viewer previews selection with the Refine Edges settings

5. In the Refine Edge Window, click the View Mode and choose how you want to view your selection area by choosing one of the following menu choices:

 - **Marching Ants**—Set your selection indicator to a marquee.
 - **Overlay**—Set your selection indicator to an overlay.
 - **On Black**—Set your selection indicator to display the selection on a black background.
 - **On White**—Set your selection indicator to display the selection on a white background.
 - **Black & White**—Set your selection indicator to display the selection as a white area on a black background.
 - **On Layers**—Set your selection to display on its own layer.
 - **Reveal Layers**—Set your selection indicator to display the selection on a white background.

6. Click the Show Radius check box to show the radius of the selection.

7. Click the Show Original check box to show the original selection.

8. Click the Smart Radius check box to turn on the Smart Radius feature.

9. Click the Radius slider and drag left or right to adjust the size of the Smart Radius selection tool. Left decreases the size, and right increases the size.

10. Click and drag the slider for the Adjust Edge Smooth, Feathered, and Contrast options for the selection edge.

11. Click the Shift Edge slider to shift the selection edge in or out of the selection area.

12. Click the Decontaminate Colors check box to maintain the tonal colors around the edges of your selection. Click and drag the Amount slider to set the decontamination color amount.

13. Click the Output To menu and choose one of the following methods for how to output the selection:

 - **Selection**—Output is just the selection area.
 - **Layer Mask**—Output is the selection created with a layer mask.
 - **New Layer**—Output the selection on a new layer.
 - **New Layer with Layer Mask**—Output is the selection on a new layer with a layer mask.
 - **New Document**—Output is the selection to a new document.
 - **New Document with Layer Mask**—Output is the selection to a new document with a layer mask.

14. Click Remember Settings if you want the Photo Editor to remember your settings for use with other selections.

15. Click OK to apply the refined edge options and close the window.

Using the Magic Wand Tool Option

The final selection tool that we need to cover is the Magic Wand tool option. This tool option is part of the Quick Selection tool. We covered the Quick Selection tools in Chapter 6. In the Expert mode, the Quick Selection tool has one more tool option, the Magic Wand. This tool makes selections based on colors and texture in the photo.

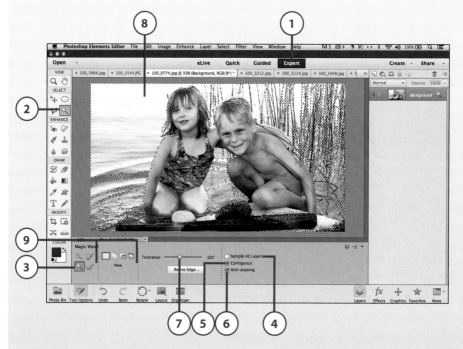

1. In the Photo Editor, open a photo, and then click the Expert mode.

2. Click the Quick Selection tool.

3. Choose the Magic Wand tool option.

4. If you want to sample the images on all layers in a document, click Sample All Layers.

5. Click Contiguous to deselect this option. This is selected by default.

6. Click Anti-aliasing to deselect this option. This is selected by default.

7. Click and drag the Tolerance slider to adjust the tolerance. You can also click in the Tolerance field and type a number between 0–255.

8. Click in an area of the image that you want to select. The Photo Editor selects an area automatically based on your settings selected in steps 4–7.

9. Click the New, Add, Subtract, and Intersect options to adjust your selection.

When to Use the Magic Wand Tool

The Magic Wand tool works best in areas that are more uniform in color or texture. It is sometimes better to use the Magic Wand to select a background instead of a person or complex object. After you have the background selected, you can choose Select, Inverse from the menu bar to invert the selection to be just the object in the photo.

Modifying Photo Composition

Photoshop Elements 13 has a few different techniques for modifying a photo's composition. You can recompose a photo by rearranging where people are located in a photo and delete objects or a person you don't want in a shot. You can also straighten a photo that is slightly off in its orientation, appearing crooked. The Photo Editor in the Expert mode gives you the tools to change and transform a photo. These tools are found in the Modify tools of the Toolbox.

Recompose tool

Crop tool

Content Aware Move tool

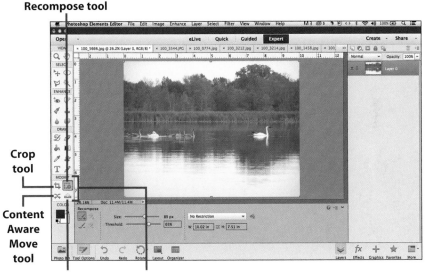

Straighten tool Modify tools

We covered the Crop tool in Chapter 6, but the Expert mode has one more Crop tool option that we will cover next, the Cookie Cutter tool option.

Using the Cookie Cutter Tool Option

The Cookie Cutter tool option lets you use a preset shape for cropping. This is similar to using a cookie cutter to cut out shapes. This tool is an option of the Crop tool. The Crop tool in Expert mode works the same as in Quick mode, except for the addition of this new tool option.

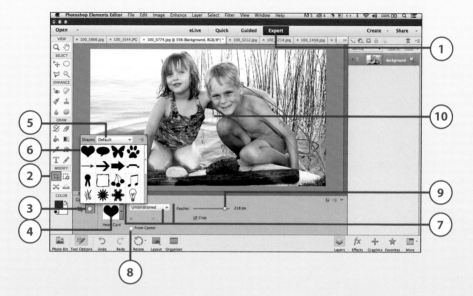

1. In the Photo Editor, open a photo and then click the Expert mode.

2. Click the Crop tool.

3. Click the Cookie Cutter tool option.

4. Click the Custom Shape Picker.

5. Click the Shapes menu, and then choose a Shapes category.

6. Click a Shape from the menu.

7. If you need a shape in a preset size, click the Set Geometry Options menu and choose a preset. You can also keep the default setting of Unconstrained and type a Width and Height into the fields.

8. Click to select the From Center option to create the shape from the center out.

9. Click the Feather slider, and then choose a feathering for the edges. You can also click in the Feather field and type a number between 1–250.

10. In the image, click and drag the shape.

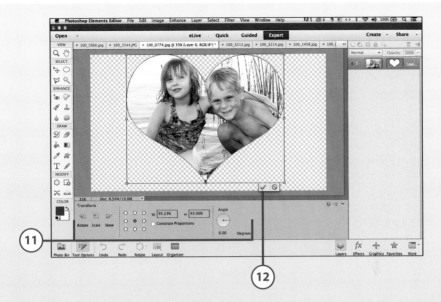

11. Use any of the Transform tool options to resize or relocate the cropping shape. You can also click and drag the shape handles or the shape to resize and/or relocate the shape in the Viewer. See Chapter 6 for more information on transforming and manipulating shapes.

12. Click Confirm to apply the layer mask to the photo.

Creating Transparency with the Cookie Cutter Tool Option

You can create a full image transparency for the image that you crop with the Cookie Cutter tool option by setting the Feather slider to a high number, such as 240 to 250 pixels. Based on your setting, this applies the feathering effect to a large area of the image.

Recomposing a Photo

You can also recompose the objects in a photo by using the Recompose tool. This is a new feature of Photoshop Elements 13. For instance, if you have a family picture with one person not quite in the group, you can move them into the group shot with the Recompose tool in the toolbox of the Expert mode.

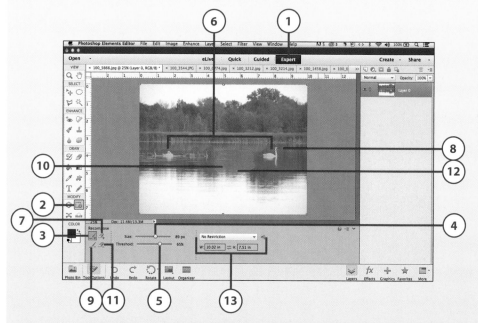

1. In the Photo Editor, open a photo and then click the Expert mode.

2. Click the Recompose tool.

3. Click the Mark for Protection option.

4. Click the Size slider and adjust your brush size. You can also click in the Size field and type a number.

5. Click the Threshold sliders and adjust the threshold for maintaining the aspect ratios of the Protected areas of your image. You can also click in the Threshold fields and type a number.

6. Click and drag to paint over areas you want to protect in the recomposing process.

7. Click the Erase Highlights Marked for Protection to erase any or parts of an area marked for protection.

8. Click and drag through any green highlighted Marked for Protection areas to erase them.

9. Click the Mark for Removal option.

10. Click and drag over the areas in the image that you want to remove in the recomposing process.

11. Click the Erase Highlights Marked for Removal to remove areas marked for removal.

12. Click and drag through any red highlighted areas to erase them.

13. To initiate the recompose process, you need to set the image size. You can do this through one of the following:

 • If you want to recompose the image based on the original image aspect ratio, click the Recompose Image Based on Aspect Ratios menu and choose a preset ratio. Keep the menu set to the default of No Restrictions and click in the Width and Height fields and type numbers.

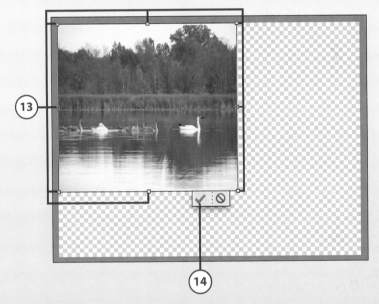

 • If you want to recompose the shape manually, click a handle and drag into the image to reset the image size. Handles are located in the corners and midpoints along the photo border.

14. Click Confirm to apply the Recompose Image settings.

15. The Adobe Photoshop Elements window displays. Click Cancel if you want to stop the process.

Using the Content-Aware Move Tool

The Content-Aware Move tool is another tool that lets you recompose your image. You can use this tool to move an object in your photo, or you can extend an object as well. This tool is a handy way to recompose a photo.

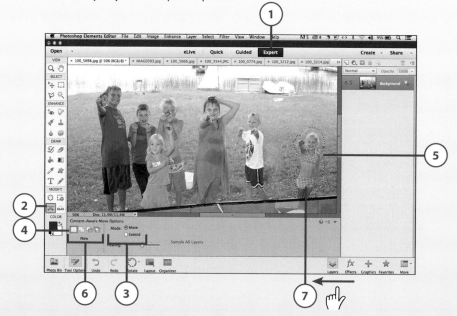

1. In the Photo Editor, open a photo and then click the Expert mode.

2. Click the Content-Aware Move tool.

3. Click either the Move or Extend option. Move lets you move an object, and Extend lets you extend the length of an object.

4. Click the New Selection option.

5. Click and drag around the object you want to move or where you want to extend the object.

Use Other Selection Tools with the Content-Aware Move Tool

You can create your selection of an object with any selection tool. Make sure you have the selection active and then click the Content-Aware Move tool. Move the selected object by dragging it to a new location.

6. Click the Add, Subtract, and Intersect options to adjust your selection.

7. Click and drag the selected object to a new location.

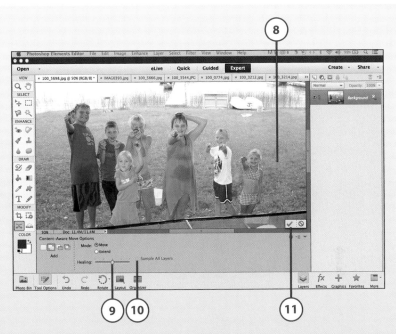

8. The Photo Editor processes the Move or Extend by analyzing the background and the new location, and then moves the object, filling in the background for a natural transition.

9. The healing in the background might not be perfect, but you can click and drag the Healing slider to apply a little or a lot of healing to the photo to try to clean up any leftover artifacts.

10. If this is multilayered document, click the Sample All Layers option, and then click and drag the Healing slider to apply healing to all layers.

11. Click Confirm to apply the content-aware move.

Straighten a Photo

Photoshop Elements 13 can straighten photos that appear crooked or that have a horizon line that is not straight. The Photo Editor in the Expert mode has the Straighten tool. You can straighten a photo both vertically and horizontally.

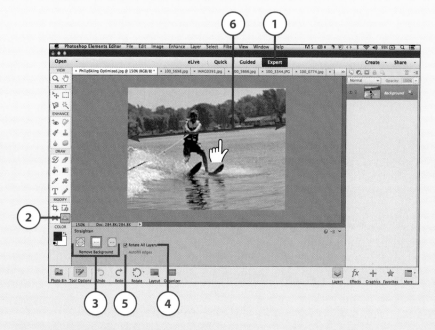

1. In the Photo Editor, open a photo and then click the Expert mode.

2. Click the Straighten tool.

3. Click one of the Straighten options for how to handle the extra background that can display when the photo is straightened:

 - **Grow or Shrink Canvas to Fit**—The Photo is rotated to straighten the image, and the photo corners now extend outside the canvas area. This creates white background areas to display around the photo. No pixels are clipped out of the photo.

 - **Crop to Remove Background**—The Photo is rotated to straighten the image, and the image is cropped to remove any blank background areas.

 - **Crop to Original Size**—The canvas and the image are kept at the same size when rotated to straighten the image. Blank background areas will display, and the image is clipped.

4. Click the Rotate All Layers option to include all layers in the document in the straightening.

5. If you choose either the Grow or Shrink Canvas to Fit option or the Crop to Original Size option, you can click the Autofill Edges to automatically fill in the blank background areas that display with these two options.

6. Click and drag across the crooked horizon or dividing line in the photo.

7. The photo is automatically straightened.

Fixing Imperfections

The Expert mode of the Photo Editor also has new tools for fixing imperfections and blemishes in a photo. The Toolbox in the Expert mode has six tools for enhancing photos: the Red Eye Removal, Smart Brush, Blur, Spot Healing Brush, Clone Stamp, and Sponge tools. Each of these tools has tool options for even more enhancing functionality and blemish-fixing features. We covered the Red Eye Removal and the Spot Healing Brush tools in Chapter 6. Now we look at other tools for fixing imperfections in the Expert mode.

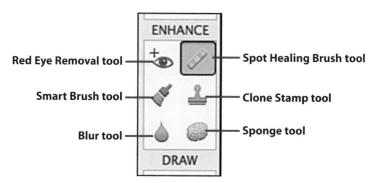

Using the Healing Brush Tool

The Healing Brush tool option is used to fix imperfections or remove objects from large areas. This tool is a tool option of the Spot Healing Brush tool and is similar in functionality but provides more control for your edits.

1. In the Photo Editor, open a photo and then click the Expert mode.

2. Click the Spot Healing Brush tool.

3. Click the Healing Brush tool option.

4. Click and drag the Size slider to set the size of the brush.

5. Click Brush Settings. See Chapter 6 for how to set the Brush Settings.

6. Click Aligned to sample pixels continuously from the current sample point. Leave this deselected to only sample from the initial sample point.

7. Click the Source menu and choose either Sampled or Texture. Sampled uses the sample point, and Texture uses a texture pattern for the sample.

8. Click Mode menu and choose a blending mode.

9. Click the Clone Overlay menu.

10. Click the Show Overlay to deselect this option. By default this option is selected and shows the overlay inside the brush stroke.

11. Click and drag the Opacity slider to adjust the opacity of the brush.

12. Click the Clipped option to deselect this option and not clip the overlay to the brush size.

13. Click the Auto Hide option to select it if you want to hide the overlay when you paint a brush stroke.

14. Click the Invert Overlay to select it if you want to invert the colors used in the overlay.

15. Click the Sample All Layers option to sample all layers in a multilayered document.

16. Move your cursor into the photo and position it close to the object you want to remove.

17. Hold down the Option (Mac)/Alt (PC), and when your cursor changes to a target icon, click to sample this area.

18. Click and drag over the object you want to remove.

Use Selections to Help Define the Area for the Healing Brush

If the object you want to erase is close to an edge, or the photo has high-contrast objects close by, it is a good idea to first select an area just larger than the edge or high-contrast object. Then, use the Healing Brush tool to sample a point inside the selection. This helps keep other objects from bleeding into the area that the Healing Brush is covering.

Using the Clone/Pattern Stamp Tool

The Clone tool is a great tool for erasing an object that you don't want in your photo. It is also great for duplicating objects in your photo. It works by sampling an area of the photo and then painting that image sample over existing images in the photo. Based on your brush size, you can touch up blemishes or add objects to transform the photo into the perfect shot.

1. In the Photo Editor, open a photo and then click the Expert mode.

2. Click the Clone Stamp tool.

3. Click the Clone Stamp tool option.

4. Click the Brush Preset Picker and choose a Brush.

5. Click Sample All Layers to select this and sample all layers in the photo.

6. Click and drag the Size slider to set the size of the brush. You can also click in the Size field and type a number from 0–2,500.

7. Click and drag the Opacity slider to set the opacity of the clone. You can also click in the Opacity field and type a number from 1–100.

8. Click the Mode and choose a blending mode.

9. Click Aligned to deselect it. When you deselect, this tool paints only with the originally sampled area. If this option is selected, the sampled area moves with your brush strokes.

10. Click the Clone Overlay.

11. In the Clone Overlay window, click the Show Overlay option to deselect this. If this is selected, you will see the sampled area in the Brush size display as you paint.

12. Click and drag the Opacity slider to adjust the opacity of the clip overlay display. You can also click in the Opacity field and type a number from 0–100.

13. Click the Clipped option to deselect it if you don't want the clipped overlay added to the Brush size.

14. Click Auto Hide to select this and hide the clip overlay from the brush strokes.

15. Click Invert Overlay to select and invert the colors of the clip overlay.

16. Click the Close button to close the window.

17. In the photo, move your cursor to an area that you want to sample; this usually is somewhere close to the object you want to erase.

18. Hold down the Option (Mac)/Alt (Windows PC) key and your cursor changes to a target icon. Then click to sample that area. Let go of the key.

19. Click and drag over the area that you want to disappear.

Duplicate Objects with the Clone Stamp Tool

To create a copy of an object, choose the Clone Stamp tool and then set your brush size to cover the object you want to duplicate. Sample the center of the object and then move your brush where you want to clone the object. Click and drag to re-create it.

Using the Pattern Stamp Tool

The Pattern Stamp tool option is grouped with the Clone Stamp tool and works similarly, but it paints in a pattern. You can choose your pattern from the Pattern Picker and set the opacity. Then, paint with the pattern.

Using Blur Tools and Tool Options

The Expert mode also offers the Blur tool in the Toolbox for blurring or softening edges or areas of a photo. This tool has three tool options: Blur, Sharpen, and Smudge. The Blur tool is used to blur edges and areas in a photo by painting over them. The Sharpen tool can sharpen an edge or area, and the Smudge tool smudges as you paint. The more you paint with each tool over an area, the stronger the effect. The settings and the process are basically the same for each tool, so we cover only the Blur tool here.

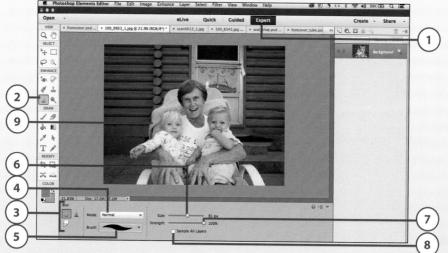

1. In the Photo Editor, open a photo and then click the Expert mode.

2. Click the Blur tool.

3. Click one of the three tool options: Blur, Sharpen, or Smudge.

4. Click the Mode menu and choose a blending mode.

5. Click the Brush Preset Picker and choose a brush.

6. Click and drag the Size slider to set the size of the brush. You can also click in the Size field and type a number from 0–2,500.

7. Click and drag the Strength slider to set the strength of the tool. You can also click in the Strength field and type a number from 1–100.

8. Click the Sample All Layers to apply the tool to all layers in the photo.

9. Click and drag over an edge or an area of the photo.

Use Blur Filters to Blur Large Areas or the Entire Photo

The Blur tool is to be used on small areas or edges in your photo that you want to blur. If you want to blur the entire photo or a large area, such as a background, you would use a Blur Filter. See Chapter 10, "Enhancing Photos."

Using Sponge Tools and Tool Options

The Sponge tool also has three tool options: Sponge, Dodge, and Burn. The Sponge tool is used to adjust the color saturation in a photo, to either deepen the color or lighten it. The Dodge tool lightens an area, whereas the Burn tool darkens it. Again, these three tools work basically the same, so we cover only the Sponge tool here.

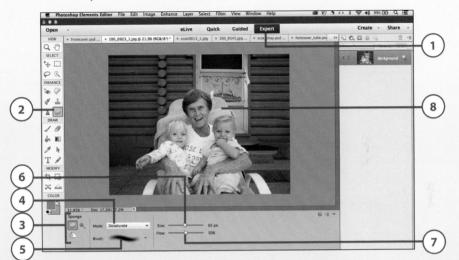

1. In the Photo Editor, open a photo and then click the Expert mode.

2. Click the Sponge tool.

3. Click one of the three tool options: Sponge, Dodge, or Burn.

4. Click the Mode menu and choose either Desaturate or Saturate.

5. Click the Brush Preset Picker and choose a brush.

6. Click and drag the Size slider to set the size of the brush. You can also click in the Size field and type a number from 0–2,500.

7. Do one of the following based on the tool you have selected:
 - If you have the Sponge tool selected, click and drag the Flow slider to set the flow of the tool. You can also click in the Flow field and type a number from 1–100.
 - If you have the Dodge or Burn tool selected, click and drag the Exposure slider to adjust the exposure. You can also click in the Exposure field and type a number from 1–100.

8. Click and drag over an edge or an area of the photo.

Precisely Adjusting Color

You can precisely adjust color in a photo with Photoshop Elements 13. There are a few techniques for doing this. The Expert mode of the Photo Editor has a Smart Brush that lets you adjust color in a variety of ways in your photo. You can also use the Replace Color command in the menu bar to precisely adjust color in your photos.

Smart Brush tool

Replace Color command

Smart Brush tool options

Using the Smart Brush to Adjust Color

The Smart Brush is just as the name implies—a smart brush that can be used to change color and color tonality in an area of the photo or for the entire photo. The Smart Brush has two tool options, the Smart Brush and the Detail Smart Brush. Both can be used to adjust and change color in a photo, as well as brighten and darken an image or an area. The Smart Brush is used for overall color enhancements and adjustments, and the Detail Smart Brush is used for finer, more precise enhancements and adjustments. Both these tool options automatically create an Adjustment layer so you can tweak the color change you apply to your photo without altering the original photo.

1. In the Photo Editor, open a photo and then click the Expert mode.

2. Click the Smart Brush tool.

3. Click one of the two tool options: Smart Brush or Detail Smart Brush.

4. Click the triangle to the right of the Effect Picker.

5. The Effect Picker opens. Click the Presets menu and choose a category.

6. Click an Effect.

7. By default, the Add New Selection option is active.

8. Next, set your Brush by doing one of the following:

 • If you chose the Smart Brush, click and drag the Size slider to set the size of the brush. Then click the Brush Settings and set these settings.

 • If you chose the Smart Detail Brush, click the Brush Preset Picker and choose a brush. Then click and drag the Size slider to set the size of the brush.

9. Click in the Photo and paint over the areas where you want to apply the effect.

10. A new Adjustment layer is automatically created in the Layers panel, and it contains the adjustment.

11. To add or subtract from the selection, click the Add to Selection option or the Subtract from Selection option, and then click in the photo to adjust your selection.

12. You can also add or subtract from the selection using the new display of these options located close to the selection.

13. To adjust the selection, do one of the following:

 • Double-click the Effect in the Adjustment layer.

 • Double-click the pin marker for the enhancement.

14. Adjust the effect in this window. Adjustments vary based on the effect you applied.

15. Click the Close button to close the window.

16. To delete the Smart Brush or Smart Detail Brush effect, do one of the following:

- Delete the Adjustment layer by selecting the layer and then clicking the Trash icon.

- Right-click the effect in the photo and choose Delete Adjustment.

Precisely Replacing Color

You can also precisely replace colors in a photo. This menu command is only accessible in the Expert mode. It analyzes the color, the color tonality, and the texture, and then replaces the color with a new color that you choose. When you replace colors in a photo, you are replacing the pixels in the photo. This technique doesn't create an Adjustment layer.

1. In the Photo Editor, open a photo, and then click the Expert mode.

2. Click the layer in which you want to change a color.

3. Choose Enhance, Adjust Color, Replace Color from the menu bar.

4. In the Replace Color window, click the Localized Color Clusters option to have the Photo Editor analyze color clusters in the photo.

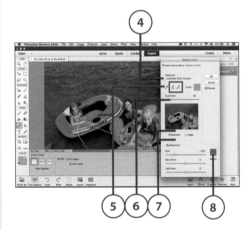

5. By default, the Color Picker tool option is active. Move your cursor into the photo and click to select the color you want to replace.

6. Click and drag the Fuzziness slider to adjust the Fuzziness setting.

7. Click either Selection or Image to replace just the color in the selection or for the entire image.

8. Click the Result Color Picker.

9. Choose a new color to be used as the replacement color.

10. Click OK to close the Result Color Picker.

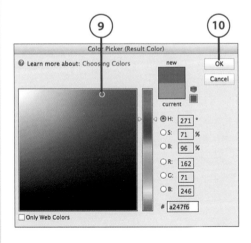

11. Set the Result Color settings by clicking and dragging the associated slider for Hue, Saturation, and Lightness.

12. Click the Add to Selection or the Subtract from Selection option and sample colors that still need to be replaced in the photo.

13. Work between these two options by selecting one and then sampling colors in the photo, and then choosing a Result color to replace all the colors in the photo that you need.

14. Click OK when you are finished replacing colors.

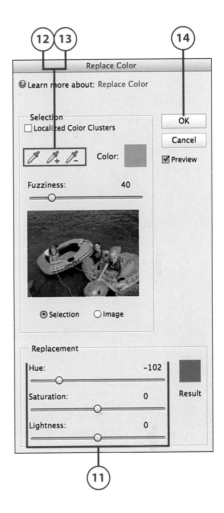

Using Photomerge Compose

Photoshop Elements 13 has a new feature for creating a great group shot—Photomerge Compose. This new feature lets you take an object from one photo and then add it to another. It works similarly to the Guided Edits covered in Chapter 8, "Correcting and Retouching Photos Using the Guided Mode," in that it uses a wizard to guide you through the process. There are several Photomerge effects you can apply. You need to have two photos opened in the Photo Editor, one for the source photo and one for the destination photo.

Destination photo **Source photo**

1. In the Photo Editor, open two photos and then click the Expert mode.

2. Open the Photo Bin by clicking Photo Bin.

3. Select both photos by Shift+clicking them.

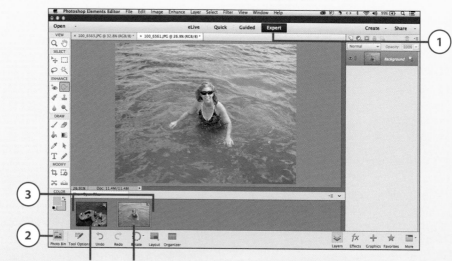

4. Choose Enhance, Photomerge, Photomerge Compose.

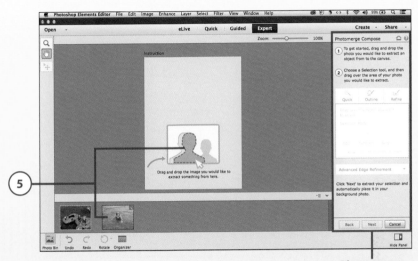

Photomerge Compose wizard

5. Click and drag the source photo from the Photo Bin to the prompt window.

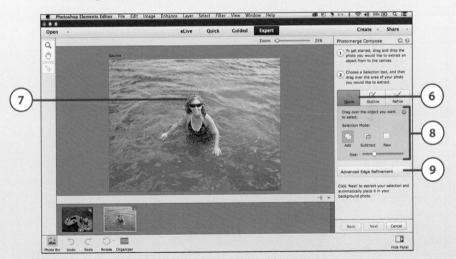

6. The wizard proceeds to the next step. Choose a selection technique.

7. Click and drag to select the object that you want to add to the destination photo.

8. Use the Add, Subtract, and New options to fine-tune your selection. Click the Size slider to set the size of the brush.

9. Click the Advanced Edge Refinement option and refine your selection edges.

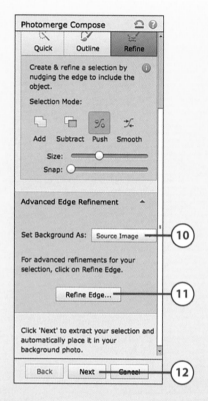

10. Click Source Image to set the background for the source photo to one of the following:

 - **Source Image**—This is the default setting, which uses the background from the source photo when the object is added to the destination photo.

 - **Transparent**—Turns the background in the source photo to transparent.

 - **Black**—Turns the background in the source photo to black.

 - **White**—Turns the background in the source photo to white.

 - **Overlay**—Uses the background in the source photo as an overlay.

11. Click Refine Edge to refine the edge of the object in the source photo.

12. Click Next.

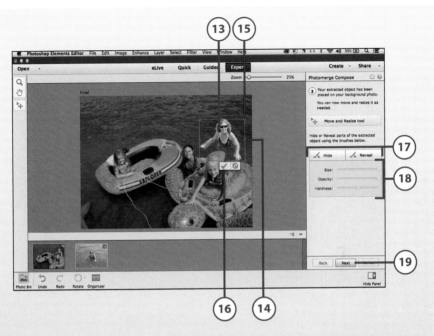

13. The source object displays in the destination photo. Click and drag it to the location in the photo that you want.

14. Click the handles and enlarge or shrink it to fit the destination photocomposition.

15. You can also rotate it by positioning your cursor outside of a corner handle, which causes the curved arrow to display, indicating the you can rotate the object. Click and drag to rotate the object.

16. Click Confirm.

17. Fine-tune your source object by clicking the Hide or Reveal options and then dragging around the source object to adjust what is revealed or hidden in the source object.

18. Use the Size, Opacity, and Hardness options to fine-tune each Hide or Reveal option that you apply.

19. Click Next.

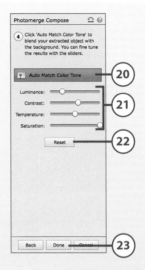

20. Click the Auto Match Color Tone option to adjust the color tone of the source object with the destination photo.

21. Click and drag to adjust the Luminance, Contrast, Temperature, and Saturation sliders to further adjust the color tone.

22. If needed, click Reset to reset the color tone.

23. Click Done to finish the Photomerge process.

24. A new layer is created in the destination photo with the Photomerged source object.

Explore the Other Photomerge Enhancements

The Photomerge feature lets you apply other types of enhancements, such as Photomerge Exposure, Faces, Group Shot, Panorama, and Scene Cleaner. Each has a wizard that guides you through the enhancement. Explore these other Photomerge features to learn more about them and how to apply them to your photos.

Adding a Watermark

The final enhancement that we are going to cover is how to add a watermark to your photo. Watermarks are a way to informally copyright or brand your photos so others know that they are your photos. When you apply a watermark

it is added permanently to your photo. You'll save the watermarked photos in this process; it is a good idea to have a separate folder for grouping your watermarked photos. This lets you keep the original photo in your catalog.

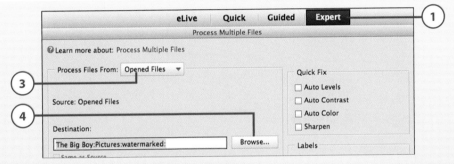

1. In the Photo Editor, click the Expert mode.

2. Choose File, Process Multiple Files.

3. In the Process Multiple Files window, click the Process Files From menu and choose one of the following:

 - **Folder**—Designate a folder that holds the photos you want to watermark.
 - **Import**—Import new photos so you can watermark them.
 - **Opened Files**—Watermark any opened files in the Photo Editor.

4. Set the destination folder by clicking Browse and navigating to the folder.

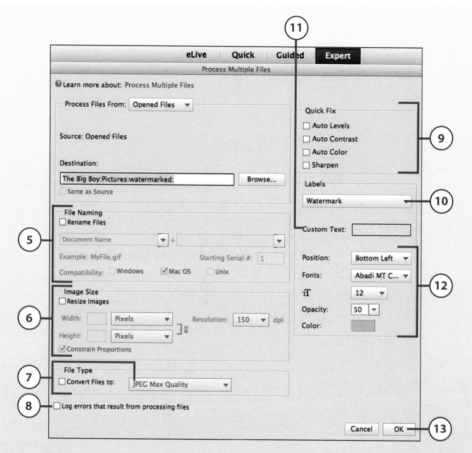

5. Click the Rename Files option if you want to rename your photos after applying the Watermark. Set the options for a naming convention. Leave this unselected to use the same name as the original photo.

6. If you want to automatically resize your images, click the Resize Images option and set your resize settings.

7. If you want to automatically change the file type, click the Convert Files To option, and then click the File Type menu to set the file type.

8. Click the Log Errors That Result From Processing Files option to create a log of file errors during the watermark process.

9. Click any of the Quick Fix options to automatically apply these fixes during the watermark process.

10. Click the Labels menu and choose either Watermark or Caption.

11. If you chose Watermark in step 10, click in the Custom Text field and type your watermark text—for example, Copyrighted 2014.

12. Set the Position, Font, Font Size, Opacity, and Color for the watermark by choosing from the menus, Color Picker, and setting the Opacity slider.

13. Click OK to initiate the watermark process.

14. To see your watermarked photo, open it from the folder you designated in the watermark process.

Filter
Variations Filters

Effects

In this chapter, you will learn how to add special effects, textures, filters, and frames to your photos. Also covered is how to draw and paint on your photos. You can use both the Quick and the Expert modes of the Photo Editor to add these enhancements. Topics include the following:

→ Drawing and/or painting on a photo
→ Adding Shapes to a photo or selection
→ Applying Effects to a photo in the Expert mode of the Photo Editor
→ Applying Filters to a photo in the Expert mode of the Photo Editor
→ Applying Textures to a photo in the Quick mode of the Photo Editor
→ Applying Frames to a photo in the Quick mode of the Photo Editor

Enhancing Photos

Photoshop Elements 13 offers many features to modify and enhance your photo images and photo projects. You can apply preset effects, textures, filters, and frames to your photos. Draw and paint on your photos or add preset shapes. This chapter explores all these enhancement features and functionality.

Applying Effects, Textures, Filters, and Frames

Both the Quick mode and the Expert mode offer tools and features for enhancing your photos. The Quick mode of the Photo Editor has Effects, Textures, and Frames that you can apply to a photo to enhance it. Like the Quick mode, the Expert mode also has the

Effects panel, but it also has Filters and Style tabs. Each of these features works the same in that you can choose from several preset Effects, Textures, and Frames to enhance your photos.

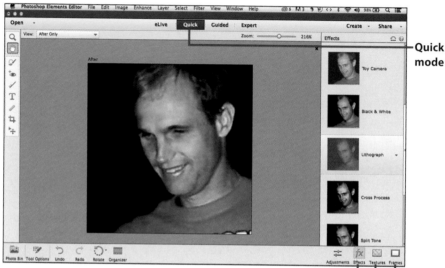

Quick mode

Effects | Frames
Textures

The Expert mode of the Photo Editor lets you apply Effects, Filters, and Styles to your photos. You can also make a selection in the photo and apply these special effects to just that selection. We look at both the Quick mode and the Expert mode enhancements next.

Expert mode Effects Filters Styles

Effects button

Adding Effects in the Quick Mode

The Quick mode of the Photo Editor has 10 different effects, and each has four variations of the effect that can quickly be applied to your photo, transforming it with a new look.

1. Open a photo from either the Organizer or from your hard disk in the Photo Editor. See Chapter 6, "Applying Quick Fixes with the Photo Editor" for how to open a photo in the Photo Editor.

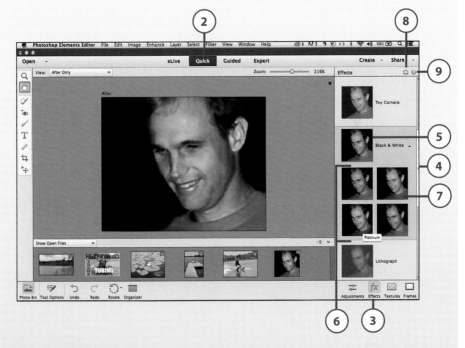

2. Click the Quick mode.

3. Click the Effects button in the taskbar. This button is a toggle button, so if you click this button again the pane closes.

4. In the Effects pane, use the scrollbar to scroll through the Effects.

5. Click the Effect that you want to apply.

6. Hover your mouse over any of the four preset variations of the Effect to see a ToolTip of the variation's name.

7. Click the one you want to apply.

8. Click the Reset button to reset the photo.

9. Click the Help button to launch Photo Editor Help for Effects.

Undo Does Not Work with Effects, Textures, or Frames

The Undo button does not work with Effects, Textures, or Frames. You need to use the Reset button in the upper-right corner of the active pane to undo your Effects, Textures, or Frames.

Adding Effects in the Expert Mode

Photoshop Elements 13 has beefed up the effects that you can use to enhance your photos. The Photo Editor has eight Effects in the Expert mode, and Adobe has added an additional four Effect Variations for each Effect. Unlike the Quick mode, the Expert mode lets you apply the Effect Variation not only to the entire photo but to just a selection in the photo or to an individual layer as well.

1. Open a Photo in the Photo Editor and click the Expert mode.

2. Click Effects in the taskbar.

3. If the Effects tab is not active, click it.

4. Click the Effects menu.

5. Click to choose an Effect.

6. Hover your cursor over an Effect Variation to see a ToolTip labeling the variation.

7. In the Effects pane choose a variation and drag it to either the photo, a layer, or to a selection in the photo. See Chapter 7, "Working with Layers," for how to create layers; see Chapter 9, "Advanced Photo Corrections," for how to make a selection and how to create a layer.

8. Click the Undo button in the task-bar to undo the Effect.

9. Explore the eight Effects and their Effect Variations.

Apply Multiple Effects

You can apply multiple Effect Variations to a photo, layer, or selection. You can also work between the Quick mode Effects and the Expert mode Effects, applying them to your photos. The possibilities are limitless for enhancing your photo to get the look that you want.

Adding Textures

Another nice feature that the Photo Editor has is Textures. This enhancement is available only in the Quick mode. There are ten preset Textures that you can instantly apply to your photo to enhance it.

1. Open a photo either from Organizer or from your hard disk in the Photo Editor.

2. Click the Quick mode.

3. Click the Texture button in the taskbar. This button is a toggle button, so if you click this button again the pane closes.

4. In the Texture pane, click any one of the ten preset Texture variations that you want to apply.

5. Click the Reset button to reset the photo.

6. Click the Help button to launch Photo Editor Help for Effects.

Adding One Touch Frames

You can also add a digital picture frame to your photos. Again, this enhance-ment is available only in the Quick mode. You can choose from ten one touch frames as well as use features for positioning and sizing the frame and the photo in the frame.

1. Open a photo either from Organizer or from your hard disk in the Photo Editor.

2. Click the Quick mode.

3. Click the Frames button in the taskbar. This button is a toggle button, so if you click this button again the pane closes.

4. In the Frames pane, hover your cursor over any one of the 10 preset Frames to see it display in the Viewer.

5. Click the Frame you want to add to the photo.

6. If the Tool Options bar is not displayed, click Tool Options in the taskbar.

7. By default, the Move tool is selected in the Toolbox and Move options are displayed in the Tool Options bar.

8. The Frame is added in a layer on top of the photo. The Tool Options bar presents layer options for organizing your layers in the photo—in this case, the photo and the frame layers. Under Move you can click to turn on and off the following settings:

 - **Auto Select Layer**—This setting is selected by default and automatically selects the photo layer—the background layer.

 - **Show Bounding Box**—This setting is selected by default and automatically displays the bounding box of the photo layer—the background layer.

 - **Show Highlight on Rollover**—This setting is selected by default and controls whether the Viewer displays the frame that you hover your mouse over.

9. Click the Arrange menu and choose any of the four menu options. The photo layer is the layer that is selected and these Arrange commands apply to that layer:

 - **Bring to the Front**—When working with layers, you can click to select a layer and then bring it all the way to the front to be the first layer with this command.

 - **Bring Forward**—When working with layers, use this command to move a layer forward one layer at a time.

 - **Send Backward**—When working with layers, use this command to move a layer back one layer at a time.

 - **Send to the Back**—When working with layers, you can click to select a layer and then send it to be the last layer with this command.

10. The Align and Distribute options are grayed out and not accessible with Frames.

11. You can also position, zoom, and orient your photo layer in the frame. Click one of the handles or position your cursor over the photo layer boundary and the cursor becomes a double-headed arrow tool. Click to select the boundary.

12. The Tool Options bar displays new options for orienting, transforming, sizing, and positioning your photo in the frame. To rotate your photo, click the Rotate option.

Degrees rotated

13. Move your cursor into the photo boundary and position it over a handle. The cursor becomes a curved double-headed arrow. Click and drag up, down, left, and right to manually rotate the photo.

Finding Hidden Handles

Sometimes when you are transforming a photo, you cannot see the corner handles because the size of the photo layer is larger than the frame. Note that there are always eight handles on the photo layer. To access these missing handles, click in the middle of the photo and drag up, down, left, or right to reposition the photo in the frames. You'll be able to find the handles as you move the photo around in the frame.

**Scale size in width
and height**

14. To manually scale a photo, click the Scale option.

15. Click a handle in the photo and drag left, right, up, or down to resize the photo. Hold the Shift key to constrain the scale to the photo's dimension ratio.

16. To skew the photo, click the Skew option.

17. Click a handle and drag left, right, up, or down, skewing the photo layer and the photo image.

Rotate, Scale, and Skew Anytime

You can rotate a photo layer in a Frame anytime, as long as the page boundaries are visible. Move your cursor into the photo in the viewer and position it over a corner handle. It automatically displays as the curved double-headed arrow tool; click and drag to rotate the photo.

The same is true for scaling and skewing. Position your cursor over a handle so that the cursor displays as a double-headed arrow tool. Click and drag to scale or skew the photo. If you click a handle that is in the middle of the photo layer boundary, you scale the photo, distorting the photo layer dimensions and the photo image. You can constrain this modification to the dimension ratio of the photo layer by holding down the Shift key while you scale the photo. If you click and drag a corner handle, this keeps the photo dimension ratio and scales the photo, keeping its image intact without any distortion.

18. Click a Reference Point to change this Reference Point location for the photo. By default the Reference Point is set for the center of the photo.

What Is a Reference Point?

Scaling and skewing are controlled based on the Reference Point location in the photo. The Reference Point location sets the point that scaling and skewing references for resizing and transforming a photo. Click any of the reference points to change this location. Practice scaling and skewing with a new Reference Point to understand better how this applies to transformations.

19. To move a photo around in the Frame, click in the photo and drag it left, right, up or down to reposition it.

20. To manually scale based on a percentage of the original photo, click in the W (Width) and H (Height) boxes and type a percentage between 1 and 100.

21. Click the Constrain Proportions box to force the scale to adhere to the photo's dimension ratio.

22. To manually rotate the photo, click in the Angle dial icon and drag the bar up, down, left, and right.

23. You can also click in the Degrees box and type in a degree.

24. To zoom in or out on the photo image, click and drag the Zoom slider left or right.

25. Click Confirm to apply the transformations.

26. Click Reject to cancel out of the transformation and return to the original photo orientation.

27. To return to the original photo, click the Reset button.

28. To get help on these features, click the Help button.

>>>*Go Further*
CREATING A MULTIPLE-FRAMED PHOTO

You can apply multiple Frames to a photo to create a custom frame. Click a Frame to apply it to the photo. Use the Transformation tools to position and size the photo in the Frame as you like. Then Confirm your transformations.

Click Textures, Effects, or Adjustments in the taskbar. Click Frames again to return to the Frames pane. Then click a second Frame type to apply it to the photo. Again, use the Transform options to position the frame within the first frame.

Applying Filters

You can also apply filters to your photos to stylize and enhance your photos and photo projects. Filters are accessible only in Expert mode. There are 12 filters, and each filter has multiple variations.

1. Open a Photo in the Photo Editor and click the Expert mode.

2. Click Effects in the taskbar.

3. Click the Filters tab.

4. Click the Filters menu.

5. Click to choose a Filter.

6. Hover your cursor over a Filter Variation to see a ToolTip labeling the variation.

7. In the Filters pane choose a Filter Variation and drag it to either the photo, a layer, or to a selection in the photo. See Chapter 7 for how to create layers; see Chapter 9 for how to make a selection.

8. Click the Undo button in the task-bar to undo the Filter.

9. Explore all 12 Filters and their Filter Variations.

Use the Filter Menu

You can also use the Filter menu in the Photo Editor menu bar to apply filters. This menu has all 12 Filters that are in the Filter pane of the Effect panel, as well as a new one, Adjustments filters. We cover Adjustments filters next. When you choose a Filter from the Filter menu, it is applied immediately to the photo based on the Photo Editor's analysis of the photo, the selected layer, or selection.

Using Adjustments Filters

There are also Adjustments filters available in Photoshop Elements 13. These are found under the Filters menu, and they let you apply specific adjustments to your photos, layers, and selections. The Adjustments filters are not found in the Filters pane of the Effects panel.

1. Open a Photo in the Photo Editor and click the Expert mode.

2. From the menu bar, choose Filter, Adjustments; then from the submenu choose one of the Adjustments filters.

Applying the Equalize Adjustments Filter

The Equalize Adjustments filter adjusts the brightness values of pixels in the photo. It calculates the brightness level of all pixels in the photo or the selection and adjusts them so that they are more evenly represented.

1. From the Photo Editor menu bar, choose Filter, Adjustments, Equalize.

2. If you are applying the filter to a selection in the Photo, the Equalize window displays. Click an Equalize option.

3. Click OK to apply the filter and close the window.

Applying a Gradient Map Adjustment Filter

The Gradient Map Adjustments filter analyzes the grayscale range in the photo or selection and then maps a gradient fill to that range of pixels.

1. From the Photo Editor menu bar, choose Filter, Adjustments, Gradient Map.

2. The Gradient Map window displays. Click this to get help on the Gradient Map feature.

3. Click the Gradient bar to access the Gradient Editor and create your own custom Gradient.

4. In the Gradient Editor, click the Preset menu and choose a preset gradient.

Choose a Preset Gradient

You can choose a Preset Gradient for a Gradient Map. In the Gradient Map window, click the triangle to the right of the Gradient bar. This displays the Preset menu of gradients. Click the Default menu to choose a Preset Gradient style. Then click a gradient swatch.

5. Click to select a gradient swatch.

6. Click the Type menu and choose a Type.

7. Click in the Smoothness field and type a number value between 0 and 100.

8. In the Name field type a name for the custom gradient.

9. Adjust the gradient's opacity by clicking and dragging the Opacity Stops.

10. You can manually adjust the location of an Opacity Stop by clicking it to select it; then click in the Location box and type a number from 0 to 100.

11. Click directly above the Gradient bar to add a new Opacity Stop.

12. To adjust the amount of opacity for an Opacity Stop, click it to select it; then click in the Opacity box and type a number between 0 and 100.

13. Adjust the flow of the colors in the gradient by clicking and dragging the Color Stops.

14. Click directly below the Gradient bar to add a new Color Stop.

15. To change the colors in the gradient, click a Color Stop to select it, and then click the Color Picker and choose a color.

16. To delete either a Color or Opacity Stop that you created, click it to select it. Then click the Trash Can icon to delete the selection. You cannot delete the default starting and ending Color or Opacity Stops.

17. Click the Add to Preset button to add your custom gradient to the Preset menu.

18. Click OK to create the gradient and close the window.

Using the Filter Gallery

Photoshop Elements 13 has a Filter Gallery that groups many of the filters and filter variations into one location. This Filter Gallery lets you manually set the amount of filter or filter variation you apply. To Access the Filter Gallery, click the Expert mode and then choose Filter, Filter Gallery from the Photo Editor menu bar.

1. Click a Filter to select it.

2. Click a Filter Variation.

3. Adjust the Filter settings by clicking and dragging the sliders for each option.

4. Click the New Filter Layer button to add a new layer.

5. Click a new Filter and variation to apply another filter to the image.

6. To delete a filter layer, click the layer.

7. Click the Trash Can icon.

8. Click OK to save the Filters you applied.

Adding Titles and Text

You can also add titles, labels, and text to your photos. This allows you to explain a photo or personalize it with a message. The Photo Editor has many fonts and font sizes, as well as other text formatting options. Text is created on its own layer so that the photo image is not changed. This is called non-destructive editing. The Type tool automatically creates a layer called a text layer when you add text to your photo. You learn more about layers in Chapter 7.

Both the Quick and Expert modes have a Type tool in the Toolbox. This Type tool has seven Type Tools options you can use for your text. Each Type Tool option has its own options and settings. Following is an overview of each Type Tool option:

- **Type - Horizontal/Vertical**—Create text that displays horizontally or vertically in your photo.

- **Type - Horizontal Mask/Vertical Mask**—Use horizontal or vertical text to create a mask so that the background image is the fill of the text.

- **Text on Selection/Text on Shape/Text on Path**—Select an area in your photo or create a shape or path and then add text so that it flows around the selection area, shape, or path.

Adding Text on a Photo

The technique to add text to a photo is basically the same no matter which Type tool you select.

1. Open a photo either from Organizer or from your hard disk in the Photo Editor or a new document by choosing File, New from the menu bar.

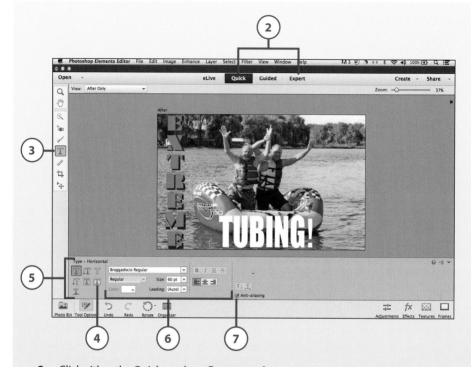

2. Click either the Quick mode or Expert mode.

3. Click the Type tool from the Toolbox.

4. In the Tool Options bar, hover your mouse over each Type Tool option.

5. Click to select a Type Tool option.

6. Click the format options you need to create the format and style of your text. Each Type Tool has its own format options, which are covered in the following topics.

7. Click the Anti-aliasing option to turn that on or off. By default this is selected.

What Does Anti-aliasing Mean?

Anti-aliasing is a feature of the Type Tools that will smooth out the jagged edges that can be present in text, especially when it is really large. By smoothing the edges, the text is more readable. The general rule is if your font size is smaller than 12 points, do not turn this feature on because it makes the text harder to read in small font sizes. But any text 12 points or larger can benefit from the Anti-aliasing option.

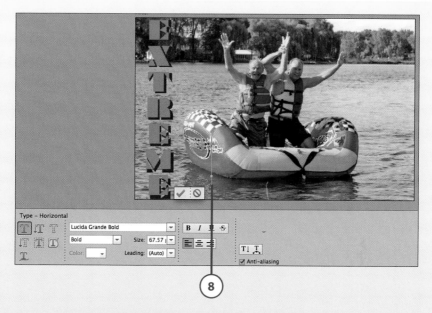

8

8. Move your cursor into the photo and position it where you want to add your text. Then do one of the following:

 - Click to set your cursor in a single line text box directly on the photo. This creates a new transparent text layer.

 - Click and drag to create a rectangle; this sets a paragraph text box. Again, this creates a new transparent text layer.

Creating a Line of Text or a Paragraph of Text

Text can be created in a single line or in a paragraph with the lines of text wrapping within the paragraph boundaries. If you click once in your photo you create a single line of text that will keep extending to the right as you type more text. You can press Return (Mac)/Enter (PC) to manually create a new line of text.

You can also create a paragraph for your text by clicking and dragging a rectangle in the photo. This creates the paragraph block of text defined by the rectangle border. When you type your text, it is restricted in the rectangle, and all lines of text will wrap to create a paragraph.

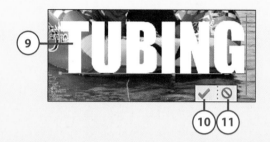

9. Type your message.

10. Click Confirm to add the text to the photo.

11. Click Reject to discard the text.

Text Tool and Move Tool

When you confirm your text, the Photo Editor switches immediately to the Move tool in the Toolbox. This is so you can position your text block in your photo. You might not like this functionality and prefer to have the Text tool stay active. You can change the default setting in the General category of the Photo Editor Preferences, which is covered in the online bonus content for this chapter at www.quepublishing.com/title/9780789753809.

Editing Existing Text Messages

After you have text in your photo, you can edit it. You can change, delete, or add words as well as modify the font or font style used. You can also reposition or move the text to a new location in the photo with the Move tool. Click to select the Type tool from the Toolbox and then click in the text you want to edit. Double-click a word in your message to select it or triple-click any word to select the entire message. You can also click and drag to select a few words, partial words, a character, or the entire message. With the text highlighted, choose any of the text format options you want, or press Delete and type in a new message.

Creating Horizontal or Vertical Text

The most common text that people create is horizontal text that flows across your photo. You can also create vertical text that flows down. You can create a single line of text or paragraphs.

1. Open a photo from either from Organizer or from your hard disk in the Photo Editor, or open a new document by choosing File, New from the menu bar.

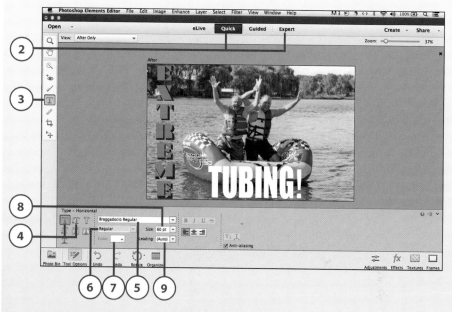

2. Click either Quick mode or Expert mode.

3. Click the Type tool from the Toolbox.

4. In the Tool Options bar, click either the Type - Horizontal Tool option to create horizontal text messages, or click the Type - Vertical Tool option to create vertical text messages.

5. Click the Font menu and choose a font.

6. Click the Font Style menu and choose font style.

7. Click the Color Picker and choose a font color for the text.

8. Click the Size menu and choose a font size. You can also double-click in the Size box and type a custom size.

9. Click the Leading menu and choose a leading size. Leading is the space between lines of text in a paragraph. You can also double-click in the Leading box and type a leading value.

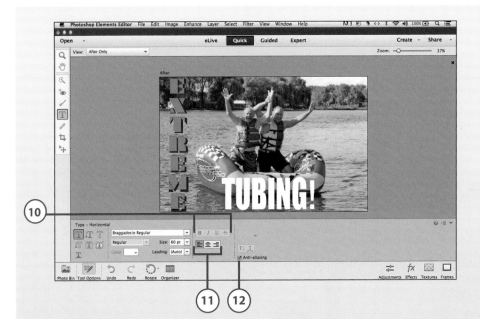

10. If the Font you select does not have a Bold or Italic variation, click a Faux style to apply that to the selected text.

 - **B**—Click this to add **Bold** to the selected text.

 - **I**—Click this to apply *Italic* to the selected text.

 - **U**—Click this to add <u>Underline</u> to the selected text.

 - **S**—Click this to apply ~~Strike Through~~ to the selected text.

11. Click an Alignment format: left, right, or center.

12. Click Anti-aliasing to turn this on or off.

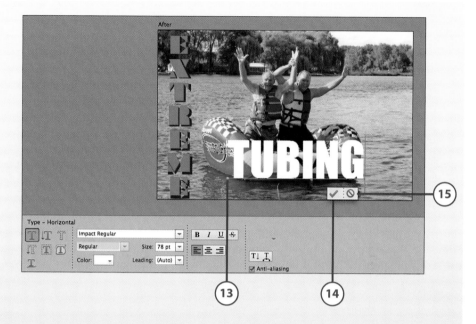

13. Click in the photo where you want to add your text and then type your message.

14. Click Confirm to add the text to the photo.

15. Click Reject to discard the text.

Creating Shadowed Text

Photoshop Elements 13 does not have an option for creating shadowed text, but you can use a workaround to create this text effect. To learn how to do so, check out the online bonus content for this chapter at www.quepublishing.com/title/9780789753809.

Creating a Mask from Text

Text can be used as a mask, creating all sorts of fun effects for your text. When you use text as a mask, the background of the photo becomes the fill area of the text based on where you position the text block. You do this instead of setting a color for the text. The Type-Horizontal Mask and the Type-Vertical Mask are the next two Type tools in the Tool Options bar. These two Type Tools create a masking layer. See Chapter 7 for how to work with masking layers.

Creating Text on a Selection

You can also create text that flows along a selection. This tool requires a single line text block but it is still a fun effect for a photo.

1. Open a photo either from Organizer or from your hard disk in the Photo Editor.

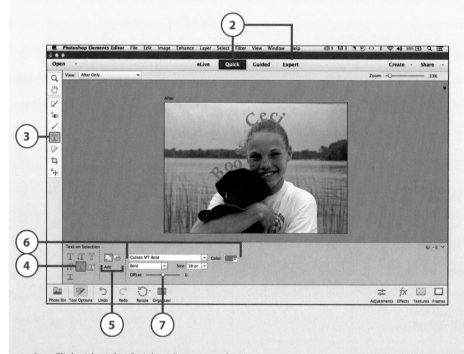

2. Click either the Quick or Expert mode.

3. Click the Type tool from the Toolbox.

4. In the Tool Options bar, click the Text on Selection Tool option.

5. Adjust your selection by clicking the Add to Selection or Subtract from Selection options and then adjusting your selection. See Chapter 6.

6. Set the Font formatting options and settings that you want.

7. Click the Offset slider and adjust the space that you want between the text and the selection path.

8. Click and drag around the edges of the object in the photo that you want to use for your selection path.

9. Click Confirm to save the selection path.

10. Click Reject to discard the selection path. You can try again by repeating step 8 to redefine a selection path.

11. With the selection path confirmed and visible, position your cursor on the path. It becomes an I-beam with a squiggle line indicating its position on the path. Click to set your cursor on the path.

12. Type your message.

13. Click the Toggle Text Orientation to flip the text orientation in its flow along the path.

14. Click Confirm to save the text.

15. Click Reject to discard the text.

Creating Text on a Shape

You can also create text along a shape that you draw directly on your photo. This again creates a layer for the shape and the text as it flows along the path of the shape. The process is similar to the previous topic, "Creating Text on a Selection."

1. Open a photo either from Organizer or from your hard disk in the Photo Editor.

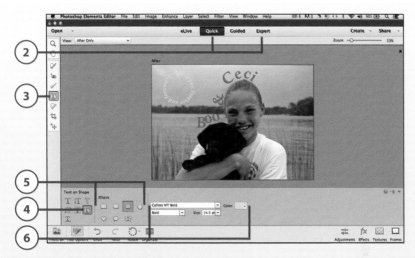

2. Click either the Quick or Expert mode.

3. Click the Type tool from the Toolbox.

4. In the Tool Options bar click the Text on Shape Tool option.

5. Click a shape from the Shape options.

6. Set the Font formatting options and settings that you want.

7. Click and drag out the shape you selected. To constrain it, hold down the Shift key.

8. Click Confirm to save the selection path.

9. Click Reject to discard the selection path; you can try again by repeating steps 6–7 to set the selection path.

10. With the shape path confirmed and visible, position your cursor on the path. It becomes an I-beam with a squiggle line indicating its position on the path. Click to set your text block on the path.

11. Type your message.

12. Click the Toggle Text Orientation to flip the text orientation in its flow along the path.

13. Click Confirm to save the text.

14. Click Reject to discard the text; you can try again by repeating steps 9–13 to create your text.

Creating Text on a Path

You can also create your own path that is not determined by an existing object or shape in the photo. This lets you create whatever shape or path size that you want. You can even modify the path by repositioning the points that create the path.

1. Open a photo either from Organizer or from your hard disk in the Photo Editor. You can also open a new document by choosing File, New from the menu bar.

2. Click either the Quick or Expert mode.

3. Click the Type tool from the Toolbox.

4. In the Tool Options bar click the Text on Path Tool option.

5. Click the Draw option.

6. Click in the photo and drag a path.

7. Click the Modify tool to modify the path.

8. With the Modify tool, click a point on the path and drag to a new location to straighten or create more of a curve to the path.

9. If you want to delete a point, hold down the Option (Mac)/Alt (PC) key and click a point.

10. When you have the path as you like, click the Draw option again. The Confirm and Reject buttons display.

11. Click Confirm to save the path.

12. Click Reject to discard the path; you can try again by repeating steps 6–10 to set another path.

13. To add text to the path, position your cursor on the path. When your cursor becomes the I-beam with a squiggle line through it, it has adhered to the path. Click to set your cursor on the path.

14. Set the Font formatting options and settings that you want. See the section, "Creating Horizontal and Vertical Text," earlier in this chapter.

15. Type your message with the chosen settings.

16. Click Confirm to save the selection path.

17. Click Reject to discard the selection path; you can try again by repeating steps 13–16 to create your message along the path.

Creating Warp Text

You might have noticed as we have worked through the Type Tool options that we have not covered an option—the Create Warped Text option. This option is accessible for the Horizontal/Vertical Type tools and the Horizontal/Vertical Mask tools. When one of these tools is selected, you can access this option in the Tool Option bar above the Anti-aliasing check box.

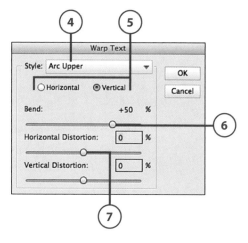

1. Using the Horizontal/Vertical Type tool or the Horizontal/Vertical Mask tool to create your text. See the "Creating Horizontal or Vertical Text" section earlier in this chapter.

2. Triple-click the message to select it.

3. Click the Create Warped Text tool.

4. This opens the Warp Text window. Click the Style menu and choose a Warp style. You'll see the existing text transform to the Text Warp style in the Viewer.

5. Click to choose an Orientation for the text block.

6. Click and drag the Bend slider left or right to adjust the bend of the Warp style. You can also click in the Bend box and type a percentage between 1 and 100.

7. Click and drag the Horizontal Distortion slider left or right to adjust the Horizontal Distortion of the Warp style. You can also click in the Horizontal Distortion box and type a percentage between 1 and 100.

8. Click and drag the Vertical Distortion slider left or right to adjust the Vertical Distortion of the Warp style. You can also click in the Vertical Distortion box and type a percentage between 1 and 100.

9. Click OK to close the window.

10. Click Cancel to cancel out of the Create Warped Text option.

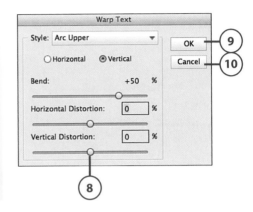

Paint and Draw on Photos

The Expert mode of the Photo Editor includes paint and draw tools. These tools are found in the Toolbox and you can use them to draw, paint, and create shapes in your photos using colors and gradients.

Draw and Paint tools

Using the Brush Tool

The Brush tool lets you paint on your photos. This tool has three Brush options and each has its own set of options and settings for achieving the brush effect or painting style you want. You can adjust the size and style of your brush and paint in different modes, such as an airbrush. You can set your opacity and color. This tool also has Tablet Settings for painting with a tablet or mobile device.

1. Open a photo either from Organizer or from your hard disk in the Photo Editor.

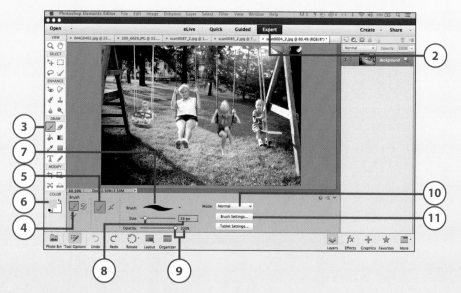

2. Click the Expert mode.

3. Click the Brush tool from the Toolbox.

4. In the Tool Options bar, the Brush option is selected by default. If it is not, click it.

5. Click a Mode option.

6. Click the Color Picker and choose a color for painting.

7. Click the Brush Picker menu and choose a brush style.

8. Click and drag the Size slider to set the brush size. You can also click in the Size box and type a number for exact pixel size.

9. Click and drag the Opacity slider to set the opacity of the paint color.

10. Click the Painting Mode menu to set a new paint blending mode.

11. Click Brush Settings.

Foreground and Background Colors

The Color Picker sets colors for both Foreground and Background. By default, when you click the Color palette, you are setting the Foreground color. You can click the curved double-headed arrow icon to switch the foreground color with the background color. To return to the default setting of a white foreground and black background colors, click the black and white squares icon.

Painting Modes for Blending Colors

Photoshop Elements has the same blending modes of Photoshop CC for its paint and draw tools, which gives you many choices for your brush. Experiment with these blending modes to see how your brush strokes interact with other colors in the image. Also see the online bonus content for this chapter for a description of each blending mode, at www.quepublishing.com/title/9780789753809.

12. Set your Brush Settings by clicking and dragging the sliders for each option.

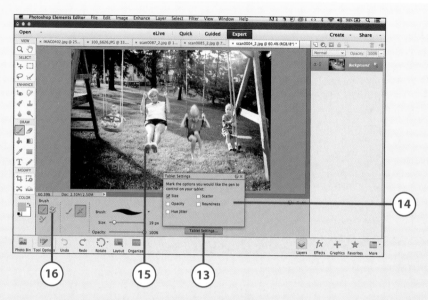

13. If you are using a tablet or a mobile device, click Tablet Settings.

14. Set your Tablet Settings by clicking the option check boxes.

15. Click in the photo and drag a brush stroke.

16. Click the Impressionist Brush option.

17. Click to set the Impressionist Brush option settings, which work the same as the Brush Option settings covered in steps 5–10.

18. Click the Advanced button to set advanced settings for the Impressionist Brush.

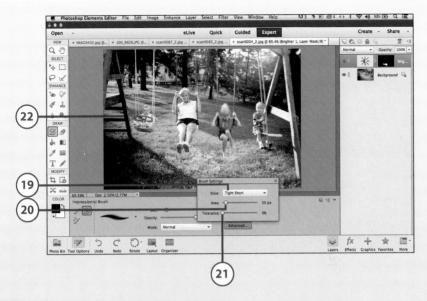

19. Click the Style menu and choose a style.

20. Click the Area slider and set the area size that the brush will affect. You can also click in the Area field and type a number.

21. Click the Tolerance slider and set the tolerance level. You can also click in the Tolerance field and type a number.

22. Click and drag to paint in the photo.

Layers and Painting

It is wise to create a new layer prior to painting with the Brush tool. This lets you paint on a layer that is on top of your background photo image so that you do not destroy your photo. If you do not like your painting, you can delete the layer, leaving the rest of the photo untouched. See Chapter 7.

Using the Color Replacement Brush and Settings

The third Brush tool is the Color Replacement Brush tool, which lets you replace colors in your photo.

1. Open a photo either from Organizer or from your hard disk in the Photo Editor.

2. Click the Expert mode.

3. Click the Brush tool from the Toolbox.

4. In the Tool Options bar, click the Color Replacement Brush tool option.

5. Click the Size slider and adjust the size of your brush.

6. Click the Tolerance slider and adjust the Tolerance for replacing a color. A low setting replaces only colors similar to the selected color, and a high setting is more liberal in the colors that are replaced based on the selected color.

7. Click the Mode menu and choose a Color mode.

8. Click a Limits option.

9. Click the Brush Setting button and set your Brush settings.

10. Click to deselect Anti-aliasing.

11. Click a Sampling option.

 - **Sampling: Continuous**—This option continuously samples colors as you drag the Color Replacement Brush.

 - **Sampling: Once**—This option samples color only one time as you drag the Color Replacement Brush.

 - **Sampling: Background Swatch**—Samples only the background layer and replaces color in this layer as you drag the Color Replacement Brush.

12. Click the Color Picker and choose the color you want to use as the replacement color.

13. Click a color in the photo. This sets the color to be replaced.

14. Click and drag in the photo to select the areas that you want to replace colors.

Drawing with the Pencil Tool

The Pencil tool lets you draw anywhere on your photo with hard-edged lines. It is similar to the Brush tool, but it can give you more precision in the stroke you create, just like a pencil can be used to achieve finer details and precision. Like any tool in Photoshop Elements, it has its own set of tool options and settings.

1. Open a photo either from Organizer or from your hard disk in the Photo Editor.

2. Click the Expert mode.

3. Click the Pencil tool from the Toolbox.

4. Click the Color Picker and choose a color.

5. In the Tool Options bar click the Pencil Brush menu and choose a brush style.

6. Click the Size slider and adjust the size of the pencil stroke. You can also click in the Size field and type a number.

7. Click the Opacity slider and adjust the pencil stroke opacity.

8. Click the Blend Mode menu and choose a blending mode.

9. Click the Auto Erase option to automatically erase the color you set for the pencil tool from the Foreground Color Picker. This works only if you start your pencil stroke on an area of the photo that has the foreground color in it. It paints in the background color over areas that have this foreground color within the stroke.

Constraining Brush Strokes

You can constrain a brush stroke to a straight vertical or horizontal line by holding the Shift key while you drag your stroke in the photo.

Creating Shapes

Photoshop Elements can create rectangles, ovals, and other preset shapes. These shapes are vector shapes, meaning that they are formed by lines, curves, and points. Vector images are created through a mathematical algorithm, which is different from a raster or bitmap shape that is created by pixels.

There are eight Shape tool options under the Shape tool in the Toolbox. This tool's icon changes based on the last Shape tool option you used. You can set many options for each Shape tool option. When you draw a shape, Photoshop Elements automatically creates a Shape layer. This new Shape layer keeps the shape separate from the photo image and is a nondestructive form of editing for your photo.

1. Open a photo either from Organizer or from your hard disk in the Photo Editor.

2. Click the Expert mode.

3. Click the Shape tool from the Toolbox.

4. Click a Shape Tool option.

5. Set your settings and options.

6. Click and drag out a shape in your photo.

7. Click Layers from the taskbar to see your layers.

8. The Photo Editor creates a new Shape layer in the Layers panel.

Adding Rectangles, Lines, and Shapes
To learn more about adding rectangles, lines, and other shapes, see the online bonus content for this chapter at www.quepublishing.com/title/9780789753809.

Modifying Existing Shapes

After you have added shapes and/or have painted or drawn on your photo, you can work with the layers to modify or adjust the shapes. You can use layers and the Shape Selection Tool option to work with your existing shapes. Use the Paint Bucket tool or the Gradient tool to change shape fill colors. Also use the Eraser tool to erase areas. Quickly sample colors in the photo to get the exact match you need.

1. To modify a shape, click the Shape tool from the Toolbox.

2. In the Tool Options bar, click the Shape Selection Tool option.

3. Click a shape to make it active. This also selects the layer that the shape exists on.

4. To customize the shape(s) on the layer, click the Shape Layer option and either add or subtract shapes on the layer.

5. Click the Combine button to combine shapes.

6. To manipulate the shape scale or size, click a handle and drag.

7. To rotate the shape, position your cursor by a corner handle. The curved double-headed arrow cursor displays; click and drag to rotate the shape.

8. Click the Confirm button to confirm the changes.

9. You can also move the shape to a new location by clicking and dragging it.

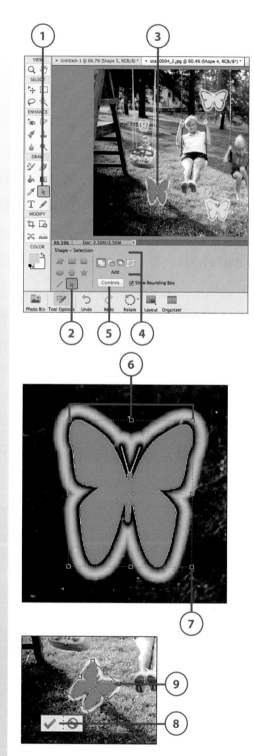

10. To modify the fill color, click the Paint Bucket tool.

11. Click the Color Picker and choose a new color.

12. Click in the active shape to fill it with the new color.

13. The Pattern Fill option does not work in this first release of Photoshop Elements 13. Hopefully, Adobe will correct this issue with the next update release of the software.

14. To work with another shape, click a different layer.

15. Work through steps 2–14 to edit other shapes.

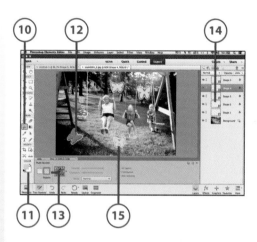

Erasing Shapes and Images

Use the Eraser tool to erase parts of shapes or even your photo image. You need to convert the background layer to a regular layer to erase the photo image. Click to select the Eraser tool from the Toolbox, and then set your Option settings. Click the layer that has the image you want to erase. Then drag through the active image.

Eraser tool **Drag through shape**

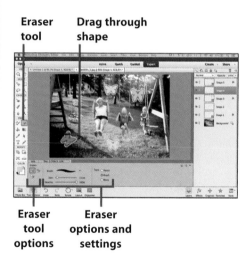

Eraser tool options **Eraser options and settings**

Setting Type Preferences

The Type Preferences of the Photo Editor can be used to customize how the Type tool works. This topic is covered in the online bonus content for this chapter at www.quepublishing.com/title/9780789753809.

Toolbox

Adjustments

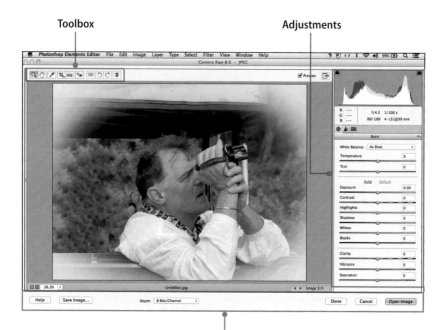

Taskbar

In this chapter, we cover how to use the Camera Raw feature of Photoshop Elements 13. You learn how to open raw image file formats in Camera Raw. Then use the tools of Camera Raw to fix with precision common problems that occur in digital photography, such as exposure, sharpness, color, and color tonal issues. Topics include the following:

11

→ Opening raw image files in Camera Raw
→ Applying white balance adjustments
→ Applying exposure and sharpening adjustments
→ Sharpening an image
→ Reducing image noise
→ Saving a Camera Raw image file

Processing Photos in Camera Raw

Camera Raw files are being used more and more in digital photography due to the massive amounts of data that this file format can contain. The Camera Raw feature of Photoshop Elements lets you take advantage of all this data by making enhancements and edits to the data prior to processing and compressing the file. This chapter covers using the Camera Raw feature of Adobe Photoshop Elements 13.

What Are Camera Raw Images?

When you take a picture with your digital camera, you might have an option to store your picture in raw format on the camera. This type of image is minimally processed and compressed by the camera—it's Camera Raw data. A Camera Raw image can be compared

to a photo negative used in film photography in that the image is not usable as a photo in this state, but it contains all the information you need to create the photo. You cannot open a raw image file through the typical Open command in the Photo Editor. It has to be opened in the Camera Raw feature of Photoshop Elements 13, and then you can perform edits and modifications to adjust contrast, color, sharpness, and white balance. This file type has a wider range in its color gamut and because it is not processed yet, it preserves most of the photo information. You can manipulate the raw data to adjust and enhance the photo, getting the best possible quality before taking it into Photoshop Elements. Then in Photo Editor you can use all the tools, filters, and enhancements that we cover in this book.

Digital Cameras and File Format

The Camera Raw image file format is specific to your digital camera, with most being propriety formats of your specific camera. Because of this, there are hundreds of image raw file formats. The Camera Raw feature of Photoshop Elements 13 can understand many of these raw file formats. When it opens an image in raw file format, Camera Raw identifies the data that it can manipulate with its Camera Raw features. Your camera might not be compatible with the Camera Raw feature, but most are. To check this compatibility visit Adobe's website at http://helpx.adobe.com/creative-suite/kb/camera-raw-plug-supported-cameras.html.

Opening Camera Raw Images

After you download your Camera Raw images from your camera, you can open them in the Photo Editor using the Open in Camera Raw menu command. These files have a different file extension, such as CRW or CR2, indicating that they are Camera Raw images. The raw data of the file can then be manipulated using the Camera Raw controls of the Photo Editor to enhance the image. When the image is enhanced, it can then be saved in a Photoshop Elements supported format and either imported into your catalog or opened normally in the Photo Editor. This process leaves the original Camera Raw image untouched and creates a new file that has been processed and compressed and therefore can be opened in the Photoshop Elements.

1. In the Photo Editor, choose File, Open in Camera Raw.

2. In the Open window, navigate to your Camera Raw files, and click Open.

3. The file(s) open in Camera Raw.

4. Click a tool from the Toolbox. These tools work the same as tools in the Photo Editor. See Chapters 6, 7, and 9.

5. Click the Zoom tool to zoom in and out on your image.

6. Click the Hand tool to move your image around when zoomed in.

7. Click the White Balance tool to adjust the white balance in your image.

What Is White Balance?

The white balance in a photo is recorded as metadata when the photo is shot. This information is used to set the color balance of the image based on the lighting conditions at the time the picture was taken. The photo color cast and gamut is based on the white balance. Typically this information is correct for the image, but you might need to adjust it through the White Balance tool and other adjustments of Camera Raw.

8. Click the Crop tool to crop your image.

9. Click the Straighten tool to straighten an image.

10. Click the Red Eye Removal tool to correct the red-eye effect in a photo.

11. Click the Open Preferences Dialog to open the Camera Raw preferences.

12. In the Camera Raw Preferences, click the Save Image Settings In menu and choose either Camera Raw Database or Sidecar ".xmp" Files.

Camera Raw Save Image Settings

There are two Camera Raw Save Image settings, Camera Raw Database or Sidecar .xmp. The Camera Raw database indexes by file content and stores the settings in a Camera Raw database. This retains the Camera Raw settings even if the file is moved or renamed. The Sidecar XMP setting stores the file content in a separate file that is stored in the same folder as the Camera Raw file. Refer to Adobe's website, www.Adobe.com for more information about Camera Raw file types.

13. Click the Apply Sharpening To menu and choose whether to apply sharpening to All Images or just to the Preview File Only.

14. Choose the Default Image Settings by clicking the options you want.

15. Click the DNG Tile Handling options that you want.

16. Click OK.

17. Rotate left or right to rotate the photo 45 degrees left or right.

18. Mac only, click the Trash icon to mark a photo for deletion. This is a toggle button; click the Trash icon again to unmark the image for deletion. You cannot delete Camera Raw files in Camera Raw for Windows.

19. Click the Preview option to deselect it and turn off the preview of changes you make with the Camera Raw settings. By default this is selected.

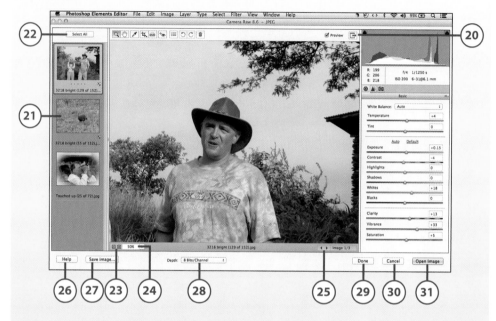

20. Click Toggle Full Screen Mode to work in the Full Screen Mode. Click again to return to the regular Camera Raw workspace.

21. If you opened multiple images, you have a Photo Bin on the left. Click a photo to switch to that photo.

22. To select all images to apply changes to at one time, click the Select All button and then adjust your settings.

23. Click a Zoom setting to change your zoom.

24. Click the Zoom menu to change to a preset zoom. You can also click in the Zoom field and type a custom number.

25. If you have multiple images opened, click the Previous or Next buttons to cycle through your opened images.

26. Click Help to get help on the Camera Raw mode, tools, and functionality.

27. Click Save Image to process and compress the image into DNG format, which is Adobe's proposed standard format for Camera Raw files.

28. Click the Depth menu to set either 8 Bits/Channel or 16 Bits/Channel.

29. Click Done to apply your settings and not open the image in the Photo Editor.

30. Click Cancel to cancel out of your edits to the image in Camera Raw.

31. Click Open Image to apply your settings and open the image in the Photo Editor.

Open Processed Images in Camera Raw

Photoshop Elements lets you open other image file types, such as JPG, PNG or TIFF, in Camera Raw. This lets you take advantage of the Camera Raw adjustments and enhancement features on a processed file.

Working with Basic Adjustments

Three panes enable you to access adjustments and settings for Camera Raw: Basic, Detail, and Camera Calibration. The default pane is the Basic pane, and here you have access to many adjustments for fixing problems in the raw format image. You can correct overexposed or underexposed images, sharpen or fix contrast issues, and work with color, color saturation, and tonal issues. You can also clarify an image. All adjustments have a histogram that graphically displays the range of the tonal adjustments you make to the image.

1. Open an image in Camera Raw.

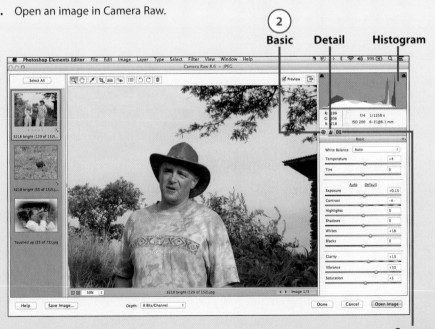

2. By default, the Basic pane should be displayed; if it's not, click Basic.

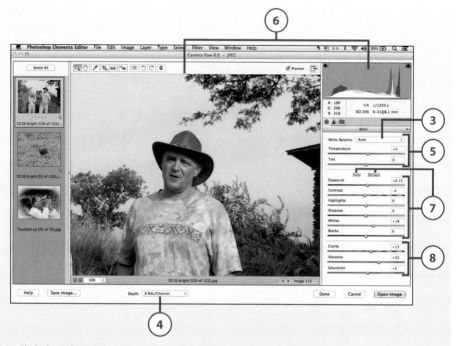

3. Click the White Balance menu and choose one of menu choices:

 - **As Shot**—This setting uses the camera's white balance settings.

 - **Auto**—This settings uses Camera Raw to read the white balance settings.

 - **Custom**—This setting is automatically selected when you use the White Balance tool from the Toolbox and you manually click and select colors to pull from the color cast of the image.

Understanding the White Balance Adjustments

You have a choice of using your camera's white balance information or using the auto White Balance feature of Camera Raw. You can also create your own custom white balance by using the White Balance tool in the Toolbox. Select this tool, and then click in the image on a color that you want to pull from the color cast of the image.

4. To get the most color information from your raw image when applying adjustments, click the Depth menu and choose 16 Bits/Channel.

5. Click and drag the Temperature and Tint sliders to adjust these settings. You can also click in the Temperature or Tint fields and type a number.

6. If you have Preview selected, the Preview image shows the adjustments and the Histogram reflects the new color tonal range. This occurs each time you make an adjustment.

Interpreting the Histogram

The Histogram displays the channel's color using the RGB color mode. This helps you see where your colors and color settings are in the image. If they are all bunched up in one area, this provides information about your image, such as whether it is heavy in shadows or highlights. As you adjust the various settings, the histogram adjusts to show the graphical display of the changes you are making to the image. Move your cursor into the image and you will see the color channels display the RGB values at that location in the image.

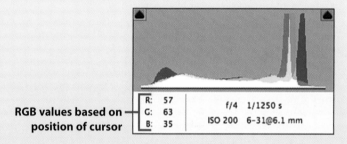

RGB values based on position of cursor

R: 57
G: 63
B: 35

f/4 1/1250 s
ISO 200 6-31@6.1 mm

7. The next set of adjustments control Exposure, Contrast, Highlights, Shadows, Whites, and Blacks. You can do one of three actions:

 • Click Auto to let Camera Raw adjust the settings based on its analysis of the file format information.

 • Click Default to use the default settings.

 • Click and drag the sliders to manually adjust the settings.

8. The next set of adjustments control the Clarity, Vibrance, and Saturation of the image. Click and drag to adjust the sliders.

Checking the Camera Raw Process

Camera Raw has been in Adobe Photoshop Elements since the Version 6 release. You might have used Camera Raw with other images. When you open a file in Camera Raw, it automatically interprets the image's raw file format and identifies the most current and improved features in Camera Raw that will work with your image. Photoshop Elements has three Process Versions that it uses for your file:

- Process Version 2012, which is the default and is used in Adobe Photoshop Elements 2011 and later.

- Process Version 2010, which is used in Photoshop Elements 2010.

- Process Version 2003, which is used in Photoshop Elements 2009 and earlier.

You can check what version was used for your files by clicking Camera Calibration and then clicking the Process menu. This lets you match earlier files that you modified in Camera Raw with your new files by changing this menu to match the process method used for your older files.

Also note that some of the adjustments in the Basic and Detail panes might not be accessible if the process method you choose does not support that feature.

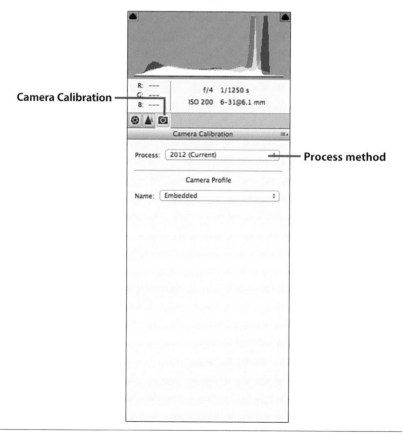

Camera Calibration ——

Process method

Working with Detail Adjustments

The Detail pane of Camera Raw lets you set adjustments to reduce the image noise that can be present in images. Image noise is the extraneous variations in the image brightness and color. This image noise reduces the quality of your image. The Detail pane lets you fix and smooth out these artifacts and grainy textures through adjusting the Sharpening and Luminance of the image.

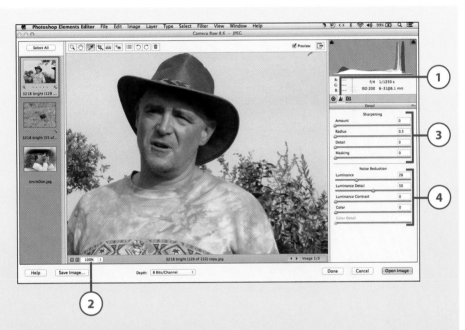

1. Click Detail to display the Detail pane.

2. Zoom in to at least 100% for your image, because you will be able to see these image noise adjustments better in the Preview image.

3. Click and drag the Sharpening sliders to adjust the sharpness of the image.

4. Click the drag the Noise Reduction sliders to adjust the Luminance and Color.

Color Detail Slider Not Accessible

The Color Detail Slider is not accessible when the Detail pane is first displayed. This slider is tied to the Color slider. You need to first adjust the Color slider and then the Color Detail slider becomes accessible and can now be used to adjust the Color Detail in the image.

Saving and Processing Your Camera Raw Images

After you have your image enhanced as you like, the final step to your Camera Raw adjustments is to save the image. When you save a Camera Raw image, it is processed and compressed into a file format Photoshop Elements can understand. This format is the DNG, or Digital Negative format, and is a standard for the Adobe products. Photoshop Elements can import and open this new image file. Camera Raw has a couple of techniques for saving raw file format images.

1. Click the Done button to save the raw image in DNG format and close Camera Raw.

2. Click the Save Image button and set your save file settings in the Save window with a set file format that you choose to process and compress the image.

3. Click the Open Image button to save the raw image in DNG file format and then open it in the Photo Editor.

4. Click Cancel to cancel your adjustments and settings. This returns the image to the original format.

New shapes added to
the Photo Editor

In this chapter, you learn how to extend the functionality of Photoshop Elements 13 through plug-ins and Adobe Add-ons. You can find many plug-ins for adding new enhancements, actions, brushes, styles, and custom shapes on the Internet. Topics include the following:

12

→ Downloading plug-ins and add-ons from the Internet
→ Installing plug-ins into Photoshop Elements 13
→ Adding and using actions
→ Adding new brushes
→ Adding new styles
→ Adding custom shapes

Extending Photoshop Elements Functionality

There are few ways to get additional functionality in Photoshop Elements 13. Adobe Add-ons and third-party plug-ins are available for extending the functionality of Photoshop Elements in a variety of ways. For instance, you can download a plug-in for new special effects or enhancements and install it in Photoshop Elements. Now these new special effects or enhancements are available to you when you work in the Photo Editor. There are Adobe Add-ons and plug-ins for adding actions, brushes, styles, and custom shapes. This chapter explores how to get a lot more functionality and features for the Photo Editor and how they can be used immediately with your photos.

Extend Photoshop Elements Functionality

You can add Adobe Add-ons and plug-ins to extend Photoshop Elements 13 functionality. These can be enhancements, filters, actions, styles, brushes, and custom shapes. Because Photoshop Elements is similar to Photoshop, you can even install some of the Add-ons or plug-ins that are made for Photoshop. Not all Photoshop Add-ons or plug-ins will work with Photoshop Elements, but many do.

Adobe has free and retail Add-ons for both Photoshop Elements and Photoshop through the Adobe Add-ons or Adobe Extension Manager.

Other third-party websites specialize in plug-ins for both applications. They offer free and retail plug-ins that you can install to extend Photoshop Elements 13 functionality. You need to search the Web to find these third party plug-ins and then download them.

Based on where you find your Add-on or plug-in, the site will have instructions on how to install it.

1. To find an Add-on/plug-in, do one of the following:

 - In your browser, search the Web with the keyword phrase "Photoshop Elements Plug-ins" or something similar.

 - In your browser, go to Adobe Exchange/Add-ons by typing https://www.adobeexchange.com/ into your browser address line.

2. Explore and choose an Add-on/ plug-in by clicking it.

3. Check the compatibility of the Add-on/plug-in; some are for Mac or Windows only, and some are just for Photoshop.

4. When you find the Add-on or plug-in that you want, follow the developer's instructions for downloading it. Pay attention to the instruction on where the plug-in is located in the Photoshop Elements workspace.

Installing Compressed Plug-ins

Many times, downloaded plug-ins are in compressed or Zip format. You'll see an extension of .zip following the plug-in name. You need to unzip the plug-in before you can install it.

Installing zipped or compressed plug-ins in Photoshop Elements 13 is relatively simple. You place the plug-in into a folder where you will store your plug-ins. The Preferences in the Photo Editor let you designate a folder for your additional plugs-ins.

1. At the Operating system level, double-click the plug-in to unzip it.

2. Open the Photo Editor. See Chapter 1, "Getting Comfortable with the Photoshop Elements 13 Workspace, Preferences, and Settings."

3. Open the Photo Editor Preferences by choosing Photoshop Elements Editor, Preferences, Plug-ins (Mac)/Edit, Preferences, Plug-ins (PC).

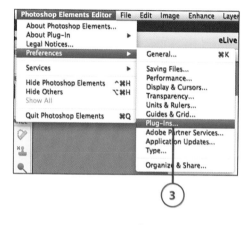

4. In the Plug-ins Preferences, review the default setup indicating that the Additional Plug-ins Folder will be used for additional plug-ins. If you want to change this to a different folder, click Choose and designate a new folder.

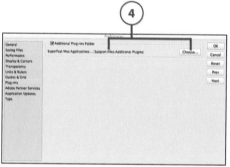

Additional Plug-ins Folder

By default the Additional Plug-ins Folder is used as the folder for storing any plug-ins you download for Photoshop Elements. You can choose any folder you want, but it is a good idea to place this folder in the Photoshop Elements folder.

5. Switch to your operating system and drag the unzipped plug-in file (or folder) to the Additional Plug-ins folder in the Photoshop Elements application folder.

6. Restart Photoshop Elements by quitting the application and then reopening it. This causes Photoshop Elements to load any new plug-ins.

Disable Installed Plug-ins

Be aware that the more plug-ins you install, the more RAM (random access memory) is used and the slower Photoshop Elements operates. You can disable the plug-ins that you do not use very often. For example, maybe you installed a plug-in for a project you were working on six months ago but now you don't need it. You don't want to uninstall it, but you want to disable it. You can by putting a tilde (~) before the plug-in file or folder name.

Using Plug-ins

Based on their purpose, all plug-ins work a little differently. Some are little applications that launch inside of Photoshop Elements and let you toggle between the workspace and their application. Others are added to menus in Photoshop Elements. Also, brushes, filters, and enhancements can be added to the Filters or Enhancement panels in the Photoshop Elements workspace. Pay close attention to the developer's instructions on how to install and then use the plug-in.

Adding and Using Actions

Actions are prerecorded steps that you need to perform to create certain functionality. For instance, there are actions that create a certain enhance-ment effect or type of frame. These actions, when initiated, instantly create the effect or frame in your Photoshop Elements document. These are huge time savers and can be downloaded from the Internet or accessed directly in Photoshop. Some Photoshop actions work in Photoshop Elements because Photoshop Elements understands the file format. All actions end with the file extension of .atn. It's a good idea to create a new folder for your downloaded actions.

1. Download an action that you want to add to Photoshop Elements 13.

2. Open a photo in the Photo Editor.

3. Open the Actions panel by doing one of the following:

 - Choose Window, Actions from the menu bar.

 - Click the More button in the Tool Options bar, and then click the Actions tab.

4. To load a new action, click the Options menu and choose Load Actions from the list.

5. Navigate to the action you want to load. Click to select it and then click Open.

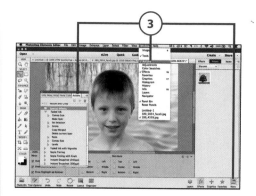

6. This loads the action into the Action panel. Find the action and select it.

7. Click Play to initiate the action on the opened photo.

8. To delete an action that you no longer want, click to select the action.

9. Click the Trash icon.

10. To stop an action that is in the process of being applied, click the Stop button.

Actions Menu

The Options menu in the right corner of the Actions panel also contains other commands that can help you manage and work with your actions. You can Reset Actions, Clear All Actions, Play, and Delete actions. Most panels have the Options menu, and it always contains commands that are specific to the panel that you have opened.

Adding Additional Brushes

You can also find other brushes either from Adobe Add-ons or from third-party developers. These can be downloaded from the Internet. It's a good idea to create a new folder for your downloaded brushes. Also, you can use some of the brushes developed for Photoshop. A brush has an extension of .abr, and Photoshop Elements recognizes this extension and therefore can load it as a new brush into Photoshop Elements 13.

1. Download a new brush that you want to add to Photoshop Elements 13.

2. Open a photo in the Photo Editor.

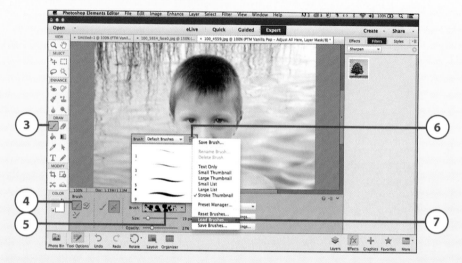

3. Click the Brush tool.

4. Click the Brush Tool option.

5. Click the Brush type menu.

6. Click the Options menu.

7. Click Load Brushes.

8. Navigate to the new brush and click to select it. Then click Open.

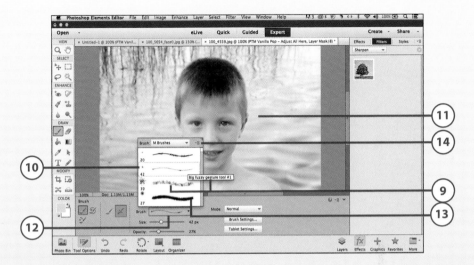

9. The new brush displays in the Brush Type menu. Hover your mouse over a brush type and a ToolTip displays the name of the brush.

10. Click to select a brush.

11. Paint in the photo where you want to apply the brush.

12. To delete a brush, click the Brush Type menu.

13. Click to select the brush to delete.

14. Click the Options menu.

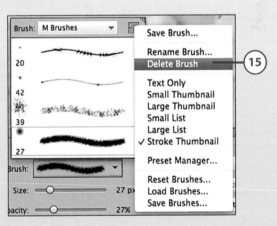

15. Click Delete Brush.

16. A window displays to confirm deleting the brush. Click OK.

17. You can also reset your brushes by clicking Reset Brushes.

Adding Additional Styles

New styles are another feature that you can find on the Internet and download to load into Photoshop Elements 13. Also, you can use some of the styles developed for Photoshop. A style has an extension of .asl. Photoshop Elements recognizes this extension and can load it as a new style. By using preset styles you can quickly get the enhancement that you want for your photos.

1. Download a new style that you want to add to Photoshop Elements 13.

2. Open a photo in the Photo Editor.

3. Click Effects in the taskbar.

4. Click the Styles tab.

5. Click the Options menu.

6. Click Load Styles.

7. Navigate to the new style and click to select it. Then click Open.

8. The new style displays. Hover your mouse over a style type and a ToolTip displays the name of the style.

9. Click to select a style.

10. Drag it to the photo or double-click it to apply it to the active layer.

11. To delete a style, click to select the style to delete.

12. Click the Options menu.

13. Click Delete *style name*.

Delete Only Styles You've Loaded

You can delete only styles you've loaded into Photoshop Elements. A style that was included in Photoshop Elements when it shipped can't be deleted.

14. You can also reset your styles by clicking Reset Styles.

Adding Custom Shapes

Just like styles, you can also load custom shapes into Photoshop Elements. They have the file extension of .csh and are vector graphics. Custom shapes are available on the Internet for download, and you can make your own custom shape. You can't use Photoshop Elements to make a custom shape, but you can use Photoshop. After you have downloaded or created your custom shape, you can load it into Photoshop Elements.

1. Download a new custom shape that you want to add to Photoshop Elements 13.

2. Close Photoshop Elements 13 by choosing Photoshop Elements Editor, Quit Photoshop Elements (Mac) or File, Quit (PC).

Copy .csh file into Shapes folder in Photoshop Elements 13, Support Files, Presets folder

3. Switch to your operating system and copy the uncompressed download for a custom shape into the Presets folder in the Photoshop Elements 13 application folder.

4. Launch Photoshop Elements and open the Photo Editor. See Chapter 1.

5. Click the Expert mode.

6. Click the Shape tool.

7. Click the Custom Shape tool in the Tool Options bar.

8. Click the Color Picker and choose a color.

9. Click the triangle to the right of the Custom Shape Picker.

10. Click the Shapes menu and click the new custom shape menu.

11. Click the custom shape you want.

12. In the photo, click and drag to add your new custom shape.

13. See Chapter 10, "Enhancing Photos," for how to modify and enhance shapes.

Use Photoshop to Make Custom Shapes

Photoshop can be used to create custom shapes. Custom shapes are vector images and have a .csh file extension. Visit this website to learn more about creating your own custom shapes to load into Photoshop Elements 13: http://www.sweetshoppedesigns.com/tutorials/index.php/2012/10/making-your-own-custom-shapes-in-photoshop/.

Photo book

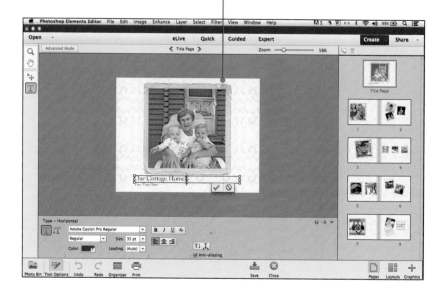

In this chapter, you learn how to create custom print projects, picture packages, and contact sheets. We also cover how to create photo projects such as photo books, photo calendars, collages, slideshows, and more. Learn a Photoshop Elements 13 new feature of creating a Facebook Cover for your Facebook profile and banner image. Topics include the following:

13

→ Creating custom print projects
→ Creating and developing a photo book
→ Creating a Facebook Cover photo
→ Uploading and using a Facebook Cover photo for your Facebook profile photo and banner
→ Creating a slideshow

Creating Greeting Cards, Collages, Photo Books, and More

Photoshop Elements 13 has a variety of photo projects you can create from your photos. You can create custom prints of your photos or print photo packages and contact sheets. You can also create photo books, photo calendars, slideshows, and collages, as well as greeting cards, CD/DVD jackets, and CD/DVD labels. These can be created in either the Organizer or the Photo Editor.

Custom Photo Printing

The Create menu is the key to creating your photo projects. You'll find this menu in both the Organizer and the Photo Editor. It contains many functions for creating photo projects. In this chapter, you use the Photo Editor to create, and then you can print picture packages and contact sheets that you make on the fly. See Chapter 15, "Printing Your Photos and Photo Projects," to learn how to print

in Photoshop Elements using your printer and online print vendors. You must first have the photos opened before creating or printing your photo project.

Based on whether you are using a Mac or PC, the Print and Photo Package windows are different. The process is similar, but the print feature is different in functionality and the window layout. Here is an overview of how to print in either platform from the Photo Editor.

1. Open the photos you want to print in the Photo Editor. See Chapter 2, "Importing Photos and Video."

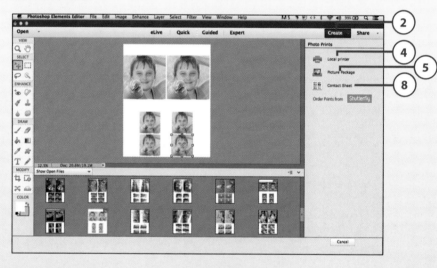

2. Click the Create button.

3. Choose Photo Prints.

4. Click Local Printer to print to your local printer. See Chapter 15.

5. Click Picture Package to create a picture package.

Macintosh

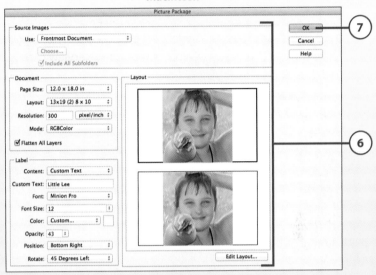

Windows

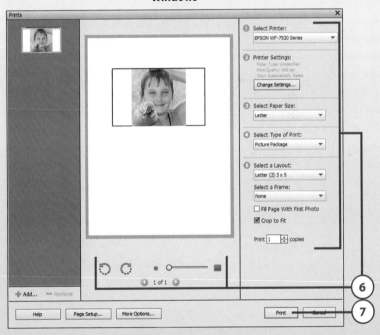

6. Set your print, paper, and photo settings.

7. To print, click this button.

8. Click Contact Sheet to print a contact sheet.

Macintosh

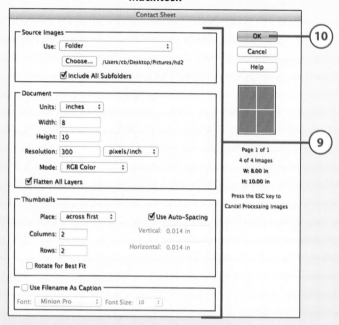

Windows

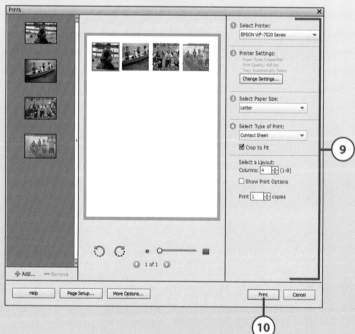

9. Set your print, paper, and photo settings.

10. Click this button to print.

11. Click Order Prints from Shutterfly (or your online vendor) to order photos from your online print vendor. See Chapter 15.

12. Click Cancel at any time to cancel out of the Photo Print option.

Access Specific Instruction on Printing Photos, Contact Sheets, or Picture Packages

Visit the online bonus content for this chapter at www.quepublishing.com/ title/9780789753809 for instructions on how to print photos, contact sheets, or picture packages using either Photoshop Elements 13 for Mac or Windows.

Creating Photo Projects

Photoshop Elements 13 has many photo projects you can create, such as photo books, calendars, and collages. You can modify and change the page layout and add graphics and shapes to each. That's a lot of flexibility for quickly creating the right project to showcase your photos. Next, we'll create a photo book because it is the most complex in steps, but you can use any of the features covered with the other photo projects.

1. The quickest way to create a photo book is to first open the photos that you want to showcase in the photo book in the Photo Editor or select them in the Organizer. See Chapter 2 for instruction on opening photos in the Photo Editor.

2. To review your opened photos, open the Photo Bin by clicking Photo Bin.

3. Click Create.

4. Click Photo Book.

5. In the Photo Book window, click the Print Size from the options listed.

6. Click the Theme you want for the photo book.

7. If you want to autofill the book with the opened documents in the Photo Editor, leave the Autofill with Selected Images option selected. Turn this off by clicking it to deselect it if you want to fill the pages with photos manually.

8. Click in the Number of Pages field and type the number of pages for your book.

9. Click OK.

Printing Photo Books

The print sizes listed in the Photo Book depend on your printer and the online print vendor that is in your geographic area. You will see different print sizes in the Photo Book window. Also, when you print locally, each side of the spread is printed on a separate sheet of paper. You can print 1 to 30 pages.

Photo Print Sizes Vary

You can create a photo book from 2 to 78 pages in length if you print to your local printer. If you are printing to an online print vendor, you need to check with them for the limits on pages for their photo books.

10. If this is the first time you have used this theme, you'll see the Adobe Photoshop Elements window display, indicating that it is downloading an Asset for the photo book. Click Cancel if you want to stop the process.

11. You'll see a series of message windows display and close as Photoshop Elements builds the photo book.

12. The title page displays in the Viewer. You can zoom in or out on the photo by clicking and dragging the Zoom slider to position it as you want.

13. Use the Hand tool to move the image around in the Title Page image placeholder.

14. To resize, click and drag the handles.

15. Click the Rotate button to rotate the image 45 degrees counterclockwise.

16. Click Confirm to confirm your changes to the title page photo. You'll need to center and size your other photos throughout the photo book.

17. To use a different photo, click Open and navigate to a new photo. You can also click and drag a photo from the Photo Bin on top of the Title Page photo in the Viewer.

18. Double-click in the Title and Text placeholders and type a title and text message. Click Confirm to add the text.

19. Use the Type tool options to format the text.

20. To go to a new page, click the page in the Photo Book Pages pane. You can also click the Previous or Next buttons.

21. To change the page layout, click Layouts.

22. Double-click a layout to apply it to the active page.

23. Use the tools in the Toolbox to add more type or size and position your photos and photo placeholders.

24. To access more tools, click the Advanced Mode.

Basic Mode and Advanced Mode

Basic Mode is the default mode that opens when you create a photo book, calendar, or collage. This mode is restricted in the tools and functionality that you can use. It is also set to print your photo project in 72 DPI. The Advanced mode gives you access to the full Toolbox of the Expert mode. This mode is set to print your photo projects to 220 DPI.

25. To delete a page, click the page and then click the Trash icon.

26. To add a new page, click New Page.

27. To rearrange the pages, click and drag a page to a new location in the pages panel. A horizontal bar displays between existing pages, indicating this is where the page will be located.

28. Click Graphics to access preset graphics to add to your photo book.

29. Click the Previous or Next buttons to go to the page you want to apply the graphic.

30. Double-click a Background, Frame, or Graphic. You can also click and drag a graphic to the active page in the Viewer.

31. Work between all the Tools, Tool Options, Photo Bin, panes, and modes to fine-tune your photo book.

32. Click Save to save the photo book.

33. Click Close to close the photo book.

Saving Photo Projects

When you save a photo project, it is saved in Photo Projects Format, or PSE. It is added to your Catalog and displayed in Organizer. You can designate where you save the project on your hard drive. Each photo project has a project file and supporting folders containing the files needed to support the project display. The project photos maintain links to the photos in your Catalog, so be careful when moving your photos to a different location on your hard drive, because this will break the link between the photos and your photo projects.

Creating Other Photo Projects

Choose any of the other Create menu commands for photo projects. Develop the project using the steps we just covered for the creation of the photo book. The Photo Collage, Photo Calendar, Greeting Cards, CD/DVD Jacket, and CD/DVD Label all use the same features and functionality of the Photo Book.

Creating a Facebook Cover

You can also create a Facebook Cover in Photoshop Elements and upload this directly to your Facebook page. You need to have a Facebook page and to set the link between Photoshop Elements and your Facebook page. There are a few techniques for creating the look you want for your Facebook Cover.

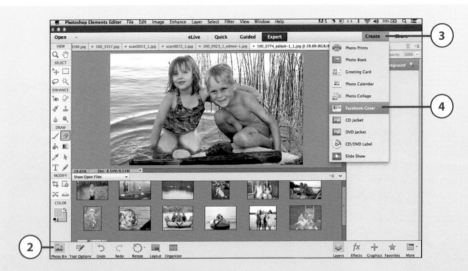

1. The quickest way to create a Facebook Cover is to first open the photos in the Photo Editor that you want to showcase in the Facebook Cover. You can also select the photos in the Organizer. See Chapter 2 for instruction on opening photos in the Photo Editor.

2. To review your opened photos, open the Photo Bin by clicking Photo Bin.

3. Click Create.

4. Click Facebook Cover.

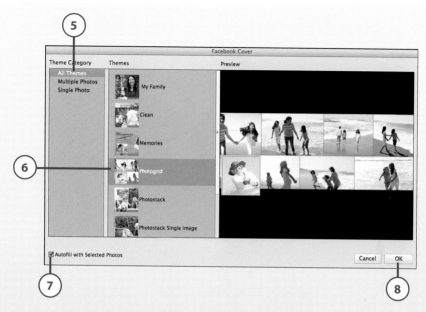

5. In the Facebook Cover window, click a Theme Category.

6. Click a Theme.

7. Click to deselect the Autofill with Selected Photos if you want to add your photos manually.

8. Click OK.

9. If this is the first time you have used this feature, you'll see the Adobe Photoshop Elements window display, indicating that it is downloading an Asset for the Facebook Cover. Click Cancel if you want to stop the process.

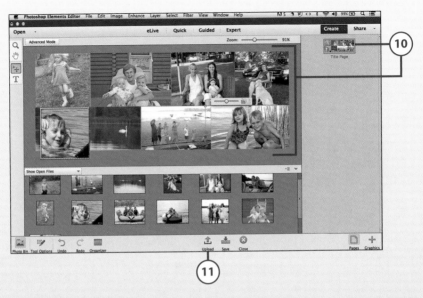

10. Your Facebook cover displays. You can edit and modify the photos as you learned in the previous topic.

11. To upload your Facebook Cover, click Upload.

12. You'll see a series of screens that set up the link between Facebook and Photoshop Elements. Your browser will also be accessed. Work through these screens until you see that you have successfully authorized Photoshop Elements to upload to Facebook.

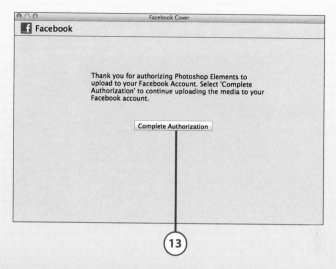

13. Switch back to the Photo Editor, and you will see another confirmation message. Click Complete Authorization to finalize the process.

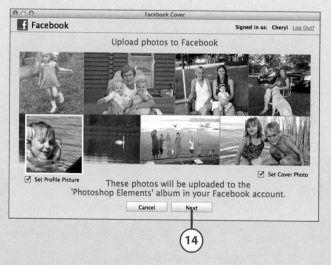

14. Another window displays, click Next.

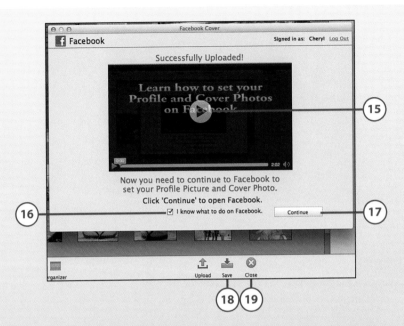

15. In the next window, click the video to see how to set your Profile and Cover Photos on Facebook.

16. Click the I Know What to Do on Facebook option.

17. Click Continue.

18. To save the Facebook Cover, click Save.

19. To close the Facebook Cover process, click Close.

Creating a Slideshow

You can also create a slideshow of your photos. You can generate a slideshow from either the Organizer or the Photo Editor. We cover how to use the Organizer to create a slideshow in this instruction.

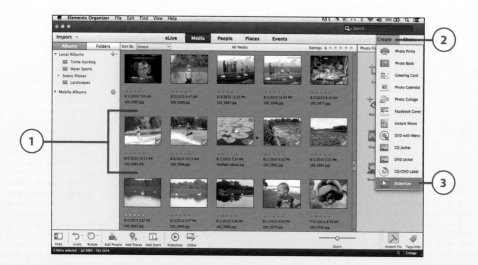

1. In the Organizer, select the photos that you want to use in your slideshow.

2. Click Create.

3. Click Slideshow.

4. In the Slideshow window, click a Theme.

5. Click Next.

6. Photoshop Elements prepares the slideshow and then automatically plays it for your review with the default settings and music.

7. Move your cursor into the slideshow to display the slideshow controls. Click the Play button to play the slideshow again.

8. Click Save to save the slideshow.

9. Click Export to export the slideshow.

10. Click Exit to close the slideshow.

11. Click the Edit button to edit the slideshow.

12. To remove a photo, click it and then click Remove.

13. Click Themes to change to a new theme.

14. The Themes area displays; click a new theme.

15. Click Apply to apply the new theme.

16. Click Audio to add your own music.

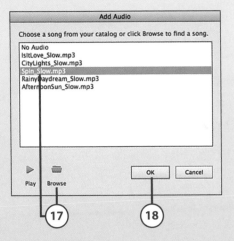

17. In the Add Audio window, click Browse and navigate to your music. Click to select the audio file you want for your slideshow.

18. Click OK to select the new music.

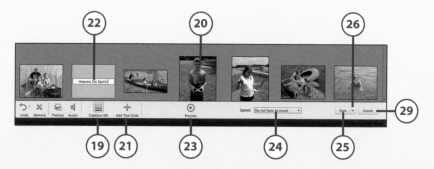

19. Click Captions On to turn on captions.

20. To add a Text Slide, first click the photo in the Viewer. The Text Slide will be inserted in front of this photo.

21. Then click the Add Text Slide.

22. In the new Text Slide, click and type your caption.

23. Click Preview to preview the slideshow.

24. Click the Speed menu and choose a speed menu option.

25. Click Save to save the slideshow.

26. You can also click the triangle to the right of Save to access the Save As command.

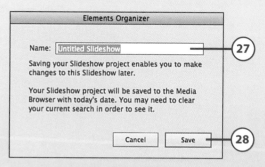

27. In the Elements Organizer window in the Name field, click and type a name for your slideshow.

28. Click Save.

29. Click Cancel to close out of the slideshow.

Share menu Share button

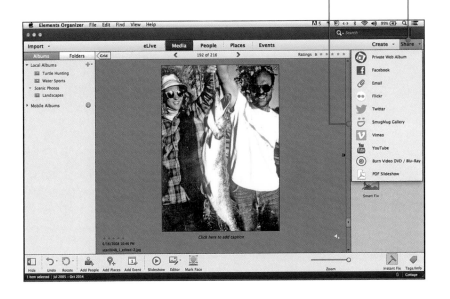

You learn how to share your photos and photo projects in this chapter. We cover how to set up and use the Private Web Album of Adobe Revel to share your photos online. Also learn how to share to social media sites like Facebook, Twitter, and Vimeo. Learn how to email and export your photos and how to burn your photos to a DVD/Blu-ray disc. Topics include the following:

14

→ Sharing photos and photo projects with a Private Web Album

→ Posting and sharing your photos on Facebook and other popular social media sites

→ Sharing photos through email

→ Burning a DVD/Blu-ray disc of your photos

→ Creating a PDF slideshow

→ Sharing photos in a website

→ Exporting photos

Sharing Your Photos

After you have enhanced and modified your photos, you'll want to share them with others. Photoshop Elements 13 has a variety of methods for sharing your photos. You can create an online Private Web Album and post your photos to this album. Then invite your friends and family to view them through a direct link to your Private Web Album. Also share your photos to popular social media sites. Other more traditional ways of sharing, such as exporting, emailing, or burning to a DVD disc, are covered as well.

Sharing Photos and Photo Projects

Both the Organizer and the Photo Editor have the capability to share photos and photo projects. Both have a Share button to share photos and photo projects. The Organizer offers more options for sharing, and we explore this menu in this chapter. The Photo Editor has fewer sharing options, and the ones it offers actually launch the Organizer to access the sharing functionality.

1. To access the sharing features of either the Organizer or the Photo Editor, click the Share button.

2. Choose the sharing menu command that you want.

Organizer Share menu

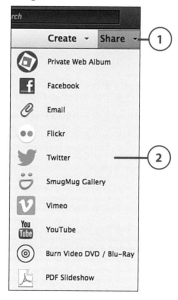

Photo Editor Share menu

Sharing to a Private Web Album

Adobe offers a solution for sharing your photos online through its Adobe Revel product. You can create a Private Web Album and post photos or photo projects there. Then you can send email invites to people you want to see your photos. You need an Adobe ID to use this Private Web Album sharing platform. When you sign up for an Adobe ID, you automatically get a complimentary account on Adobe Revel for up to 2GB of data. If you need more space you can purchase the Premium plan for $5.99/month for unlimited storage. Visit https://www.adoberevel.com/ for more information.

After you have an account set up with Adobe Revel, you can upload your photos and photo projects through the Share button in both Organizer and the Photo Editor.

1. In Organizer, click to select the photos or photo projects that you want to share. In the Photo Editor, open the photos or photo projects that you want to share.

2. Click the Share menu.

3. Choose Private Web Album.

4. The Private Web Album window displays. If you have an account with Adobe Revel, sign in with your Adobe ID. To create an Adobe ID, see the online bonus chapter content, "Creating an Adobe ID Through Photoshop Elements 13."

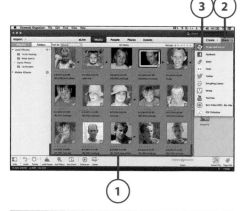

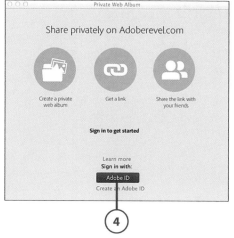

5. Adobe Photoshop Elements displays a series of windows for processing and then uploading the selected photos. Click Cancel if you want to cancel the process; otherwise, wait for the process to complete.

6. In the Private Web Album window, click the Library menu and choose your library to share.

7. Click the Add Album button.

8. In the Album field, type a name for your Private Web Album.

9. If you want to allow others to download your photos, leave the Allow Downloads option clicked. To disable this functionality, click to deselect this option.

10. Click Start Sharing.

11. Photoshop Elements again goes through a series of windows indicating that it is processing and uploading your photos and finally displays another Private Web Album window indicating successful sharing to Adobe Revel. Click the Guest Link to open an email message with the link. You can share your photos at this URL.

12. In your automatically generated email message, add the email addresses for your family and friends, and then send it.

13. Switch back to Organizer and click Done to complete the process.

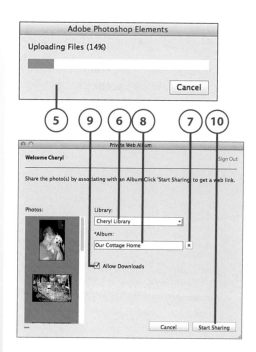

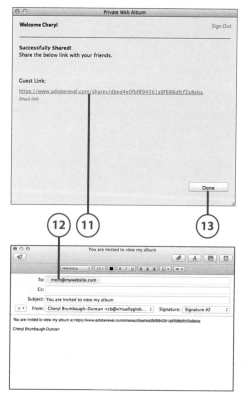

Posting Photos to Facebook

You can also share your selected photos and photo projects to Facebook. You need to have a Facebook account to do this.

1. In Organizer, select the photos to share to Facebook.

2. Click Share and choose Facebook.

3. In the Facebook window, click to deselect the Download Facebook Friend List option if you do not want Photoshop Elements to automatically download your Facebook Friends list. By default this option is selected.

4. Click Authorize to authorize Photoshop Elements to upload photos to Facebook.

5. The Thank You page opens in your browser.

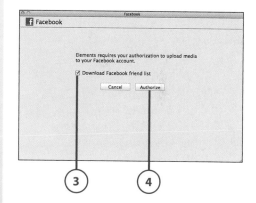

6. Switch back to the Organizer, and click Complete Authorization in the Facebook window.

7. In the Facebook window, click the plus sign to add more photos.

8. To delete a photo from the upload, click the photo(s) in the Preview, and then click the minus sign.

9. Click to deselect the Upload People Tags in these Photos if you do not want to include your People tags in the photo upload. By default, this is selected.

10. Click one of the following upload options:

 - Click Upload Photos to an Existing Album, and then click the triangle to choose an existing album that you have already up on Facebook.

 - Click Upload Photos to a New Album, and then click and type in the Name, Location, and Description fields.

11. Click in the Who Can See These Photos field and choose from the menu who can see the photos. This information is based on your Facebook account settings.

12. Click an option under the Choose Your Photo Upload Quality.

13. Click Upload to upload the photos.

14. Click Visit Facebook to see your uploaded photos.

15. Click Done to complete the Facebook upload process.

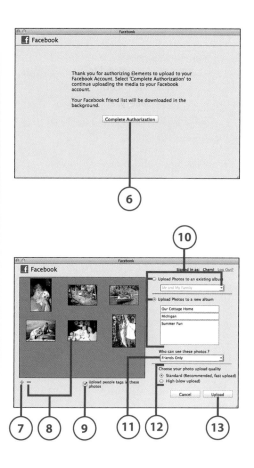

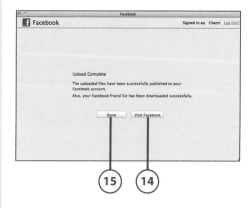

Uploading to Flickr, Twitter, SmugMug Gallery, Vimeo, and YouTube

The process to upload to Flickr, Twitter, SmugMug Gallery, Vimeo, and YouTube is similar to the Facebook process. You can post multiple photos to Flickr, SmugMug Gallery, and YouTube, but you can post only one photo at a time to Twitter. Use this instruction on Sharing to Facebook to help guide you through setting up sharing with these other social media sites. You need to already have an account with each of these social media sites prior to setting up the sharing process between Photoshop Elements and that particular site.

Sharing by Email

You can also share your photos as attachments in an email message. Photoshop Elements automatically identifies your email software and generates an email message.

1. In Organizer, select the photos to share by email.

2. Click Share and choose Email.

3. In the Email Attachments pane, to delete any of the photos you selected for sharing via email, click them and then click the Trash icon. This deletes the photos from just the email message, not from your Catalog.

4. By default, photos are converted to JPEG files and the Convert Photos to JPEGs option is selected. Click this to deselect it and attach your photos in their original file format.

5. If the Convert Photos to JPEGs option is selected, you can access other JPEG options. Click the Maximum Photo Size menu and choose a size option.

6. Click and drag the Quality slider to adjust the Quality setting for the photo(s).

7. Click Next.

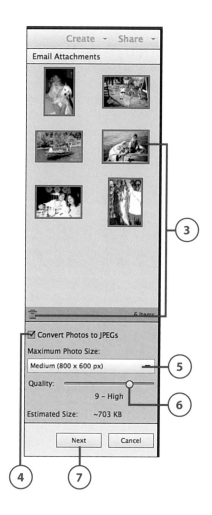

8. In the next Email pane, click Edit Recipients in Contact Book to choose your email recipients.

9. Click in the Subject field and type a subject for the email.

10. Click in the Message field and type a message for the email.

11. Click Next.

12. Photoshop Elements automatically generates an email message. Click Send to send the message.

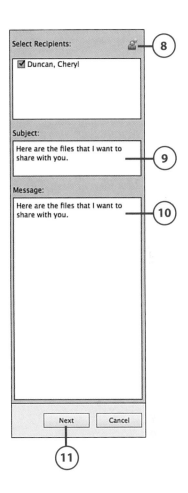

Sharing by Burning a DVD/Blu-ray Disc

You can also create a video of your photos and photo projects, and then burn your video to a DVD or a Blu-ray disc. Organizer processes the photos and imports them into Adobe Premiere Elements. You must have a copy of Adobe Premiere Elements for this feature to work. You also need to know how to use Adobe Premiere, which is outside the scope of this book.

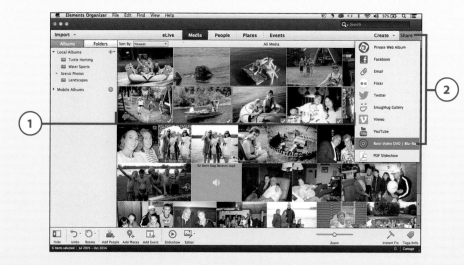

1. In Organizer, select the photos to share by burning a DVD or a Blu-ray disc.

2. Click Share and choose Burn Video DVD/Blu-ray.

3. In the Edit with Premiere Elements window, click OK.

4. If this is a new video project, you'll see the Missing Disc Menu window. Click Yes.

5. In the Choose a Menu Theme window, click a theme and then click Continue.

Photos added to Timeline **Adjustments**

Premiere
Elements
Timeline

6. Make your Adjustments, and then click Done.

Adobe Premiere Elements and Video

Adobe Premiere Elements is the video counterpart to Adobe Photoshop Elements. It lets you create your own videos and burn them to DVD or Blu-ray as well as share them online. When you choose the Burn Video DVD/Blu-ray command from the Share menu in Photoshop Elements 13, it accesses Adobe Premiere Elements for this functionality. The photos you select to burn are placed in the current video Timeline in Premier Elements Editor. This process works a little smoother if you already have Adobe Premiere Elements and a video project open.

7. Insert a writable DVD or Blu-ray disc into your computer.

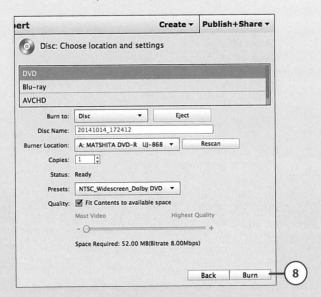

8. Select the options you need from the Disc window, and click Burn.

Sharing by PDF Slideshow

You can also create a PDF Slideshow for a group of photos and then email this PDF document to family and friends. This process creates a PDF document from your photos. You have control over the photo quality settings for your PDF document.

1. In Organizer, select the photos to include in the PDF Slideshow.

2. Click Share and choose PDF Slideshow.

3. Click and drag any additional photos from the Viewer to the PDF Slideshow pane.

4. Click the Maximum Photo Size menu and choose a photo size.

5. Click and drag the Quality slider to adjust the quality setting for the photos.

6. Click in the File Name for PDF Attachment field and type a file-name.

7. Click Next.

8. In the Email panel, choose a contact(s), create your subject and body message, and click Next. See "Sharing by Email" earlier in this chapter.

9. Photoshop Elements creates the PDF and opens an email mes-sage addressed to your chosen contacts. The PDF Slideshow is an attachment to this message. Click Send.

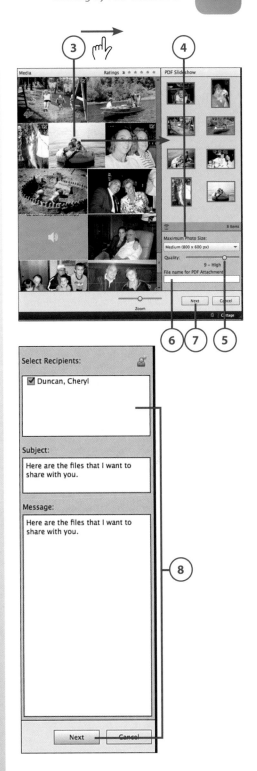

Sharing Photos in a Website

The Photo Editor lets you convert images and photos for use in a website. This requires that you optimize them for the Web by reducing them in resolution but maintaining the highest possible image quality. The Photo Editor guides you through this process. The Organizer does not have this Save for Web functionality.

1. In the Photo Editor choose File, Save for Web.

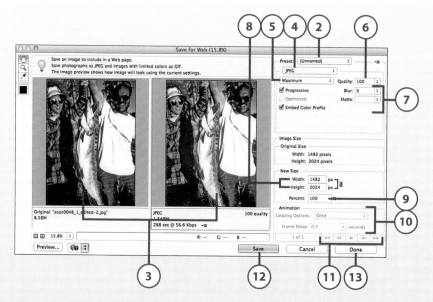

2. In the Save for Web window, click the Preset menu and choose a preset web format.

3. Compare the two preview images. The one on the left is the original image. The one on the right is the optimized preview of the photo. Having them side by side lets you compare your optimization while maintaining the best possible image quality.

4. To set your own optimization format and settings, click the Optimized File Format menu and choose a web graphic format.

5. Click the Compression Quality menu and choose a compression option.

6. Click the Quality menu and either choose a preset quality or click in the field and type a number.

7. Set the other compression options as needed.

8. If you want to resize the image, click in the Width and Height fields and type a dimension.

9. You can also click in the Percent field and type a number for a percent resize of the photo.

10. If you are saving a group of GIF files, you can combine them to an animated GIF file by clicking the appropriate Animation options.

11. Click the Video Playback buttons to play, rewind, and advance forward in your animation.

12. Click Save to save the web graphic.

13. Click Done.

Exporting Photos

The final way that you can share photos is to export them. You can export only from the Organizer. The export file formats that Photoshop Elements supports are JPG, PNG, TIFF, and PSD. You can also export the file in its original format.

1. In Organizer, choose File, Export as New File(s).

Save Photos

You can save your photos and photo projects. This topic was covered in Chapter 6, "Applying Quick Fixes with the Photo Editor."

2. In the Export New Files window, click Add to add other photos.

3. Click to select a photo in the Preview and then click Remove to remove the photo from the export process.

4. Click a File Type option.

5. Click the Help button to see information on export file types.

6. Set your Size and Quality options.

7. Set a location by clicking the Browse button and navigating to a folder.

8. To use a custom filename, click the Common Base Name option and then click in the field and type your common base name.

9. Click Export.

Photos to print Print preview Print settings

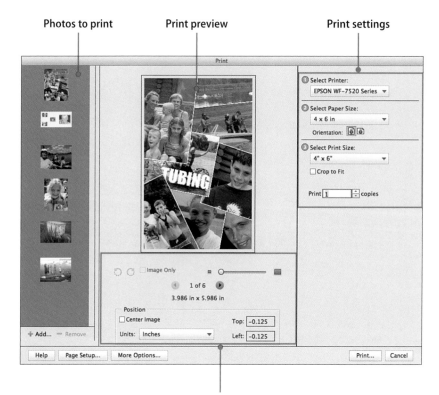

Layout and orientation
settings

In this chapter, you learn how to print in Photoshop Elements 13. You'll learn how to print to your local printer as well as to an online print service vendor. Topics include the following:

→ Printing to your local printer
→ Printing to an Adobe Partner specializing in print services
→ Printing to an online print service

Printing Your Photos and Photo Projects

Printing your photos and photo projects in Photoshop Elements 13 is similar to other software applications. A couple of Print commands are available in the menu bar. You have the option of printing to a local printer or to an online print service vendor through these commands.

Print to Your Printer

After your photos or photo projects have been modified and enhanced, they can be printed to your local printer. The Photo Editor is the only component that can print, and it has a Print command under the File menu in the menu bar. The Organizer offers a print command, too, but it opens the Photo Editor to perform the print. Each component can be used to initiate a print by choosing the Print menu command.

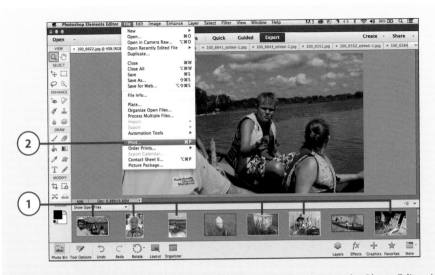

1. Click to select a photo or photo project from the Photo Bin in the Photo Editor. Use the Shift or Command (Mac)/Control (PC) keys to select multiple photos.

2. Choose File, Print.

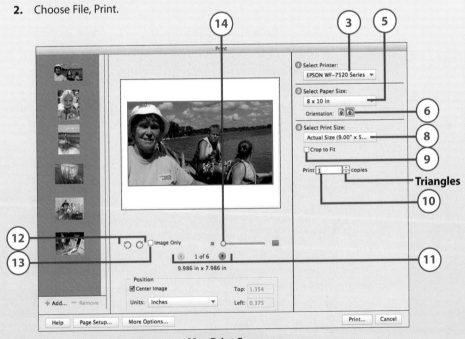

Mac Print Screen

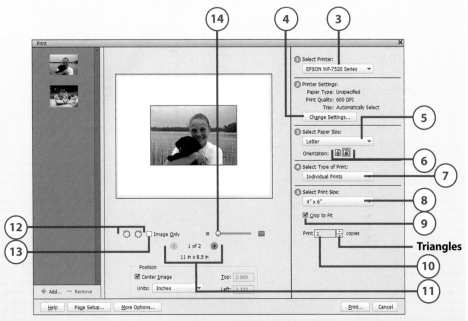

Windows Print Screen

3. Set your Print settings first by clicking Select Printer and choosing your local printer. The Print settings apply to all photos in the print batch.

4. (Windows only) Click Change Settings to change your Printer settings.

5. Click Select Paper Size and choose a paper size.

6. Click a paper Orientation option.

7. (Windows only) Click Select Type of Print and choose a type of print option.

8. Click Select Print Size and choose a print size.

9. Click the Crop to Fit option to crop the photo to fit the selected paper and print sizes.

10. Click in the Print field and type the number of copies needed. You can also click the triangles to the right to choose a number from the menu.

11. In the page layout and orientation settings area, make sure you are viewing the first photo of your selected photos. The layout and orientation settings apply to each photo individually. Click the Forward/Backward button to go forward or backward through the selected photos, setting the page layout and orientation settings for each photo.

12. To adjust the photo orientation of the active photo, click either the Rotate Left or Rotate Right button.

13. To rotate only the background image, click the Image Only option.

14. To zoom in on the photo, click and drag the Zoom slider.

Printing Multiple Photos or Photo Projects

The Print Settings, unlike page layout or orientation settings, apply to all selected photos. It is a good idea to choose photos or photo projects that you want to print at the same paper and print size. Use the Remove button in the Print window to remove photos that you might have selected in error; use the Add button to add more photos to the print batch.

Understand Rotate for Photo Orientation

You can rotate a photo Placeholder or the Image Only. The photo Placeholder sets the boundary of the area for the photo and is tied to the Print Size you selected. Click the Image Only option to rotate just the image in the photo Placeholder.

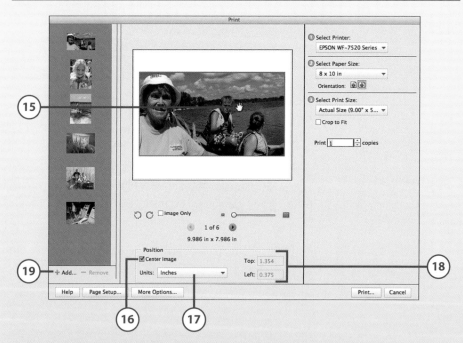

15. To center the image better in the new zoom view, move your cursor into the preview and click and drag to move the photo around.

16. Under Position, click Center Image to center the image in the photo placeholder.

17. Click the Units menu and choose a unit of measurement. The Position options are not accessible if the Center Image option is selected.

18. Click in the Top and Left boxes to set a new margin for the photo.

19. Click the Add button to add a new photo to the Print window. You can also select a photo and click Remove to remove it from the print batch.

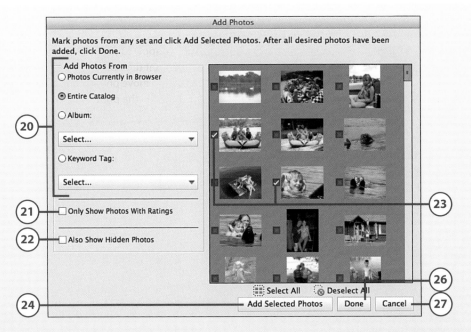

20. Under the Add Photos From area choose a photo from one of the following options:

 • **Photos Currently in Browser**—Click this option to choose photos from the Photo Bin.

 • **Entire Catalog**—Click this option to choose photos from your Catalog.

 • **Album**—Click the Album option and then the Album Menu to choose photos from your Albums.

 • **Keyword Tag**—Click this option and the Keyword Tag menu to choose photos from Keyword Tags.

21. Click Only Show Photos with Ratings to show only photos that have a rating attached.

22. Click Also Show Hidden Photos to show hidden photos.

23. In the Preview display, click the check box to the left of the photos to select the ones to add to the Print.

24. Click Add Selected Photos to add the selected photos to the Print.

25. Repeat steps 19–24 to add more photos.

26. Click Done to add the photos to the Print.

27. If needed, click Cancel to cancel out of the Add Photos window.

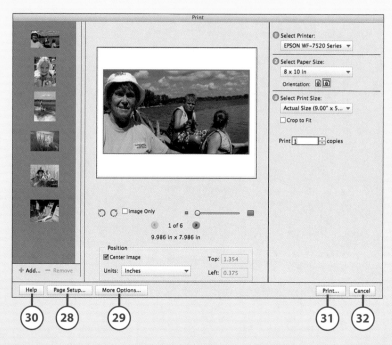

28. To change your page setup, click Page Setup.

29. Click More Options to access the More Options feature of your printer. See "Setting Printer More Options" next for how to set these options.

30. Click Help to access Photoshop Elements 13 Help.

31. Click Print to print.

32. Click Cancel to cancel the print.

Organizer and Printing

In the Viewer of the Organizer, you can also select photos to print. Choose File, Print from the Organizer menu bar.

Organizer doesn't perform the print; a window displays indicating that the Photo Editor has this printing feature. Click Yes to access the Photo Editor for printing the photos. Click No to cancel out of the Print feature.

>>>*Go Further*

PRINT LAYERS IN A PHOTO

You can also print just one layer in a photo or a selection of a few layers. To do this, first open the photo that has multiple layers in the Photo Editor. Open the Layers panel and click the Eye icon to the left of the layer to turn the layer either off or on.

Then choose File, Print. This opens the Print dialog box displaying the visible layers in the Preview. Select your Print Options and then click Print.

Setting Printer More Options

The More Options button in the Print window displays settings that are unique to the photo or photo project that you are printing. You can display a date, caption, or filename with your photo, as well as add borders and backgrounds. You can even print trim guidelines and crop marks or flip an image for iron-on transfer.

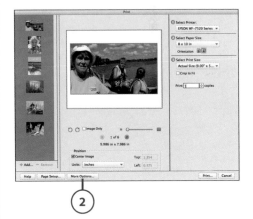

1. Select your photos to print, and then choose File, Print. Set your printer settings. See the previous section, "Print to Your Printer."

2. Click the More Options button in the Print window.

3. The Printing Choices category is selected by default; click it if it is not.

4. In the Photo Details area, click the check box to show the date, caption, or filename with the printed photo.

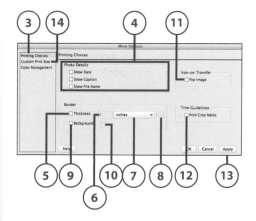

5. In the Border area, click Thickness to set a border width.

6. Click in the Thickness field and type a number.

7. Click the Thickness menu to set a unit of measurement.

8. Click the Border Color Picker to set a color.

9. Click Background to add a background color to the border area.

10. Click the Background Color Picker and choose a color for the background area enclosed in the border.

11. Click Flip Image to flip the image for an iron-on transfer.

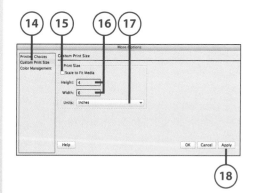

12. Click Print Crop Marks to set trim guidelines.

13. Click Apply.

14. Click the Custom Print Size category.

15. Scale your photo to fit a specific media size by clicking the Scale to Fit Media button.

16. Click in the Height and Width boxes and set a custom size if needed.

17. Click the Units menu and choose a unit of measurement.

18. Click Apply.

19. Click the Color Management category.

20. Click the Color Handling menu and choose the Color Management method.

21. Click the Printer Profile menu and choose a printer profile for your printer.

22. Click the Rendering Intent menu and choose how colors are handled when switching between color spaces.

23. Click OK to apply these new options.

24. If necessary, click Cancel to cancel More Options.

25. Click Help to access Photoshop Elements 13 Help.

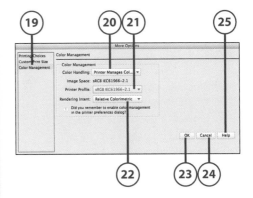

Use the Create Button to Print to Your Printer

You can also use the Create Button to print to your local printer. Click the Create button, and then click Local Printer. This opens the same Print window as the File, Print command in the menu bar. See Chapter 13, "Creating Greeting Cards, Collages, Photo Books, and More."

Use Adobe Partner Online Printing

You can also print your photo(s) or photo projects through an online print service. Adobe has an Authorized Partner program just for print vendors and Partner programs for other services, such as training or solutions. These are companies that specialize in Adobe products and have completed the Adobe Partner authorization and certification process. These companies specialize in custom printing for files created in Adobe products, such as Photoshop Elements 13, Illustrator CC, or Photoshop CC.

1. In your Browser type this URL into the Address line: http://partners.adobe.com/public/partnerfinder/psp/proxfind.do.

2. This opens the Adobe Partner Finder for print services page. Browse through the Adobe Partners listed and click Select to choose the one that you want.

3. This takes you to the selected Adobe Partner's website. Each partner has a different process for transmitting files. Follow the instructions for sending the partner your print jobs.

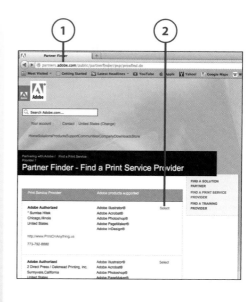

Adobe Partner Printing Services and Products

Each Adobe Partner specializes in printing files created with Adobe products by offering an array of printing, products, and other services. A few examples of their printing services are high-quality printing, large-format graphics, envelope/letterhead printing, CD/DVD duplication services, and other more advanced printing, packaging, and fulfillment services. Explore these Adobe Partners for more information about their printing services.

Online Resources for Photos, Greetings Cards, Photo Books, and Other Photo Projects

Adobe also has relationships with several online print vendors, such as Shutterfly.com in the USA or Commandez chez Service photo online in France. The File, Order Prints menu command in both the Organizer and the

Photo Editor prints to the closest online print vendor. You establish your location when you first open the Organizer and the Photo Editor, and this location sets up the display of the Order Prints menu command. Here are the four online print vendors based on four set locations that Adobe has identified as of the writing of this book.

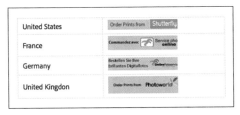

United States	Order Prints from Shutterfly
France	Commandez avec [logo] Service pho online
Germany	Bestellen Sie Ihre brillanten Digitalfotos [logo] Online [...]
United Kingdon	Order Prints from Photoworld

You can use other online printing vendors other than the ones that Adobe has established relationships though. Either which way, you need to have an account with an online print vendor to begin using them for your print projects.

1. In either Organizer or the Photo Editor, select the photos or photo book projects that you want to send to an online printer for printing.

2. Choose File, Order Prints, Order *print vendor name* Prints from the menu bar.

3. The Adobe Photoshop Elements message window displays, requesting that you save all unsaved photos. Click OK to automatically save these files.

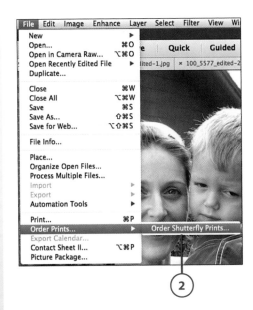

4. In the online print vendor window, set up your account or log in to your existing account. Each online print vendor has its own process for creating and accessing an account. Follow the vendor's process for logging in to an account.

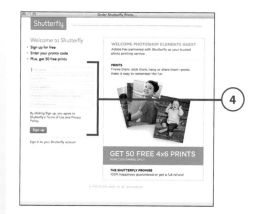

5. In the online print vendor site, set your print options for your online print job. Most online vendors can both print and mail your print copies.

>>>Go Further

SETTING UP ONLINE PRINTING SERVICE PROVIDERS

There are several online printing service providers. Here is a list of the current online service providers based on geographic location.

Region	Photo Prints	Photo Book	Greeting Card	Calendar
USA & Canada (inches)	Shutterfly Costco	Shutterfly • 8 x 8 • 11 x 8 • 12 x 12	Shutterfly • 4 x 8 Flat • 8 x 4 Flat • 5 x 7 Folded • 7 x 5 Folded	None
United Kingdom (mm)	Photoworld	Photoworld • 276 x 211	Photoworld • 195 x 105	Photoworld • 303 x 216
France (mm)	Service Photo Online	Service Photo Online • 276 x 211	Service Photo Online • 195 x 105	Service Photo Online • 303 x 216
Germany (mm)	Online Foto Service	Service Photo Online • 276 x 211	Service Photo Online • 195 x 105	Service Photo Online • 303 x 216
Rest of the world	Not available	Not available	Not available	Not available

The print services available depend on your geographic location. Each online print vendor offers services that vary based on the print project as well as the paper size used in that geographic area. When you opened Photoshop Elements 13 for the first time, see Chapter 1, "Getting Comfortable with the Photoshop Elements 13 Workspace, Preferences, and Settings," you were asked to choose your geographic location. This selection sets your location and the Adobe Partners in that area. For instance, if you live in France, photo books, greeting cards, and calendars are printed through Commandez chez Service Photo Online and the print size is set to millimeters, whereas in the United States they are printed by Shutterfly and the print size is set to inches.

If you move to a new geographic location, you can change the Organizer preferences to set this new location so that you can access an online printing service provider in that location. You have to use the Organizer Preferences for setting this location; you cannot set this in the Photo Editor.

Change Your Location

Follow these steps to change your location and therefore the list of Adobe Partners in your geographic area. Based on whether you are using a Mac or Windows version of Photoshop Elements, the instruction for accessing your geographic location is slightly different.

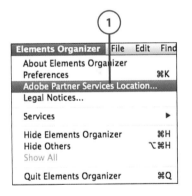

1. In Organizer, do one of the following based on your operating system:

 - (Mac) Choose Elements Organizer, Adobe Partner Services Location from the menu bar.

 - (Windows) Open the Adobe Partner Services Preference by choosing Edit, Adobe Partner Services from the menu bar. In the Adobe Partner Services Preference window, under Location click the Choose button.

2. In the Choose Location window, click the Country menu and choose your country or the closest country to you.

3. Click OK.

4. The second Choose Location Window displays. Click OK to close it.

5. You need to refresh Adobe Partner Services. In the Photo Editor, choose Photoshop Elements Editor, Preferences, Adobe Partner Services (Mac)/ Edit, Preferences, Adobe Partner Services.

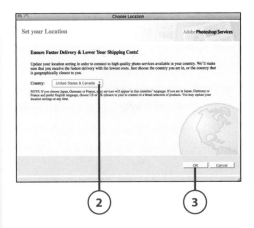

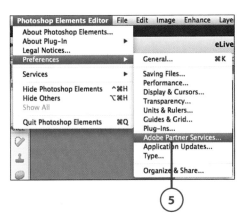

6. Click the Refresh button to refresh the authorized Adobe Partner Services in your new geographic area.

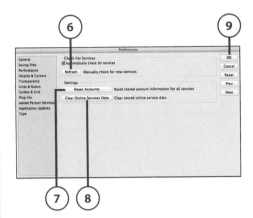

7. Click Reset Accounts to reset store account information for the Adobe Partner Services.

8. Click Clear Online Services Data to clear stored online services data.

9. Click OK to close the Preferences window.

Restart Photoshop Elements 13 After Geographic Location Change

You also might need to restart Photoshop Elements 13 after changing the geographic location. This propagates the change in both components, Organizer and the Photo Editor, and refreshes the preference files for both components.

Index

B

F

T